WRITING ABOUT
VISUAL ART

DAVID CARRIER

ART
ABOUT

WRITING ABOUT VISUAL ART

DAVID CARRIER

School of
VISUAL ARTS

ALLWORTH PRESS
NEW YORK

08 07 06 05 04 03 5 4 3 2 1

Copublished with the School of Visual Arts

Published by Allworth Press
An imprint of Allworth Communications, Inc.
10 East 23rd Street, New York, NY 10010

Cover and interior design by James Victore, New York, NY

Page composition/typography by Integra Software Services Pvt. Ltd., Pondicherry, India

Cover image: *Royal Road Test*. Original concept by Ed Ruscha and Mason Williams; photograph by Patrick Blackwell, courtesy Gagosian Gallery.

ISBN: 1-58115-261-2

Library of Congress Cataloging-in-Publication Data:
Carrier, David, 1944-
 Writing about visual art / David Carrier.
 p. cm.
 ISBN 1-58115-261-2
 1. Art criticism—Authorship. 2. Description (Rhetoric) I. Title.

N7476 .C378 2003
808'.0667—dc21
 2002152013

AESTHETICS TODAY
Editorial Director: Bill Beckley

The Chronicles of Now: The Ways of the World in Pictures and (Some) Words by Anthony Haden-Guest
Sticky Sublime, edited by Bill Beckley
Uncontrollable Beauty, edited by Bill Beckley with David Shapiro
Out of the Box: The Reinvention of Art: 1965-1975, by Carter Ratcliff
Redeeming Art: Critical Reveries, by Donald Kuspit
The Dialectic of Decadence: Between Advance and Decline in Art, by Donald Kuspit
Beauty and the Contemporary Sublime, by Jeremy Gilbert-Rolfe
Sculpture in the Age of Doubt, by Thomas McEvilley
The End of the Art World by Robert C. Morgan
Lectures on Art, by John Ruskin
Imaginary Portraits, by Walter Pater
The Laws of Fésole: Principles of Drawing and Painting from the Tuscan Masters, by John Ruskin

Printed in Canada

David Carrier's books include:

Truth and Falsity in Visual Images (1983), with Mark Roskill
Artwriting (1987)
Principles of Art History Writing (1991)
Poussin's Paintings: A Study in Art-Historical Methodology (1993)
*The Aesthete in the City: The Philosophy and Practice of American Abstract
Painting in the 1980s* (1994)
Nicolas Poussin. Lettere sull'arte, (1995); editor, with an introduction
High Art: Charles Baudelaire and the Origins of Modernism (1996)
England and Its Aesthetes: Biography and Taste (1997); editor, with an
 introduction
Garner Tullis: The Life of Collaboration (1998)
The Aesthetics of the Comic Strip (2000)
*Rosalind Krauss and American Philosophical Art Criticism: from Formalism to
beyond Postmodernism* (2002)
Sean Scully (2003)

Hegel, with characteristic profundity, spoke of beautiful art as the Idea given sensuous embodiment. As a start, this gives us the rudiments of a philosophical concept of art, and a first stab at a theory of criticism: the critic must identify the idea embodied in the work, and assess the adequacy of its embodiment.

—*Arthur C. Danto*

Nothing is more depressing than to imagine the Text as an intellectual object (for reflection, analysis, comparison, mirroring, etc.). The text is an object of pleasure.

—*Roland Barthes*

This book is for
Peggy and Dick Kuhns
and
George J. Leonard

NTENTS

A problem is not genuinely a philosophical problem unless it is possible

to imagine that its solution will consist of showing how appearance has

been taken for reality.

—*Arthur Danto*[1]

ACKNOWLEDGMENTS

Clement Greenberg provided a blurb for the cover of my *Artwriting* (1987):

> A good book. It gave me food for thought, which isn't given too often nowadays. There's much . . . in it that I disagree with—rather, take issue with. That's part of the good.

When it sold out and the publisher refused to print a revised, enlarged edition, Bill Beckley offered to include something by me in his Allworth Press series. We did not want to republish *Artwriting*, for that book, now in part dated, is available in libraries. My aim, rather, was to rework the argument from scratch.

In "le cygne" (1859), Charles Baudelaire describes the past—the past of Andromache, Hector's widow, and also the old Paris destroyed when Baron Haussmann rebuilt that city.[2]

> The Paris of old is there no more—a city's pattern changes, alas, more swiftly than a human heart—
> Only in my mind's eye can I see those makeshift booths, those piles of rough-hewn capitals and pillars, the weeds, the massive blocks of stone stained by the puddles green, the jumble of cheap bric-à-brac glittering in shop fronts.

This transformation filled him with despair.

> Paris is changing, but naught in my melancholy has moved. These new palaces and scaffoldings, blocks of stone, old suburbs—everything for me is turned to allegory, and my memories are heavier than rocks.

But change need not inspire such melancholy. When cities rebuild, sometimes buildings are torn down and replaced with totally new structures

but often rebuilt gutted structures preserve something of the older exteriors, in forms unrecognizable to the original inhabitants. This book, analogously, redevelops the arguments of *Artwriting* using some of my old examples, but in a novel format.

Richard Wollheim's treatise *Art and Its Objects: An Introduction to Aesthetics* (1968) explains that a work of art is[3]

> a product of human labour and also something that falls under a concept of art. . . . Art, and its objects, come indissolubly linked. . . . Aesthetics then may be thought of as the attempt to understand this envelope in which works of art invariably arrive.

Wollheim, who gave "minimal art" its name, was interested in the relationship between bare physical objects and associated theorizing, the envelope in which the sculpture of Carl Andre and Donald Judd arrived, which made it possible to identify these objects as art.[4] When *Art and Its Objects* appeared, a great revolution was taking place within the American art world. With the abstract expressionism era concluded, pop artists, conceptual artists, and Wollheim's minimalists were defining their places as the most important figures of the next generation. The Civil Rights Movement and Vietnam War created interest in political art, feminism was transforming the art world, and the amazing books of Roland Barthes, Michel Foucault, Jacques Derrida, and Jacques Lacan, were finding readers. These writings, which most American philosophers found obscure, provided the vocabulary for post-formalist art.

New forms of art were becoming dominant, and they were described in novel ways. In his blurb for *Artwriting,* Arthur Danto spoke with a certain sense of wonder of how my study of this period had taken

> what one would have supposed ephemeral and occasional—the literature of art criticism—and given it a philosophical weight and an almost epic dimension.

In truth, the radical transformation of art writing had some connection with changes in the larger society. As Amy Newman's recent close-up history of *Artforum* shows, within our community the struggles seemed to have an epic dimension.[5]

Richard Kuhns was my teacher at Columbia University, and he and his wife Peggy have always played a role in my life. George Leonard, a distinguished commentator on Kuhns, was a rock-and-roll star and the choreographer for Sha Na Na. George has written about popular culture in ways that have decisively influenced me. In the winter of 2000, what seemed like a casual conversation in San Francisco with Bill Berkson provided one starting point for this book. (That conversation is transcribed in chapter 4.) Then I realized what I learned from other similar conversations with Ann Stokes and Ian Angus, Paul and Ruth Barolsky, Arthur Danto, Aneta Georgievska-Shine, Marianne Novy, and Loethke and Gary Schwartz. I thank the editors who have published my art criticism: the late Richard Martin and Barry Schwabsky, *Arts Magazine*, now also deceased; Joseph Masheck and Jack Bankowsky, *Artforum*; Michael Peppiatt, *ArtInternational*; Richard Shone and Caroline Elam, the *Burlington Magazine*; Karen Wright, *Modern Painters*; Graham Shearing, formerly with the *Tribune-Review*, Pittsburgh; and Demetrio Peperoni and Simona Vendrama, *Tema Celeste*.

I owe much to Richard Hertz, who suggested that I write about art galleries; to Lydia Goehr and Alexander Nehamas; and to the writings of Thomas Crow. Appointments as Lecturer in the Council of the Humanities and Class of 1932 Fellow in Philosophy, Princeton University, Spring Semester, 1998; as visiting lecturer at the National Academy of Art, Hangzhou; and as Getty Scholar, 1999-2000, provided opportunities to discuss these issues. At Princeton, Paul Benacerraf and Nehamas provided generous support; in China, Ding Ning was a gracious host. Liz Carrier, Catherine Lee, Marianne Novy (who gave me my title), Sean Scully, Lillian Tomasko, and Barbara Westman helped me, and lively audiences at Kent State University and the Studio School, New York provoked productive discussion. And I thank Nicole Potter and Kate Lothman for generously respectful editing.

When in late spring 2001, I was appointed Champney Family Visiting Professor, a post divided between Case Western Reserve University and the Cleveland Institute of Art, one of my tasks was to teach a class bringing

xiii

together art historians from Case with art students from the Institute. A version of this book was my text. I thank my students and two auditors, Cathleen Chaffee and Todd Masuda, for helping me work through these materials, and my colleagues and our benefactress, Helen Cole, for making this marvelous teaching assignment possible. My focus on visual thinking was heavily influenced by frequent walks through the galleries next door at the Cleveland Museum of Art.

Pittsburgh, July 2001 – Cleveland, June 2002

Notes to the Acknowledgments

1. Arthur C. Danto, *Connections to the World: The Basic Concepts of Philosophy* (Berkeley, Los Angeles, London: University of California Press, 1997), 6.
2. Charles Baudelaire, *The Complete Verse*, translated Francis Scarfe (London: Anvil Press Poetry, 1986), 174-176.
3. Richard Wollheim, *Art and Its Objects: An Introduction to Aesthetics* (New York, Evanston, London: Harper & Row, 1968). This preface was suppressed after the original edition.
4. Wollheim's examples of minimalist art are not by these minimalists, but art of Robert Rauschenberg, Marcel Duchamp, and Ad Reinhardt.
5. Amy Newman, *Challenging Art: Artforum 1962-1974* (New York: Soho Press, 2000).

FOREWORD: Story Art

I began this series, Aesthetics Today, in the mid-90s, with books by John Ruskin and Walter Pater. It was an economical as well as an aesthetic experiment, in the sense that their works, copyrights long lapsed, were free to anyone who wanted to print them. I believe Ruskin, both a socialist and an aesthete, would have found this later-day publishing endeavor poetic. I chose that combination of authors to begin because, whatever their differences in the philosophy of art and poetry at Oxford in the early 1870s—Ruskin a proponent of art linked to social evolution, and Pater proclaiming in *The Renaissance* art for art's sake—a sense of beauty united them. Of course, a brilliant young Oxford student Oscar Wilde took their ideas and ran, influencing artists and writers on both sides of the Atlantic.

In a deeper sense, it seemed ironic to me that belief in the value of human pleasure had somehow fallen by the wayside in favor of a very literal kind of social responsibility, when, in fact, to be socially responsible is in part to acknowledge those fleeting moments in human experience that are expansive, such as when a child appreciates the colors and transparencies of Lego.

The purpose of this series is to bring art criticism to the fore, to present art writing as an object not unlike the objects of which art criticism speaks. This book by David Carrier is an exclamation point in that endeavor. It addresses the nature of art writing itself.

To my delight, David chose as examples to support his premise some of my favorite passages in literature and art criticism: the pronunciation of the fictional Lolita's name in the first chapter of Nabokov's novel, a passage that I have known by heart since late pubescence, as well as Ruskin's reflections on his nonfictional entry into Venice. David also referenced Proust's fictional account of the death of the art critic Bergotte, which includes a description of a little patch of yellow wall that may or may not have existed at one moment in time, but lives now as a little patch of nonfictional yellow paint in Vermeer's *View of Delft* at The Hague. So this text becomes a volatile and sensual texture, combining the works of art writers and writers of fiction through an understanding of narrative structures—specifically the stories that have become the fairy tales as well as the directives of our lives.

The premises of this text—that art history is as susceptible to narrative structure as fiction, and how it is possible to see art devoid of this narrative structure—liberate us from obligations that have become unconscious givens. It is a new way of seeing.

Once, in a rickety little car, I was driving through Florence. Just before entering the city, the old brass radiator sprang a leak. A fountain spouted from the car in two arched streams, a kind of watery hood ornament.

It was twilight. We had been driving in the open car for hours, covered in dust, engine grease, and oil, and were exhausted. So many traffic lights and so much traffic, the curse of both Italian commuters and Italian architecture, only accentuated the problem as the car overheated. I had so wanted to stop in a hotel in the city and wake the next morning and roll out of bed into the Uffizi Gallery. But now it seemed the only recourse was

to get out of traffic and out of town as fast as we could. So I drove to what I thought was the nearest exit, up a hill into the countryside. I was not aware at the time that it was the hill of Fiesole, where not so long before, if you consider the lifespan of galaxies, Galileo first gazed through his telescope at the stars. The car chugged up the hill, and finally, at some point near the top, it simply gasped a billow of steam in a great long sigh and stopped.

The car had expired, and so had we, by chance, in front of a building with a beautiful façade. This building, by some incredible coincidence, happened to be a hotel, by the name of Villa San Michele. In the purple light of dusk I marveled at the façade—and I am not going to claim that it is more incredible than the east façade of Gaudi's Sagrada Familia, an aria by Janis Joplin, Smithson's *Spiral Jetty*, or even a chorus of Sid Vicious's "My Way." But my head was spinning from something. I was distracted only by the hope, façade or no façade, that there would be one available room that evening, whatever the cost.

It turned out to be the most expensive hotel in the world. What seemed like thousands of fireflies kept me awake much of the night, as did the water that cascaded into the swimming pool from some dimly lit higher level—call it the sublime. Years later I found, as I researched *The Laws of Fésole*, the peculiar book that inaugurated this series, that Ruskin too had slept there when it had been a Franciscan monastery.

The morning after, from a brochure on the bedside table, I found that Michelangelo had designed the façade. So, the evening before, I had experienced a Michelangelo, not devoid of experience or content, for I had brought that all with me like the road dirt that covered my body, but I had experienced a Michelangelo *almost* outside my story of art—like new, at least for a second.

This is something of what David's book is about, and this book is also about what his friend, Arthur Danto, differentiated as the beauty in, as opposed to the beauty of, a work of art. It *is* what Roland Barthes so aptly

spoke of as the province of books and facades, paintings and sculptures, fountains and songs-the pleasure of a text.

And the fireflies everywhere in sky and cloud rising and falling, mixed

with the lightning, and more intense than the stars.

Bill Beckley

September 8, 2002

"Any language . . . is a conspiracy against experience in the sense

of being a collective attempt to simplify and arrange experience

into manageable parcels."

—*Michael Baxandall*[1]

OVERTURE

A significant portion of many high modernist novels, and much recent popular literature, is devoted to lovingly detailed accounts of material objects. Learning about these things tells us much about the fictional characters who use them. At the start of Gustave Flaubert's *Madame Bovary*, for example, consider the leisurely account of Charles Bovary's hat:[2]

> It was a head-gear of composite nature, combining elements of the busby, the lancer cap, the round hat, the otter-skin cap and the cotton nightcap—one of those wretched things whose mute ugliness has great depths of expression, like an idiot's face . . .

The foolish hat identifies all too accurately the character of its wearer, and so, this description allows us to anticipate his unhappy fate. When, similarly, Henry James's *Golden Bowl* describes the wedding gift that gives his novel its title, how much we learn about the secret lovers, the Prince and Maggie Verner:[3]

> Simple, but singularly elegant, it stood on a circular foot, a short pedestal with a slightly spreading base, and, though not of signal depth, justified its title by the charm of its shape as well as by the tone of its surface. . . . As formed of solid gold it was impressive; it seemed indeed to warn off the prudent admirer.

We ought to be well warned by this impressive bowl.

Literary scholars discuss the ways that accumulation of such naturalistic details creates the reality effect, the illusion that mere fiction describes actual characters and real events:[4]

> The ceilings, curved and not too high (lower than in a church, but still higher than in any chapter house I ever saw), supported by sturdy pillars, enclosed a space suffused with the most beautiful light, because three enormous windows opened on each of the longer sides, whereas a smaller window pierced each of the five external sides of each tower; eight high narrow windows, finally, allowed light to enter from the octagonal central well.

As we might expect from Umberto Eco, author of an astute analysis of naturalism in James Bond thrillers, *The Name of the Rose* provides a very convincing description of this imaginary library.

Art writing, descriptions of visual works of art, includes not only the grand publications of Erwin Panofsky, Alois Riegl, and Aby Warburg, and journalistic reviews in provincial newspapers; but also books like Field Dawson's unacademic *Emotional Memoir of Franz Kline*:[5]

> Franz and de Kooning grinned, and de Kooning stood up and gestured, spreading his hands apart indicating Franz and myself, generously asked, "How about a drink?"
> We beamed.
> We began with whiskey and water over ice, and Franz showed us the suit he had gotten, and I was bending with laughter as Franz shyly grinned.

And it encompasses the wonderful ekphrasis on Vincent van Gogh's *Portrait of Dr. Gachet* at the start of Cynthia Saltzman's social history,[6]

> Elongated and spectral, the figure of an older man is seated at a table, painted red. He leans far to the left. His narrow head is propped upon a skeletal fist; his other hand lies, its fingers slightly spread, open on the table's edge. He is wearing a cream-colored cap and a dark blue jacket,

as well as such frankly ephemeral art criticism as Frank O'Hara's magnificent, brief review of Fairfield Porter:[7]

> In these landscapes, interiors, and portraits, the negative space of semi-realist painting is made positive by abrupt terminations of the form in the atmosphere—of a tree in the sky, of a face in the pressure upon its surface and of the air it breathes.

If you read only masterpieces, you will not fully understand art writing.

Imagine a reader passionately interested in all the literature of art, not only the great commentaries, but also minor books and essays, and even the

frankly bad writings. Emulating her provides a suggestive way of introducing the concerns of this book. Not distinguishing between art history and art criticism, between scholarly and popular texts, or between the famous and lesser writers, she reads not only canonical books, but also popular fiction and trashy writings. Such a reader would do well to share notes with an equally catholic lover of fiction, for descriptions in art criticism and art history are similar to those in the novels of Flaubert, James, and Eco.

Indeed, both real and imaginary works of art appear in novels. While describing Marcel's pursuit of the girls at the beach, Proust gives an extended word painting of an imaginary seascape by his fictional painter Elstir:[8]

> The men who were pushing down their boats into the sea were running as much through the waves as along the sand, which being wet, reflected the hulls as if they were already in the water. The sea itself did not come up in an even line but followed the irregularities of the shore, which the perspective of the picture increased still further, so that a ship actually at sea, half-hidden by the projecting works of the arsenal, seemed to be sailing through the middle of the town.

The forward momentum of the story halts as we are absorbed in this leisurely account—I quote only a small portion.

John Banville's novel *The Untouchable* brilliantly constructs a spy and connoisseur very similar to Anthony Blunt. Poussin's *Eleazer and Rebecca at the Well* was owned by Blunt, and this character possesses an imaginary Poussin, *Death of Seneca*, which enters into the narrative. Relatively early on Banville's character says:[9]

> It is a curious phenomenon, that paintings are always larger in my mind than in reality. . . . when I encounter it again after even a brief interval I have the uncanny sense that it has shrunk . . .

Then, much later, he describes his *Death of Seneca*:

> Here nature is present only in the placid view of distant hills and forest framed in the window above the philosopher's couch. The light in which the scene is bathed has an unearthly quality, as if it were not daylight, but some other, paradisal radiance. Although its subject is tragic, the picture communicates a sense of serenity and simple grandeur that is deeply, deeply moving.

Denis Mahon, as brilliantly stylish a writer as Banville, in one uncharacteristic "note of pure fantasy," as he describes it, argues that Poussin's *Rebecca Quenching the Thirst of Eliezer at the Well* (1627) is autobiographical. Eliezer may be a stand-in for Poussin and his relationship with his patron, Cassiano dal Pozzo:[10]

> We see . . . a youngish man, fatigued by his travels and exertions in the heat of a Mediterranean summer's day, at length attaining his goal and receiving solace and refreshment from the well (pozzo) at the hands of a dignified and statuesque figure worthy of typifying the eternal city—in a setting which indeed evokes the environs of Rome.

Mahon describes a real, and Banville a merely imaginary, Poussin, but no feature internal to their art writing permits making this distinction. *Death of Seneca*, like Elstir's seascape, could, for all we can tell from these quotations, be actual pictures.

That art writing be found in fiction is not sufficient to reveal whether the objects described exist, for elsewhere in Proust, Vermeer's real *View of Delft* plays a key role. Near death, his fictional novelist Bergotte[11]

> noticed for the first time some small figures in blue, that the sand was pink, and, finally, the precious substance of the tiny patch of yellow wall. His dizziness increased; he fixed his gaze, like a child upon a yellow butterfly that it wants to catch, on the precious little patch of wall.

Inspired by Vermeer, Bergotte sees how he should have written. To learn that Bergotte is Proust's invention but *View of Delft* an actual painting, we must look outside *Remembrance of Things Past*.

When a scene in the detective story *Diva* takes place in the Théâtre des Champs-Elysées, beneath[12]

> the ceiling painted by Maurice Denis. . . pastel colors that would make Andy Warhol choke. The fat, pink Muses floated blissfully in a pale sky, naked except for wisps of cloth that saved them from indecency,

mere reading cannot reveal whether this is an actual painting. Nor just within Muriel Spark's *Prime of Miss Jean Brodie* can we infer if the art teacher Mr. Lloyd, an imaginary figure, lectures about an actual painting:[13]

> He said nothing of what the pictures represented, only followed each
> curve and line as the artist had left it off. . . . The ladies of the
> *Primavera,* in their netball-playing postures, provided Mr. Lloyd with
> much pointer work. He kept on passing the pointer along the lines of
> their bottoms which showed through the drapery.

And when Vladimir Nabokov's *Ada* describes a pornographic print in
which[14]

> A Mongolian woman with an inane oval face surmounted by a hideous
> hair-do was shown communicating sexually with six rather plump,
> blank-faced gymnasts in what looked like a display window jammed
> with screens, potted plants, silks, paper fans and crockery,

we do not know if it exists. Since Nabokov's *Lolita* cites actual landscape
painters, "Claude Lorrain clouds inscribed remotely into misty azure. . . .
a stern El Greco horizon, pregnant with ink rain," this print too could be
real.[15]

Popular novelists' lives of artists, a form of art writing in-between art
history and pure fiction, also describe works of art. Irving Stone presents
Michelangelo in the Sistine Chapel:[16]

> This would be the most powerful of all his Christs; he made him Zeus
> and Hercules, Apollo and Atlas. . . He pulled back into space the right
> leg of Christ, even as he had the Moses, to cause an imbalance of weight
> and set the whole figure in a state of tension. The wall would be
> dominated by Christ's *terribilità,* his terrifying awesomeness.

Stone imagines Camille Pissarro in his studio—[17]

> Degas had been painting a plump nude model. When he saw Camille
> he called, "Welcome, I've been waiting for you." To the model he said
> . . . You have buttocks shaped like a ripe pear, like the Gioconda—

and Vincent van Gogh when he goes crazy:[18]

> "I have brought you something."
> "For me? A present?"
> "Yes. . . ."
> "What is it?"
> "Open, and you will see."
> Rachel unwrapped the papers. She stared in horror at the ear.

Stone's novels make art history accessible.

At a higher level, Dimitri Merejkowski's life of Leonardo offers a Pateresque account of *Mona Lisa*:[19]

> She who was depicted . . . was coming to resemble Leonardo more and more . . . this same smile he had seen in the case of Thomas the Doubter, inserting his fingers into the Lord's wounds, in the sculpture of Verocchio, for which the youthful Leonardo had served as model; and in the case of Our Mother Eve before the Tree of Knowledge in the master's first picture; and in the Angel shown in the Virgin of the Rocks, and in Leda and the Swan . . . as though all this life, he had been seeking a reflection of his own charm, and had, finally, found it in the face of Gioconda.

And Lion Feuchtwanger's biography of Goya describes *The Family of Carlos the Fourth* as seen by its creator:[20]

> He believed in absolute monarchy. . . . But the ugly events which were besetting Spain . . . all this was in Goya's head as he painted. . . . And it was precisely because he painted without hatred that . . . the pitiable humanity of every single one of those representatives of royalty leaped to the eye with stark, factual brutality.

Academic art historians usually adopt an impersonal point of view, but since it would be possible to translate these descriptions into third-person accounts, that does not in itself explain the difference between such fiction and art history.

The ekphrases in Philostratus's *Imagines* have been much analyzed by classicists, who remain uncertain whether they describe real frescoes, perhaps like those unearthed in Pompei, or are merely a literary exercise:[21]

> Now look at the painting and you will see just this going on. The look-out gazes at the sea. . . . The colours of the fish vary, those near the surface seem to be black, those just below are not so black, those lower still begin to elude the sense of sight. . . . The group of fishermen is charming, and they are brown of complexion from exposure to the sun.

In vividly presenting paintings, such writing cannot in itself tell us whether that art described actually exists. Real paintings can be described in fiction, and imagined paintings in art history writing. An art historian tells that X-rays of *View of Delft*[22]

reveal that numerous small changes have been made in the rooftops. These changes indicate that Vermeer compressed the cityscape into a dense frieze by simplifying the city's profile and spreading out its forms . . .

Proust could have used this observation in his description of the dying Bergotte observing Vermeer's cityscape.

Julian Barnes's *History of the World in 10½ Chapters* gives a madly inventive account of Géricault's *Raft of the Medusa*:[23]

> Let us start with what he did not paint. He did not paint:
> 1) The *Medusa* striking the reef;
> 2) The moment when the tow-ropes were cast off and the raft abandoned;
> 3) The mutinies in the night. . . .
> In other words his first concern was not to be 1) political; 2) symbolic; 3) theatrical; 4) shocking; 5) thrilling; 6) sentimental; 7) documentational; or 8) unambiguous.

Michael Fried offers an even more imaginative description of *The Raft of the Medusa*:[24]

> The strivings of the men on the raft to be beheld by the tiny ship on the horizon, by startling coincidence named the *Argus*, may be viewed not simply by a desire for rescue from the appalling circumstances depicted in the painting but also by the need to escape our gaze, to put an end to being beheld by us.

Nothing within these quotations permits us to deduce that Barnes is writing fiction, and Fried very serious art history. Just as Barnes tells us what is *not* in the painting, so elsewhere, in analysis of Courbet's *Hunter on Horseback*, Fried notes that a horse is depicted *not* standing in water, but on snow.[25]

When in a 1955 review, Leo Steinberg writes that in Willem de Kooning's abstractions we see not things[26]

> but events—a darting, glancing, evading, overlapping, and colliding; a grammar of forms where all nouns were held in abeyance; systems of turbulence whose rate of motion was so flickering fast that the concretion of a "thing" became unthinkable,

no textual detail allows us to know that this is art criticism, not a passage from fiction.[27]

> They noticed in the corner of the canvas the tip of a bare foot emerg-
> ing from the chaos of colours, tones, and vague hues, a shapeless fog;
> but it was a delicious foot, a living foot. . . . The foot seemed to them
> like the torso of some Venus in Parian marble rising from the ruins of
> a city destroyed by fire.

Balzac's account of Frenhofer's unfinished masterpiece seems to prophesize abstract expressionism.

Sydney J. Freedberg brilliantly describes Caravaggio's *Death of the Virgin* (1605):[28]

> The tenor of emotion, contained and stilled, remains like that of clas-
> sicism, but it probes in private regions that the conventions of classi-
> cism would close off: there is no secret of the psyche that Caravaggio
> cannot find out. . . . the only touch of rhetoric or self-conscious art is
> in an accessory of setting, in the curtain.

In context, Caravaggio's immediacy is contrasted with Annibale and Ludovico Carracci's need to idealize. Oliver Banks's *Caravaggio Obsession*, about a policeman pursuing a stolen Caravaggio, also describes *Death of the Virgin*,[29]

> The Virgin Mary . . . was not shown dying, as was the custom, but
> dead. Worse than dead: a bloated corpse resting on a crude bed in a
> nondescript cellar. There were no choirs of angels carrying her soul
> heavenward, either,

anticipating Freedberg's contrast between the idealizing tradition and Caravaggio's directness. A novelist could use Freedberg's description or, conversely, an art historian might appropriate Banks's account, but even then there would be a difference in kind between Freedberg's words, which describe and evaluate a painting, and Banks's, which advance a narrative. Elstir's seascape, Poussin's *Death of Seneca*, and the pornographic print in *Ada*, merely imaginary, exist only in the fiction of Proust, Banville, and Nabokov. For novelists, fictional works of visual art can be as good as real ones.

Arthur Danto argues that because a work of art may be indiscernible from a mere physical object, art cannot be identified just by its visual appearance. Marcel Duchamp's *Fountain* (1917) is essentially indiscernible from a plumb-ing fixture, and Andy Warhol's *Brillo Box* (1964) is basically identical to

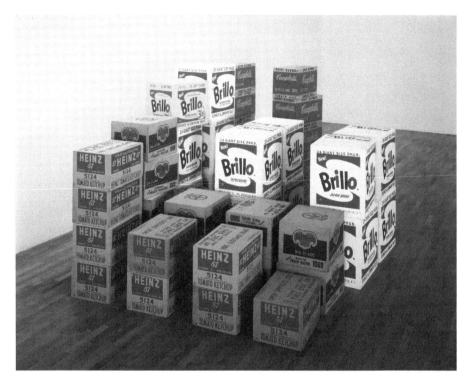

Warhol, Andy (1928-1987). *Various Box Sculptures*, 1964. © The Andy Warhol Foundation for the Visual Arts/ARS, NY. Copyright The Andy Warhol Foundation, Inc./Art Resource, NY

Brillo boxes in the grocery. Only when placed in art galleries and the museums do those objects become art. Similarly, the difference between descriptions of real art in writings by historians or critics, and indiscernible accounts in fiction, can only be understood by knowing context. Novelists use art to advance stories or, like Stone, Merejkowski, and Feuchtwanger, to tell stories about painters. In a novel, art writing thus serves as a means to an end. The historian or critic, by contrast, wants descriptions that accurately describe, interpret, and evaluate actual works of art. Just as *Fountain* and *Brillo Box* only become art when set in galleries or museums, so such descriptions only become art history in the right literary context. To extend our parallel in a natural way, to understand *Fountain* and *Brillo Box* we need to analyze the museums in which they are displayed, and to understand art writing we need to identify its setting.

The concerns of art writers thus have some natural connection with those of novelists. Hayden White's claim that[30]

there has been a reluctance to consider historical narratives as what they most manifestly are: verbal fictions, the contents of which are as much *invented* as *found* and the forms of which have more in common with their counterparts in literature than they have with those in the sciences,

was highly controversial, for it suggested that history was merely a form of fiction. Historians, White's critics replied, do not merely tell convincing-sounding stories, but create narratives true to the facts. What seems plausible may not be true and what happens may be improbable. Accepting that argument, I would extend White's observation in a very natural way to art writing.

> *There has been a reluctance to consider art writers' narratives as what they most manifestly are: verbal fictions, the contents of which are as much invented as* found *and the forms of which have more in common with their counterparts in literature than they have with those in the sciences.*

In the literature of art, it is impossible to absolutely separate, or entirely distinguish, the arguments of an art writer from the literary structures used to present those arguments. This I dub Barolsky's Principle, in honor of Paul Barolsky, who has identified numerous examples, many of great ingenuity, of Vasari's literary devices.[31]

How we see painting or sculpture is very much determined by what we have read. Art critics and historians verbalize responses to visual works of art, structuring our thinking in ways very hard, if not impossible, to escape. Giotto, for example, when asked by an envoy from the pope to produce a drawing, drew, freehand, a perfect *O*. His drawing puzzled that simple-minded man, but the pope and his courtiers recognized the artist's excellence, and gave him important commissions.[32] The *O*—"tondo" in Italian, a very overdetermined story element—is a dim-witted person, like the envoy; a symbol of perfection; and a compressed form of Giotto's signature. Vasari, perhaps borrowing from a similar legend about Apelles, links a line from Dante's *Inferno* about quickly executed writing to wordplay with names of other artists. His *Lives* are history[33]

rooted in fiction, filled with imaginary artists, events, epitaphs, tombs, emblems, speeches, anecdotes, and interpretations of works of art that transform their meaning, giving them new significance.

Subtly interpreted, Vasari's truthful fictions permit us to understand the art they describe.

Can an art writer concerned with creating a verbal artifact also describe art? These two goals, it might seem, are basically different, and so can conflict. Insofar as Vasari's narrative is concerned with the intertextual play of the letter *0*, can that story also be about the painter? Just as an artist may focus either on the landscape behind his window, or on the surface of that window itself, but not on both, so, analogously, it might seem the art writer can play with words, or describe art, but not both at the same time. To understand a work of art, to pursue that analogy one step further, we need to focus very intently on an object.[34]

> In the visual arts . . . we are called upon to concentrate our attention upon individual bits of the world: this canvas, that bit of stone or bronze, some particular sheet of paper scored like this or like that.

But that requires that we compare this work of art with some others, for it is hardly possible to explain how some one thing *is* without comparing and contrasting it to other similar things.

To note that Piero della Francesca's *Flagellation* is unrhetorical, or that Goya's *Third of May* shows raw violence, implicitly compares them with other art. Someone who knew only *Flagellation* and *The Third of May* could hardly understand those judgments. And so, in trying to identify the unique qualities of an individual work of art, we must compare. As Julian Schnabel notes,[35]

> all paintings, in fact, are metaphoric. You look at one. It reminds you of something that you might have seen, a key to your imagination, not dissimilar to seeing a slogan on a wall and being able to imagine somebody painting its letters, seeing the back of his head and the stroke of his arm in the night. . . . The concreteness of a painting can't help but allude to a world of associations that may have a completely other fact than that of the image you are looking at.

As an art critic says, a painting cannot be seen in isolation because "everything in art comes out of something and what it is against is part of what it is."[36]

When Barolsky says that Vasari's interpretations of works of art "transform their meaning, giving them new significance," he implies some difference between the original meaning and the significance given this art by Vasari. But since it is not clear how we gain access to original meaning, a more radical claim may be plausible. Perhaps there is no way that art is, apart from how it is represented in art writing. When metaphysicians discuss things in themselves—reality as opposed to mere appearances—they note how we impose our conceptual categories upon experience. Unknowable directly, the world is revealed to us only as it appears through the veil of experience. We know art directly, but writing imposes verbalized ways of thinking upon these visual artifacts. Visual thinking is verbally structured by the rhetoric of art writing.

If language thus imposes its structures upon experience of art, can we ever escape its effect? Perhaps not, but when we contrast alternative accounts of one picture, we obtain differing perspectives, permitting us to "subtract out" the interpreter's rhetoric. Compare, for example, Tim Clark, Michael Fried, Robert Herbert, and Meyer Schapiro on Edouard Manet's *Bar at the Folies-Bergére*. In a lecture given in 1961, based upon materials presented in lectures going back more than three decades but only published posthumously in 1997, Schapiro writes:[37]

> By extending across the whole field of the canvas and appearing to exist beyond it, the mirror acquires the unbounded quality of the space of the real world; by its closeness to the more prominent objects reflected in it . . . there is effected a seeming continuity of real and mirrored space.

Giving the mirrored world "the openness and fullness of a real environing space," Manet "also brings the crowd as a spectacle into the picture."

Tim Clark admires Schapiro's early Marxist writing on impressionism, but his own commentary focuses on the inconsistency of the mirror image.[38]

> A mirror is a surface on which a segment of the surrounding world appears, directly it seems, in two dimensions . . .
> The mirror must therefore be frontal and plain and the things

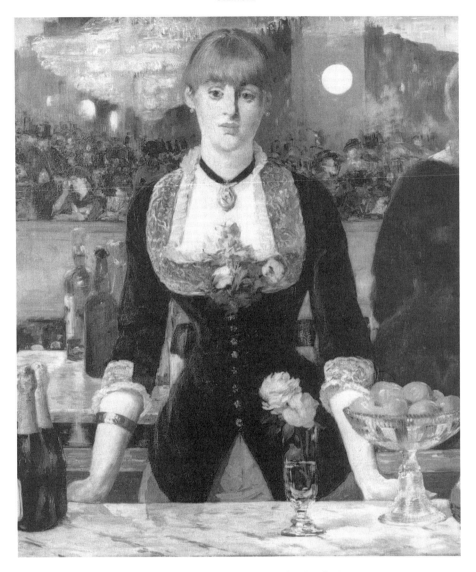

Edouard Manet (1832–1883), *A Bar at the Folies-Bergére*. Courtesy Courtauld Institute Galleries, London.

that appear in it be laid out in a measured rhythm. And yet it is clear that some of those things will not be allowed to appear too safely attached to the objects and persons whose likenesses they are. I think that this happens . . . as a result of Manet's attitude towards . . . modern life in Paris. . . .

The shifting uneasy relation between appearance and reality within *A Bar* is a perfect image of popular entertainments. Clark links this picture with

café concerts, setting it in a very different context than Schapiro who, after citing small mirrors in earlier paintings, contrasts the mirror in Ingres's *Countess d'Haussonville*.

Unlike Schapiro, Clark offers an explicitly political reading. "Modern life for Manet," he writes, "is not greatly animated, not familial, and not proletarian," a statement that reminds us of what he himself has elsewhere said about the essentially negative quality of modernist art.[39] Taking exception to this view of Manet's limitations, Michael Fried reads the failure of the reflection to match the figures in front of the mirror in a different way. This painting is[40]

> making explicit the double relation to the beholder I have ascribed to Manet's paintings generally. . . . Manet in effect painted *his own absence* from the ternary relationship on which, I have suggested, his art crucially depended.

Like Clark, Fried fits this picture into a plan developed in his own earlier writings.

In his social history of impressionism, Robert Herbert offers yet another viewpoint. Seeking to interpret the mirror reflection, "faulty, judged by the tradition of naturalistic illusions," he finds this doubling of the barmaid a way of displaying her roles:[41]

> Her frontal image is correct, even distant from us; nothing hints at her availability after hours. In the mirror, her more yielding nature is revealed, detached as it were from her body by the man's powers of wish-fulfillment.
> We can't really be that man, yet because we are in the position he would occupy in front of the bar, he becomes our second self.

George Mauner offers a very different analysis, treats the painting as an illustration of the relation between the sacred and profane, creating another context.[42]

> There is a direct opposition between the "two" barmaids who are, nevertheless, undeniably the same person. The actual girl is conceived much in the manner of the early portraits. . . . The brilliance of the setting . . . identify this looking-glass as the mirror of the vanities. Only part of the girl belongs to it, and Manet has dissociated that part of her

nature from the other part . . . (two women are) used to illustrate the
duality of human nature. . . .

Unlike Clark, he links *A Bar* closely to Renaissance art.

Setting *A Bar* in context involves linking it with pictures and
descriptions of cafés, street life, or whatever else is relevant. When these art
writers bring to the picture very diverse aesthetics, where are the points of
conflict, as opposed to mere differences of focus? Danto's *Transfiguration of
the Commonplace* presents a thought experiment that helps answer that ques-
tion. Inspired by Kierkegaard, who described an unreal history painting
showing the Israelites crossing the Red Sea after the sea closed on the pur-
suing Egyptians, Danto imagines seven identical-looking paintings.[43]

> 1. The Egyptians Drowning as they chase the Jews across the Red Sea.
> 2. *Kierkegaard's Mood*, an expression of the personality of the man who
> imagined *The Egyptians Drowning*.
> 3. *Red Square*, a Moscow landscape.
> 4. *Red Square*, a Russian minimalist painting.
> 5. *Nirvana*, a Buddhist image of the state of transcendence.
> 6. *Red Table Cloth*, a still life by a pupil of Matisse.
> 7. A red surface, the ground for a painting that Giorgione did not live
> to execute.

Poussin might have understood the joke in *The Egyptians Drowning*, but he
would have found *Nirvana* incomprehensible. *Kierkegaard's Mood* could
only have been painted in the twentieth century, and *Red Square* would
have been incomprehensible before the 1960s.

How different are these seven indiscernible red squares!

> 1. A red panel depicting the drowning Egyptians.
> 2. A red panel expressing Kierkegaard's mood.
> 3. A red panel presenting a Moscow landscape.
> 4. A red minimalist painting.
> 5. A red panel illustrating Nirvana.
> 6. A red still-life painting.
> 7. A red panel that is not a work of art.

Just as the unity of discussion here is not "a red panel," but "a red panel with
some description," so in the dispute between Clark, Fried, Herbert, and
Schapiro, the unit of discussion is not merely the Manet painting *A Bar*.
Rather, we should compare:

> *A Bar* and Clark's commentary;
> *A Bar* and Fried's commentary;
> *A Bar* and Herbert's commentary;

and

> *A Bar* and Schapiro's commentary.

These entities are as distinct as the various red squares considered by Danto, so it is unsurprising that Clark, Fried, Herbert, and Schapiro disagree. Each writer approaches the painting with different expectations, setting *A Bar* in his own quite distinctive interpretative framework.

Danto argues that *Fountain* and *Brillo Box* could not be art without the associated theorizing. In claiming that *A Bar at the Folies-Bergére* cannot be understood apart from the art writing of Clark, Fried, Herbert, and Schapiro, we are only generalizing his claim in a natural way. Danto focuses on the role of art writing in identifying art, and we are concerned with how this literature projects interpretations. But were this the whole story, there could be no conflicts amongst our historians, for each, imprisoned within his own system, would be unable to argue with anyone who held a different view. We would be in the position of readers of Philostratus' *Imagines*, unable (since these paintings probably have not survived) to know if his descriptions are truthful, or even if they describe actual works of art.[44] But in fact Clark, Fried, Herbert, and Schapiro are describing the same well-known Manet. Everyone sees the barmaid and her mirror reflection, and everyone agrees that the reflected image is inconsistent with her place, frontally facing us from the center of the picture. Richly suggestive debate proceeds only because there is much agreement.

Thus, there is a real tension between focusing on the work of art and setting it in context in art writing. Some contemporary art historians deny this, arguing that we can focus on the work of art itself, without being distracted by art writing. Bruce Cole, for example, complains that[45]

> many . . . art historians approach art not directly but theoretically. They are interested in methods and ideologies borrowed from other disciplines. . . . Attention is now focused more on the society from which the art arises than on the artist or on the individual work of art as an independent, complete entity with a unique form and meaning.

Certainly he notes a real problem—a great deal of present-day art writing is overly verbal. But I reject Cole's implied distinction between seeing the work of art itself and approaching it through art writing. When he describes *A Bar*,

> what at first seems like a deep space behind her (the barmaid) is in fact a large mirror which distortedly reflects her back, the crowded café which she faces, and the man wearing the top hat upon whom she is waiting,

how can we not think of Clark's famous commentary, which directs our attention onto the mirror? No writer can escape his era, though it is possible to resist its prevailing ruling assumptions, as Cole effectively does.

The art critic reports on what is seen. So does the art historian, but she balances visual experience against the written evidence, while sometimes we critics pretend that the art we see has never been written about by anyone else. Reviewing the 1996 Carnegie International, I noted that[46]

> Robert Gober's *Untitled (Man in Drain)*, 1993–94, is humorously and effectively placed on the far side of the room on the second floor, so that you look down into the bowels of the museum. And Rachel Whiteread's Untitled *(One Hundred Spaces)*, intelligently and effectively colonizes the room in which it is displayed. The Cindy Shermans hang about the sculpture court to stunning and witty effect.

Already there were many commentaries on Gober, Whiteread, and Sherman, but in this brief review without footnotes I write as if seeing their art for the first time. "My aim," as Stendhal said in his Salon of 1824,[47]

> is to make each spectator question his own heart, articulate his own feelings, and thus form a personal judgment and a vision based on his own character, tastes, and predominant emotions.

That, also my aim, is the natural goal of the critic:[48]

> I see the object. I translate that seeing into vision. I encode that vision into language, and append whatever speculations and special pleadings I deem appropriate. At this point, whatever I have written departs. It enters the historical past . . . while the visible artifact *remains* in the present moment.

Capturing that momentary experience, giving the illusion of describing a completely fresh experience, the art critic describes what he sees.

In 1996 you could still respond naïvely to Gober, Whiteread, and even Sherman, pretending to see their art afresh, but it is hard to look at Poussin's *Arcadian Shepherds* as if unaware of the massive literature. Much discussed within the artist's lifetime, *Arcadian Shepherds* is the subject of a classic, often analyzed commentary by Erwin Panofsky.[49] In their recent selective discussion, Elizabeth Cropper and Charles Dempsey mention Louis Marin's critique of Panofsky; the iconography of the shadow cast by the kneeling shepherd, and the account of Oskar Bätschmann; seventeenth-century views of allegorization of history; and the relation of Poussin's painting to Giovanni Benedettro Castiglione's *Temporalis Aeternitas*:[50]

> We have added to Marin's crucial observation about the relationship between history and memory, and about the discourse of painting in the *Arcadian Shepherds*, some further observations about the distinctions drawn between understanding gained through touching and through seeing, between the shadows of drawings and the colors of painting, and between the carving of memorials and the painting of memories, as well as their relative claims to immortality.

Now when a novel political interpretation of *Arcadian Shepherds* has been published, debate is likely to continue.[51]

My review of the Carnegie International is journalism, and Cropper and Dempsey's account of *Arcadian Shepherds* is art history. An art writer using the present tense, without footnotes or references to earlier commentary, usually is an art critic, or a popular journalist. There are, so it might seem, two ways of coming to know works of art—directly and by reading. But what is the relationship between seeing and reading about *Arcadian Shepherds*? Our direct experience of paintings, does that not override anything we may read? As Richard Wollheim puts it, discussing the dating of another Poussin,[52]

> it isn't, after all, as though the *Diogenes* were original or primary evidence for my interpretation of the *Phocion* painting. . . . My primary evidence for the interpretation of the *Phocion* painting is the *Phocion* painting itself.

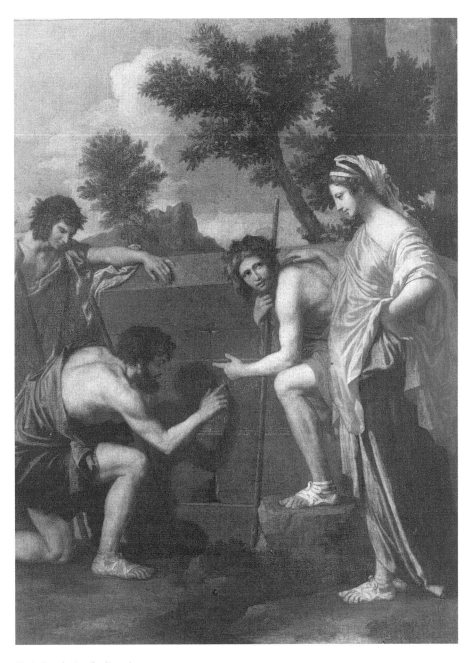

Nicolas Poussin, *Arcadian Sheperds.*

Since all evidence ultimately must come from the painting, how absurd to imagine that there could be a conflict between visual experience and commentary. True enough, but when art has been much written about, our experience of it is influenced by bookish references. Seeing *Arcadian Shepherds*, I recall what I have read; when studying that literature, I remember the painting.

It is hard not to experience a much-discussed painting in this divided way. In the museum, there is an inevitable competition between looking at the object right in front of us and remembering this literature. Even if you carry commentaries into the Louvre, still there is a moment when you turn from Poussin's painting to read. Just as we can only recollect something no longer present, so only when we are not viewing the painting can we read the accounts in which earlier commentators describe that work of art. In William Gibson's cyberpunk novel *Virtual Light*, sunglasses employing upscale computer technology project directly onto the visible world information about the history of the city:[53]

> Put 'em on, you go out walking, everything looks normal, but every plant you see, every tree, there's this little label hanging there, what its name is, Latin under that.

This device would solve our problem by permitting us to see commentary on a picture imposed upon that object itself. But until it exists, we need to move our eyes between the painting on the wall and written commentary.

Art writing deserves scrupulous close study because it defines, informs, and structures our experience of art. Analysis of this writing is important because it enables us to understand our art world. Part one of this book identifies some literary structures of art writing. The first chapter considers beginnings and the second, endings; and chapter 3 analyzes art writing that seeks to escape altogether from the constraints of temporal narrative structures. My earlier publications do not properly set this writing within its institutional framework.[54] Part two repairs that omission, explaining what art writing does. Close study of art writing matters not merely because the literary skill of some critics and historians deserves attention—although

that is important. Chapter 4 looks at the role of art-history writing in relation to the museum, and chapter 5 connects art criticism with the institution devoted to contemporary painting and sculpture, the art gallery. Chapter 6, turning to philosophy, shows how art writing creates an interpretative community. By itself, part one could seem a purely formal analysis. Set in isolation, part two might appear merely a sociological commentary. But taken together they explain how the literature of art promotes and supports visual thinking.

Notes to the Overture

1. Michael Baxandall, *Giotto and the Orators* (Cambridge: Cambridge University Press, 1971), 44.
2. Gustave Flaubert, *Madame Bovary*, translated by Lowell Blair (New York: Bantam, 1984), 3.
3. Henry James, *The Golden Bowl* (New York: Dell, 1963), 88.
4. Umberto Eco, *The Name of the Rose*, translated by William Weaver (New York: Warner Books, 1983), 78-79.
5. Field Dawson, *An Emotional Memoir of Franz Kline* (New York: Pantheon, 1967), 39.
6. Cynthia Saltzman, *Portrait of Dr. Gachet: The Story of a van Gogh Masterpiece. Money, Politics, Collectors, Greed, and Loss* (New York: Penguin, 1998), xv.
7. Frank O'Hara, *What's with Modern Art: Selected Short Reviews & Other Art Writings*, Bill Berkson, ed. (Austin: Mike & Dale's Press, 1999), 14.
8. Marcel Proust, *Remembrance of Things Past*, translated by C. K. Scott Moncrieff and Terence Kilmartin (New York: Vintage, 1982), I, 895. On Elstir, see Jean-Yves Tadié, *Marcel Proust: A Life*, translated by Euan Cameron (New York: Penguin, 2001), 529-30.
9. John Banville, *The Untouchable* (New York: Alfred A. Knopf, 1997), 26, 181-82.
10. "The dossier of a picture: Nicolas Poussin's 'Rebecca al Pozzo'," *Apollo*, March 1965, 81, 202-03. See the catalogue entry, Gabriele Finaldi and Michael Kitson, *Discovering the Italian Baroque: The Denis Mahon Collection* (London, National Gallery, 1997), 150-51.
11. Proust, *Remembrance of Things Past*, III, 185.
12. Delacorta, *Diva*, translated by Lowell Blair (New York: Ballantine, 1983), 11.
13. Muriel Spark, *The Prime of Miss Jean Brodie* (New York: Plume, 1961), 72.
14. Vladimir Nabokov, *Ada or Ardor: A Family Chronicle* (Harmondsworth, Middlesex: Penguin, 1971), 110.
15. Vladimir Nabokov, *Lolita* (New York: Vintage, 1989), 152.
16. Irving Stone, *The Agony and the Ecstasy: A Novel of Michelangelo* (Garden City, New York: Doubleday & Company, 1961), 602.
17. Irving Stone, *Depths of Glory: A Biographical Novel of Camille Pissarro* (Garden City, New York: Doubleday, 1985), 454.
18. Irving Stone, *Lust for Life: A Novel of Vincent van Gogh* (New York: Hertigle Reprints, 1937), 430-31.
19. Dimitri Merejkowski, *The Romance of Leonardo da Vinci*, translated by Bernard Guilbert Guerney (Garden City, New York: Garden City Publishing, 1928), 460.
20. Leon Feuchtwanger, *This Is the Hour: A Novel about Goya*, translated by H. T. Lowe-Porter and Frances Fawcett (New York: Heritage Press, 1951), 266.
21. Philostratus, *Imagines*, translated by Arthur Fairbanks (Cambridge, Massachusetts and London: Harvard University Press and William Heinemann, 1960), 57.

22. Arthur K. Wheelock Jr., *Jan Vermeer* (New York; Harry N. Abrams, 1981), 94.

23. Julian Barnes, *A History of the World in 10 1/2 Chapters* (New York: Vintage, 1989), 127.

24. Michael Fried, *Absorption and Theatricality: Painting and the Beholder in the Age of Diderot* (Berkeley, Los Angeles, London: University of California Press, 1980), 154.

25. Michael Fried, *Courbet's Realism* (Chicago and London: University of Chicago Press, 1990), 289.

26. Leo Steinberg, *Other Criteria: Confrontations with Twentieth-Century Art* (New York: Oxford University Press, 1972), 262.

27. Honoré de Balzac, *Gillette or The Unknown Masterpiece*, translated by Anthony Rodolf (London: Menard Press, 1988), 30.

28. S. J. Freedberg, *Circa 1600: A Revolution of Style in Italian Painting* (Cambridge, Massachusetts and London: Harvard University Press, 1983), 66, 68.

29. Oliver Banks, *The Caravaggio Obsession* (New York: Signet, 1984), 163.

30. Hayden White, *Tropics of Discourse: Essays in Cultural Criticism* (Baltimore and London: Johns Hopkins University Press, 1978), 82.

31. Paul Barolsky, *Michelangelo's Nose: A Myth and Its Maker* (University Park: Pennsylvania State University Press, 1990); *Why Mona Lisa Smiles and Other Tales by Vasari* (University Park: Pennsylvania State University Press, 1991); *Giotto's Father and the Family of Vasari's Lives* (University Park: Pennsylvania State University Press, 1992).

32. Barolsky, *Why Mona Lisa Smiles*, 10-12.

33. Barolsky, *Why Mona Lisa Smiles*, 108.

34. Richard Wollheim, *On Art and the Mind: Essays and Lectures* (London: Allen Lane, 1973), 110-11.

35. Julian Schnabel, *C-V.J. Nicknames of Maitre D's & Other Excerpts From Life* (New York: Random House, 1987), 41.

36. Matthew Collings, *This Is Modern Art* (New York: Watson Guptill, 2000), 160.

37. Meyer Schapiro, *Impressionism: Reflections and Perceptions* (New York: George Braziller, 1997), 129-31.

38. T. J. Clark, *The Painting of Modern Life: Paris in the Art of Manet and His Followers* (New York, Alfred A. Knopf, 1985), 252-53.

39. Clark, *The Painting of Modern Life*, 245.

40. Michael Fried, *Manet's Modernism or, the Face of Painting in the 1860s* (Chicago and London: University of Chicago, 1996), 345-46.

41. Robert L. Herbert, *Impressionism: Art, Leisure, and Parisian Society* (New Haven and London: Yale University Press, 1988), 81.

42. George Mauner, *Manet: Peintre-Philosophe. A Study of the Painter's Themes* (University Park and London, Pennsylvania State Press, 1975), 161. I compare his account to Clark's in "Deep Innovation and Mere Eccentricity: Six Case Studies of Innovation in Art History," forthcoming in a Routledge anthology edited by Elizabeth Mansfield.

43. Arthur Danto, *Transfiguration of the Commonplace: A Philosophy of Art* (Cambridge, MA: Harvard University Press, 1981), 1.

44. See Karl Lehmann-Hartleben, "The *Imagines* of the Elder Philostratus," *Art Bulletin* (1941), 16-41.

45. Bruce Cole, *The Informed Eye: Understanding Masterpieces of Western Art* (Chicago: Ivan R. Dee, 1999), 4.

46. *Artforum,* January 1996, 88.

47. *Stendhal and the Arts*, David Wakefield, ed. (London: Phaidon, 1973), 94.

48. Dave Hickey, "Critical Reflections," *Artforum*, Summer 1995, 81.

49. See my *Poussin's Paintings: A Study in Art-Historical Methodology* (University Park and London: Pennsylvania State University Press, 1993), Introduction; Elizabeth Cropper and Charles Dempsey, *Nicolas Poussin: Friendship and the Love of Painting* (Princeton: Princeton University Press, 1996); and my review of Cropper and Dempsey in *Art Bulletin*, LXXX, 3, September, 1998, 569-73.

50. Elizabeth Cropper and Charles Dempsey, *Nicolas Poussin*, 205.

51. Judith Bernstock, *Poussin and French Dynastic Ideology* (Bern: Peter Lang, 2000), 279-452.

52. Richard Wollheim, *Painting as an Art: The A. W. Mellon Lectures in the Fine Arts*, (Princeton, Princeton University Press, 1987), 222.

53. William Gibson, *Virtual Light* (New York: Bantam Books, 1993), 134.

54. In *Artwriting* (Amherst, 1987), chapters 4 and 5, I take too cynical a view, assimilating art to fashion; in *Principles of Art History Writing* (University Park and London, 1991), I mostly avoid this issue.

PART ONE:
Art Writing Narratives

We need to recognize that the writing of art history

is necessarily a critical, indeed poetical, act.

—*Paul Barolsky*

CHAPTER ONE:
Beginnings in Art Writing

"In the beginning God created the heaven and the earth." Genesis 1.1 describes an absolute beginning, that moment before which nothing existed. All other, more parochial narratives pick out some starting point in time. Identifying the first painting made by an individual is simple, for that merely involves chronology, but identifying the first art of a tradition can be complicated.[2] When, for example, does Islamic art originate? Robert Hillenbrandt notes that its genesis[3]

> is customarily linked with, indeed often attributed to, the whirlwind military conquests of the Arabs following the death of the Prophet Muhammad in AD 632. Such an idea is plausible enough. The creation of a world empire, the proclamation of a new faith, the formation of an art that bears its name—all seem to belong together. But do they?

Since Islamic art develops older traditions, its origin need not be identified with the origin of Islam. The link of this art to religion was complex, for there was, Oleg Grabar observes, "a Jewish Islamic art, since large Jewish communities lived within the predominantly Muslim world" and "there is also a Christian Islamic art. . . ."[4] And so it is difficult to say exactly when or why Islamic art originates.

These concerns about origins can be generalized. Since no school of artists "starts or ends quite at any one moment," Michael Baxandall urges that[5]

> if we are to perceive art in an active way, some sort of selection and arrangement must be made. The historian . . . thrusts his way into the cavalcade and waves an expository placard. . . . One would not deny

or even wish away the subjective or culture-bound element in the process.

Each object in a series is different, if perhaps only slightly different, from those immediately before and after. Thought breaks what otherwise would be a continuous series, imposing conceptual frameworks on reality, drawing lines where experience reveals only continuity. Where in art writing does the contribution of the mind end, and that of the world begin? To what extent do the structures we identify belong to the objects being described, and to what degree are they merely features of our narratives?

Comparing beginnings in art writing with those in literature helps answer these questions. The first sentences of a novel often signal its central concerns, posing questions that the entire narrative will answer. "It is a truth universally acknowledged that a single man in possession of a good fortune must be in want of a wife."[6] Jane Austen's fine irony depends upon demonstrating that in the course of events leading to the triumphant marriage of Elizabeth Bennett, no one initially acknowledges this truth. Like Elizabeth, we readers need to be educated by experience—the experience of reading *Pride and Prejudice.*

Dominique Aury's *Story of O* begins very differently. "One day her lover takes O for a walk, but this time in a part of the city . . . where they've never been before."[7] Her life, we correctly infer, is about to change dramatically. And Vladimir Nabokov's *Lolita* shows still another way of beginning a love story:[8]

> Lolita, light of my life, fire of my loins. My sin, my soul. Lo-lee-ta: the tip of the tongue taking a trip of three steps down the palate to tap, at three, on the teeth. Lo. Lee. Ta.

Read aloud and you replicate that kiss. Muriel Spark's *Prime of Miss Jean Brodie* begins using objects to define relationships:[9]

> The boys, as they talked to the girls from Marcia Blaine School, stood on the far side of their bicycles holding the handlebars, which established a protective fence of bicycle between the sexes, and the impression that at any moment the boys were likely to be away.

Like Bovary's hat, the Prince's golden bowl, and Eco's library, these bicycles tell a story.

Opening sentences in literature and art writing put the narrative in motion and set the tone. "There really is no such thing as Art."[10] The first sentence of Ernst Gombrich's *Story of Art* makes a strange impression, for the body of the book is devoted to denying this counterintuitive claim. How could there be a story of some thing that does not exist? Gombrich rejects Hegel's view of art history, in which art's history is the *bildungsroman* of Spirit, and so this polemical remark effectively sets the stage. Gombrich's story of art is not a narrative of Spirit's development. As if in homage, the first sentence of Craig Clunas's *Art in China* reads: "'Chinese art' is quite a recent invention, not much more than a hundred years old."[11] That claim, too, seems paradoxical, for most of the objects Clunas discusses are much more than one hundred years old. He begins with this paradox because he rejects the attempts of earlier historians to assimilate Chinese to European art, arguing that only when we recognize that the very category of "art" is European, can we properly understand the artifacts discussed in his book. Elsewhere, Clunas explains his reservations about the account of Chinese art in *The Story of Art*:[12]

> That Gombrich chooses to treat the Islamic world and China in the same chapter is the clearest possible symptom of his Hegelian roots. The two cultures have nothing in common except for being "not western." . . .

Resolutely anti-Hegelian in his view of Western art, Gombrich is all too Hegelian when looking outside Europe.

An artist's *oeuvre* begins with his first significant work of art, but often art writing is concerned with fictional subjects whose identity is explained in the narrative. By the "subject" I mean that entity whose origin and development are described. Thus "the Baroque," "Impressionism," or "Abstract Expressionism" are the subjects of art histories in the same way that Poussin is the "subject" of a book about his painting. The subjects whose origin and development are described in *The Story of Art* and *Art in China* are identified by the books' titles. When Leo Steinberg starts *Michelangelo's Last Paintings*,[13]

> The opening chapter of this book tells once again the story of Michelangelo's life—not as we normally trace it, year by year, project

by project, giving each season its due—but as though from the artist's septuagenarian vantage, looking back over decades of servitude;

when Rozsika Parker and Griselda Pollock begin their splendid feminist polemic by asking,[14]

> Have there been female artists? If so, what have they created? Why did they produce what they did? What factors conditioned their lives and works?;

when Norman Bryson introduces his account of still life,[15]

> The first difficulty facing any book on still life painting lies in its opening move, in the assumption that still life *exists*;

or when James Elkins opens his account of perception,[16]

> At first, it appears that nothing could be easier than seeing. We just point our eyes. . . . Nothing could be less in need of explanation. The world is flooded with light, and everything is available to be seen;

then, like Austen, Aury, and Spark, these art writers pose problems which, when solved, permit narrative closure.

Rosalind Krauss's magnificently original beginning of *The Optical Unconscious*—

> and what about little John Ruskin, with his blond curls and his blue sash and shoes to match, but above all else his obedient silence and his fixed stare?

—is as adventuresome as the French writing which has influenced her, Michel Foucault's famous evocation of *Las Meninas*, for example:[17]

> The painter is standing a little back from his canvas. He is glancing at his model; perhaps he is considering whether to add some finishing touch, though it is also possible that the first stroke has not yet been made.

In their beginnings, Krauss and Foucault do not so much raise questions that will be resolved as make unwillingness to achieve resolution their true subjects.

The subject whose origin and development is presented in Tim Clark's *Farewell to an Idea: Episodes from a History of Modernism* also is elusive.

Successive chapters discuss Jacques-Louis David's *Death of Marat* (1793); Camille Pissarro's *Two Young Peasant Women* (1892); Paul Cézanne's *Large Bathers* (1895–1906); what Clark calls "Cubism and Collectivity"; El Lissitzky; and abstract expressionism. What links them, I think, is a concern with materialism understood both as a philosophical view and as a Marxist way of thinking about history. "My candidate for the beginning of modernism," Clark writes,[18]

> is 25 Vendémiaire Year 2 (16 October 1793), as it came to be known. That was the day a hastily completed painting by Jacques-Louis David, of Marat . . . was released into the public realm.

When he allows that his candidate "at least has the merit of being obviously far-fetched," then his irony hints at the difficulty of pinning down such a date so precisely. David, thirty-five in 1793, was a well-established artist, but *Death of Marat* is a suitable starting point because this, his first important history painting made during the revolution, shows a political event.

Clark's pupil Thomas Crow argues that David's pre-1789 art is implicitly revolutionary.[19] Depicting scenes from Roman history, these 1780s paintings really are about contemporary French history. But only with *Death of Marat* does David make explicit his political concerns. The neatness of Clark's origin, by contrast, comes in explicitly linking modernism to politics. Clark defines his origin of modernism by reference to political art in opposition to Clement Greenberg's history. In his frequently criticized "Modernist Painting" (1960), after identifying Kant "as the first real Modernist," Greenberg describes the origins of modernism.[20] "Manet's became the first Modernist pictures by virtue of the frankness with which they declared the flat surfaces on which they were painted." David, he goes on to say, "tried to revive sculptural painting . . . in part, to save pictorial art from the decorative flattening-out that the emphasis on color seemed to induce." But since David's pictorial flatness was not self-critical, only with Manet does acknowledgment of the literal properties of the picture become self-conscious.

Borrowing Marxist language, Greenberg describes a self-sufficient development of art detached from political history. Yve-Alain Bois and

Rosalind Krauss also begin their anti-formalist account of modernism (and postmodernism) in response to Greenberg, remarking that[21]

> perhaps Edouard Manet's *Olympia* is not the "first" modernist painting. . . . But . . . it is at least "the first masterpiece before which the crowd fairly lost control of itself," and this unprecedented scandal would henceforth give it the impact of a radical break.

And even Michael Fried, who remains much closer to Greenberg, takes "serious objection" to Greenberg's account, arguing that his view of the origin of modernism "yields far too simple and rigid an account of Courbet's art."[22] "Modernist Painting" is so influential that one natural way to begin a history of modernism is by opposing Greenberg.

Austen's, Aury's, Nabokov's, and Spark's beginnings describe events existing only in their fiction. Even if set in real time, the start in a novel is an absolute beginning, for nothing happens before the origin of that story. But Clark, Greenberg, Bois and Krauss, and Fried describe our real world, and so it is fair to ask why they identify the origin of modernism so very diversely. As Schapiro, Clark, Fried, and Herbert describe *A Bar at the Folies-Bergère* differently, so Clark, Greenberg, and Fried identify the origin of modernism differently. The claim that David, Manet, or Courbet is the first modernist is not a fact but an interpretation of the historical facts. To describe historical change, Arthur Danto argues, we need narrative sentences. At some time the world changes, and that happens because something causes change:[23]

> 1) x is F at t-1.
> 2) H happens to x at t-2.
> 3) x is G at t-3
> . . . 1), 2), and 3) . . . has already the structure of a story. It has a beginning 1), a middle 2), and an end 3).

Narrative sentences refer "to at least two time-separated events though they only *describe* (are only *about*) the earliest event to which they refer."[24]

A narrative sentence uses a perspective accessible only from a later time. "In 1914, the war causing the revolution which allowed Stalin to take power began." In August 1914, no one knew what would happen in Russia

ten years later. "In the British Library, Karl Marx wrote the Communist Bible." No contemporary of Marx knew that. Narrative sentences are found also in fiction, as when *The Prime of Miss Jean Brodie* describes[25]

> Mary Macgregor, lumpy . . . who was later famous for being stupid and always to blame and who, at the age of twenty-three, lost her life in a hotel fire.

When Mary Macgregor was ten, no one knew how she would die thirteen years later. *Lolita* tells of Annabel, Humbert Humbert's childhood love as[26]

> that little girl with her seaside limbs and ardent tongue [who] haunted me ever since—until at last, twenty-four years later, I broke her spell by incarnating her in another.

In 1923, Humbert could not have known that in 1947 he would meet Lolita.

Narrative sentences explain development by connecting events. One cause of Stalin's rise to power was World War I, and one cause of Humbert's love affair was his childhood experience at the seaside. Narrative sentences thus suggest a story. Because Jean Brodie "thinks she is the God of Calvin, she sees the beginning and the end" and is betrayed by her pupil Sandy who, having become Catholic, rejects Calvinism.[27] Spark's heroine becomes a nun, Sister Helena, and publishes a "strange book of psychology," titled "The Transfiguration of the Commonplace," the source, Danto has explained, of the title of his treatise on aesthetics, which appeared in 1981.[28] In 1962, Muriel Spark published a book giving Danto the title for *The Transfiguration of the Commonplace*. No one could have known that in 1962. Art writers, too, use narrative sentences. Gombrich says, "Giotto begins an entirely new chapter in the history of art"; Leo Steinberg writes that Monet's water lilies are "portents and antecedents . . . recognizable in retrospect" for Rauschenberg's introduction in the early 1950s of "the flatbed or work-surface picture plane"; and Madeleine Grynstejn identifies the "first mature paintings dating from the mid-1980s" of Christopher Wool.[29] Only long after their origin can these works of art be understood.

Malevich's early abstraction *Black Square* (1915) "triggered one of modernism's most enduring fantasies, of its own beginnings."[30] Malevich could not have known in 1915 that he had made one of the first abstract paintings. "It might be a mistake—and a major source of the apparent insolubility of the question of art's origins," Whitney Davis argues, "to look for a beginning in actual individual artworks, chronologically prehistoric or otherwise. A 'figure 1' that can actually be dug up and exhibited will never be found."[31] If art is analyzed in comparative terms, only after there are at least two works of art can the first be properly identified. The narrative sentence identifying the first work of art can only be written after other similar art is made. Logically speaking, that may seem puzzling, for in a sequence of items, there must be a first.[32] But it may help to note that Davis's argument can be generalized. Only once naturalism got going, and only when there was a long Renaissance tradition could historians look back and identify the origins of these period styles. And only after Wool worked for some time, could the start of his style be identified. One isolated novel work of art is essentially incomprehensible.

Experimenting imaginatively with a reversal of literary convention, C. H. Sission's *Christopher Homm: A Novel* begins with the death of the central character:[33]

> he was a pattern of amiability when he fell flat on the gravel. The drop on his nose rolled off and became a ball of dust, but he did not move again and his subsequent history was only a funeral. . . . The palace in the yard of which he died was 92 Torrington Street,

and ends with his birth:

> Christopher crouched in his blindness. He was about to set out on the road to Torrington Street, and if he had known how bitter the journey was to be he would not have come.

As his name suggests, Sission's hero is Christ-like. Vladimir Nabokov's biography of Gogol, similarly, opens with a sentence:[34]

> Nikolai Gogol, the strangest prose-poet Russia ever produced, died Thursday morning, a little before eight, on the fourth of March, eighteen fifty-two, in Moscow,

which exemplifies the strangeness it describes. The book ends with Gogol's birth and a conversation with the alarmed publisher, who pleaded that a "straight" chronology be added. Muriel Spark, too, loves to intersperse later happenings into earlier points in narratives, reminding us of the essential role of artifice in her novels.

Christopher Homm and *The Prime of Miss Jean Brodie* are novels, and so create purely imaginary sequences of events. But Gogol was a person, and so Nabokov's narrative inverts the real temporal order. There is an air of paradox when a creative writer plays with such inversions.[35]

> The fact is that each writer *creates* his precursors. His work modifies our conception of the past, as it will modify the future.
> (A footnote adds): See T. S. Eliot, *Points of View* (1941), (pp. 25–26). (1951)

The footnote exemplifies Borges' claim, implying that he has created the precursor who earlier made this claim. *In 1941, Eliot anticipated the conception of precursor presented by Borges.* That statement only became true in 1951, when Borges published his essay.

Identifying new kinds of art often involves pointing to the ways that earlier artifacts anticipate a break with the past, and noting how later ones extend this development. Describing origins thus is necessary, if only because we must begin somewhere, placing what is being described in reference to what came before. Erwin Panofsky's *Renaissance and Renascences in Western Art* rehearses the extensive debate about the origins of the Renaissance. Men[36]

> were convinced that the period in which they lived was a "new age" as sharply different from the mediaeval past as the mediaeval past had been from classical antiquity and marked by a concerted effort to revive the culture of the latter. The only question is whether they were right or wrong.

In *Perspective as Symbolic Form*, Panofsky makes a stronger claim. The Renaissance really broke with the past.[37]

> The conquest over the medieval representational principle begins with . . . Duccio and Giotto. For the representation of a closed interior

space, clearly felt as a hollow body, signifies more than a consolidation of objects. It signifies a revolution in the formal assessment of the representational surface.

The origin he identifies is not, he implies, a merely conventional point in time, but the moment when the world really changed.

What is the first impressionist painting?; the first abstract painting?; the first installation? Answers to these questions are to some extent arbitrary, for precedents can be found for any novel development. The Guardi, Rudolf Wittkower remarks, "opened the way to . . . the Impressionists, who like them thought that form was fleeting and conditioned by the atmosphere that surrounds it."[38] Their technique may look like that of the impressionists but, working in Venice, the Guardi painted very different subjects. "Before there was an art of abstract painting," Meyer Schapiro wrote, "it was already widely believed that the value of a picture was a matter of colors and shapes alone."[39] And installations, it could be argued, were anticipated by Bernini's chapels, "in which the transitions seem obliterated between real and imaginary space, past and present, phenomenal and actual existence, life and death."[40]

If we focus on continuities, then nothing is entirely new. Does the beginning of the art writer's narrative correspond to a structure of the world, or, as in fiction, is it merely a feature of the narrative? Traditional historians who believed that they described the past as it really was, thought that narratives picked out real temporal structures. But the French narratologists and Hayden White, whose writings became very influential in the 1980s, were relativists. They urged that we should not confuse the mere structures of narratives with the nature of the world. Stories have beginnings, middles, and endings, but in the world there are only events, which lack any intrinsic order until structured by writers.

If, for example, we ask when World War II began, the Poles have one answer, and the Americans and Chinese, others. But it would be possible to argue that it really began in 1918, because the armistice of World War I

all but guaranteed that soon there would be another major conflict. And a little speculation suggests other dates—1917, the date of the triumph of Soviet Socialism, if we believe, with Alexander Kòjeve, that this war was a battle between the Hegelian Left and Right; or, indeed, why not 1812, the date of Napoleon's invasion of Russia, which prepared for Hitler's equally unsuccessful march East? Because narratologists claimed that writing is structured according to ideological concerns, they were highly sympathetic to Nietzsche's perspectivism. There are many ways to write history, they said, none uniquely determined by the data. There is no one way that the world is, but only ways of describing it that depend upon the interests of the narrator.

Does the beginning of an art writer's account mark a real moment in history, or is it merely one conventional starting point? If the same story might be told differently, then its origin merely exists in one narrative, not in the real world. In that way, narratologists argued, history writing is like fiction. Although Danto is a realist, his historiography can be modified to support relativism. We need only write alternative narrative sentences to create another history.

An origin may require an absolute break with the past, as in Vasari's account of the Renaissance:[41]

> The endless flood of misfortunes which overwhelmed unhappy Italy not only ruined everything worthy of the name of a building, but, what is more serious completely extinguished the race of artists. Then, as it pleased God, there was born in the year 1240 in the city of Florence, Giovanni, surnamed Cimabue . . . to shed the first light on the art of painting.

Johann Joachim Winckelmann's *History of Ancient Art* describes another such starting point:[42]

> In the infancy of art, its productions are, like the handsomest of human beings at birth, misshaped, and similar one to another, like the seeds of plants of entirely different kinds; but in its bloom and decay, they resemble those mighty streams, which, at the point where they should be the broadest, either dwindle into small rivulets, or totally disappear.

His aim, Winckelmann says, is not to produce "a mere chronicle of epochs, and of the changes which occurred with them," but to present a proper history, "to show the origin, progress, change, and downfall of art."

Vasari's history begins so dramatically because he treats Cimabue as the absolute beginning, the artist who inaugurates that entire visual culture. But Cimabue, too, worked within tradition, for the impact of Byzantine painting[43]

> can be felt not only in matters of format and composition but also in modeling technique, style and, especially, in the humane qualities, in the more direct appeal of the image, in a new empathy which, combined with the effects of the classical renaissance, prepared the soil for the great new art of the West.

Giotto's "obligation to Byzantium," Otto Demus argues, "went further than iconographic schemes." Or, as Gombrich puts it in his *Story of Art*, "it detracts nothing from Giotto's greatness if we realize that his methods owe much to the Byzantine masters."[44] In Hans Belting's history of late medieval art, one concern is[45]

> the period of transition between the Middle Ages and the era of the Reformation and Renaissance, when images reemerge with a new face as works of art.

Belting undercuts this concern with continuity between Renaissance art and Byzantine images.

The image formerly had been assigned a special reality and taken literally as a visible manifestation of the sacred person. . . . Now the same laws were to apply to the image as to the natural perception of the outside world. *Art and Illusion*, like Vasari's *Lives*, contrasts the history, beginning with the Renaissance in which pictures progress toward ever greater illusionism with the different, ultimately less interesting, sacred art of Byzantium where, as Gombrich says,[46]

> the achievements of Greek illusionism were gradually discarded. The image was no longer asked questions of how and when; it was reduced to the what of impersonal recital.

But it is possible to reverse this evaluation of these two traditions, as when a modern historian of icons critically compares a Raphael Madonna to an icon:[47]

> The image of Raphael is that of a human being. It is carnal and sentimental. The sacred subject only serves as a pretext to express the feelings and ideas of the painter. . . . Through the appropriate symbolism in the icon, however, we learn the teaching of the Church.

The naturalism which Vasari and Gombrich praise shows decadence, not progress. Different views of the origin, the Renaissance, yield different value judgments about Renaissance art.

Multiple accounts of origins often are possible. Could there be a better beginning than the first sentence of David Sylvester's essay on pop art?[48]

> "There's as much culture in a bottle of Coca-Cola as there is a bottle of wine." Thus an American painter friend in Paris in 1948. He looked hard at me as he said it and I rose to the bait, manifesting outrage.

In 1948, Sylvester had a long way to go before he could appreciate art using the mass culture that his fellow Englishman (and near contemporary) Richard Wollheim describes:[49]

> Rilke suggests that we are perhaps the last to have known a world of personal, or human objects: objects that have been invested, as he says, with "hope and mediation."

Sylvester's "Art of the Coke Culture" goes on to contrast the wine culture of European modernism, "it means durability; it means inequality," with the Coke culture of America and American-style pop art. "A reverence for the unique object," he concludes, is "the basic moral assumption of a wine culture, which is the kind of culture to which art can't help belonging." And so it is surprising that Sylvester links Lichtenstein and Johns to French classicism, "the tradition within which Chardin and Seurat and Léger conferred dignity on simple, ignoble, everyday objects and events." His initial opposition is undercut in favor of an acknowledgment of the relationship between American pop and its European precursors.

Thomas Crow's account of Andy Warhol begins very differently:[50]

> The public Andy Warhol was not one but, at a minimum, three persons. The first . . . was the self-created one: the product of his famous pronouncements The second consists of the complex of interests, sentiments, skills, ambitions, and passions actually figured in paint on canvas or on film. The third was his persona. . . .

Sylvester speaks of the unity of American culture, in opposition to European tradition. When Crow notes the diversity of one American pop artist, his Warhol certainly differs from Sylvester's pop artist, who confers dignity on simple, ignoble, everyday objects and events.

Nowadays few art writers start, like Vasari, by invoking God, but some basic structures of narratives have not changed. Rosalind Krauss's *Passages in Modern Sculpture* begins with Robert Smithson's *Spiral Jetty* (1969–70):[51]

> The underlying premise of the following study of modern sculpture [is] . . . that, even in a spatial art, space and time cannot be separated for purposes of analysis. Into any spatial organization there will be folded an implicit statement about the nature of temporal experience.

Vasari tells the story of art from Cimbue to Michelangelo. Beginning with Auguste Rodin's *Gates of Hell* (1880–1917), a sculpture which "resists all attempts to be read as a coherent narrative," Krauss concludes with 1960s and 1970s art in which "the transformation of sculpture—from a static, idealized medium to a temporal and material one—that had begun with Rodin, is fully achieved." The *Gates of Hell* opens up problems resolved by Smithson and his contemporaries.

Other narrators describe this period differently. After quoting Rilke's monograph on Rodin, William Tucker's *Early Modern Sculpture* notes that this essay[52]

> contains much . . . that pre-figures the development of sculpture after Rodin. . . . Rilke, pressing his own thought towards the work of art as "thing". . . projected this idea into the sculpture of Rodin, where it was latent, the work for which it was most apt, that of Brancusi, not having come into existence.

Like Krauss, Tucker sees Rodin's art as marking the beginning of the tradition of modernist sculpture, but where Krauss's Rodin leads toward

Auguste Rodin, *Gates of Hell*, 1880–1917. B. G. Cantor Collections and Stanford University Art Museum. Photograph by William L. Schaeffer. Copyright © 1981 B. G. Cantor.

Smithson, Tucker's Rodin shares concerns with Degas, Matisse, Brancusi, Picasso, Gonzalez, and, of course, Tucker himself.[53] Honor and Fleming describe *Gates of Hell* yet another way:[54]

> In his most ambitious work, *Gates of Hell*, which occupied him for 20 years . . . the pessimism and anxiety and psychic distress of the *fin-de-siècle* period take on material form. . . . Rodin . . . was the last great exponent of an old tradition, rather than the first of a new.

It is not a matter of fact that *Gates of Hell* is the last sculpture in an old tradition, for it is possible both that it closed a tradition and opened the history of modernist sculpture.

Tucker notes how[55]

> the absurd proportions and structure of the individual figures are subserved as elements of an intricate and powerful design. The frankness of the use of repetition is unequalled until Brancusi's *Endless Column*;

and Rainer Maria Rilke claims that *Gates of Hell*[56]

> is but a fresh rendering of [the] . . . theme of the contact of living and pulsating surfaces. Advancing simultaneously in the discovery of the movement of planes and of their association, Rodin ended by looking for bodies touching at many points, whose contacts were more vehement, more powerful, more unrestrained.

Leo Steinberg describes those repetitions in a different way:[57]

> Sometimes the duplications reflect Rodin's avowed interest in expressing a succession of moments; for the repetition of identical or similar poses may suggest—as the carvers of the Parthenon Frieze must have known—uninterrupted duration, or a single form evolving in time.

But noting that *Gates of Hell* anticipates *Endless Column* is not incompatible with observing its similarities with the *Parthenon Frieze*. Krauss does not necessarily contradict Tucker, nor need Honor and Fleming take issue with Steinberg.

Many histories of art, the various Pelican volumes for example, survey their subject, an historical period, without dealing in any deep way with origins. "A new epoch in Spanish architecture opened about 1480," George Kubler writes in the volume devoted to Spain,[58]

after a long period of inactivity. It began with a late medieval style in fashion under the Catholic Kings, passed through the two stages of Plateresque style under Charles V, and ended with the severe style of Juan de Herrera and his followers.

His starting point is some architects who deserve attention. "With the Sack of Rome in 1527," Rudolf Wittkower notes in his Pelican history of baroque Italian art,[59]

> an optimistic, intellectually alert epoch came to an end. For the next two generations the climate in Rome was austere, anti-humanist, anti-worldly, and even anti-artistic.
> The period from Sixtus V (1585–90) to Paul V (1605–21) has a number of features in common which single it out from the periods before and after.

And Sydney Freedberg's Penguin history of High Renaissance art also argues that 1527 is the right starting point for this history of a period style. "In Rome, the most disastrous historical event of its Christian history, the sack of the city in May 1527, interrupted the pursuit of the new-found manner there for half a decade."[60]

Let us suppose that the beginning of art's history can be identified with the making of the first representation. If art controls expression of feeling, allowing reason to deal with the irrational, as Gombrich suggests, then we have one way of understanding this origin. But if art making is an inherently regressive process in which feeling threatens to overwhelm reason, as Plato says, then we have a quite different view. Because the evidence is hard to interpret, any account will be highly speculative.

In his *Natural History*, Pliny, observing that "the question as to the origin of the art of painting is uncertain and it does not belong to the plan of this work," records the story that painting in Greece "began with tracing an outline round a man's shadow."[61] Vasari, after noting that many people, Pliny for example, attribute the invention of painting to the Egyptians, argues that[62]

> design . . . come into full existence at the time of the origin of all things, when the Most High, after creating the world . . . disclosed the first form of sculpture and painting in the charming invention of things.

God, the first artist, created man in his image. Nandy Sandars notes a logical difficulty inherent in identifying the origin of art:[63]

> A study of prehistoric art ought to begin at the beginning, but by its nature a beginning is what we cannot have. All early stages of growth possess this irritating fragility, they recede into the past, vanish from sight: everything seems to have burst into the world ready-made and history appears a discontinuous succession of levels.

Georges Bataille, by contrast, makes surprisingly confident assertions about the cave paintings of Lascaux:[64]

> There have been two capital events in the course of human history: the making of tools (with which work was born); the making of art-objects (with which play began). . . At its outset art was primarily a game. In a major sense it still is. It is play; while tool making is primarily work.

Origins matter because they shed light on an art writer's larger ways of thinking. "Primeval man," Gideon proclaims,[65]

> is very far removed from the narcissism of a creature enamored of his own beauty, as the Greeks taught us to see ourselves. . . . He seems ashamed of the form given him by nature. He hides his face, he disregards his body.

This leads to Kandinsky and Klee, "who by their work have opened up new vistas to us so that we are slowly able to understand the space conception of primeval art." Gombrich takes a different view. Imagine a child playing with a stick that he treats as a hobbyhorse. "The stick is neither a sign signifying the concept horse nor is it a portrait of an individual horse."[66] For Gombrich, the real history of art begins only when artists broke away from this regressive play and made illusionistic pictures.

Philostratus playfully suggests that the origin of art may lie outside of human culture altogether.[67]

> For one who wishes a clever theory, the invention of painting belongs to the gods—witness on earth all the designs with which the Seasons paint the meadows, and the manifestations we see in the heavens.

And Tao-chi speaks of the single brushstroke as[68]

"the origin of all existence, the root of the myriad phenomena"—one might almost, without violating the sense, translate: "In the beginning was the Brushstroke."

There is some analogy between the activity of making pictures of nature and the natural processes that create our visual world. Gombrich, similarly, suggests that animals, like humans, play with representations.[69]

> "Substitutes" reach deep into biological functions that are common to man and animal. The cat runs after the ball as if it were a mouse. The baby sucks its thumb as if it were the breast.

When Constable turns pigments into a substitute for what they depict, he is like the cat who, since he does not eat the ball, is aware that the object he plays with is not really a mouse.

"What Genesis is to the biblical account of the fall and redemption of man," Helen Gardner writes, "early cave art is to the history of his intelligence, imagination and creative power."[70]

> Man's first representations may have followed some primal experience of resemblance between a chance configuration of cave wall and the animal he had just been hunting. This might have had for him the effect of an awesome apparition of the very animal. . . .

Gardner's later narrative focuses on European art, introducing non-European art only after Christian medieval culture, because[71]

> the art of non-European civilizations (much of it) is more closely related to the art of the prehistoric period and of the Middle Ages than to that of the Renaissance and of subsequent time. . . .

Implicit in her starting point is a distinction between superior figurative art and that lesser painting which dominates outside Europe. H. W. Janson's *History of Art* gives a different view, arguing that the Lascaux paintings[72]

> must have served a purpose far more serious than mere decoration. There can be little doubt, in fact, that they were produced as part of a magic ritual, perhaps to ensure a successful hunt. . . . Apparently, people of the Old Stone Age made no clear distinction between image and reality.

Imagining the absolute beginning of art's history requires speculation, but understanding the origin of whatever period comes after modernism only requires looking at the near present. Just as (according to Greenberg) modernism both breaks with, and builds upon the old master tradition, so perhaps the same will now happen again. A new tradition may stand to modernism as modernism does to old master art. In the 1980s many commentators claimed that the era of modernism had ended. Entirely new forms of art were made. Greenberg did not much admire postmodernist art, nor did he accept this historical view, but these novel narratives built upon his.[73]

In 1968, Steinberg argued that a new antimodernist tradition started around 1950. Pictures[74]

> no longer simulate vertical fields, but opaque flatbed horizontals. . . . The flatbed picture plane makes its symbolic allusion to hard surfaces such as tabletops, studio floors, charts, bulletin boards—any receptor surface on which objects are scattered. . . . The pictures . . . insist on a radically new orientation. . . .

Identifying this shift "as expressive of the most radical shift in the subject matter of art, the shift from nature to culture," he suggested that modernism has ended, for "this post-Modernist painting has made the course of art once again non-linear and unpredictable."

Fredric Jameson, similarly, begins the chapter titled "Culture" of his *Postmodernism or, The Cultural Logic of Late Capitalism* (1991) by comparing two paintings of shoes, Vincent van Gogh's *Pair of Boots* and Andy Warhol's *Diamond Dust Shoes*. Van Gogh's shoes, whose interpretation has been famously debated by Martin Heidegger, Meyer Schapiro, and Jacques Derrida, were painted when peasants still worked the land. Because Warhol's art "turns centrally around commodification," it ought to make "powerful and critical political statements." And so comparing *Diamond Dust Shoes* with the van Gogh shoes, we find[75]

> the emergence of a new kind of flatness or depthlessness, a new kind of superficiality in the most literal sense, perhaps the supreme formal feature of all the postmodernisms. . . .

Warhol's art is the product of a culture concerned with advertising and television, now when the expressiveness of van Gogh is no longer a live option.

Jameson radically separates Warhol from the earlier modernist artists who also employed popular imagery. Other historians rather stress continuity, pointing to the way in which Warhol draws upon tradition:[76]

> In a number of ways, Andy Warhol resembles Fernand Léger. Both did book illustrations, both made avant-garde films, both played around with Mona Lisa, both like the grinning ambience of sport . . . and both, above all have celebrated the enjoyment of the surface of modern life.

Danto, like Jameson, argues that Warhol's art marks the end of the modernist tradition culminating in abstract expression. This post-historical era demands a radically new sensibility:[77]

> Warhol sought to set up a resonance . . . between art and images, it having been his insight . . . that our signs and images are our reality. We live in an atmosphere of images, and these define the reality of our existences.

Steinberg, Jameson, and Danto identify the same origin in strikingly different ways. Steinberg is concerned with the physical orientation of postmodern paintings, Jameson with the political implications of a very novel form of expressionism. Danto's focus on the ontological implications of *Brillo Box* leads in yet other directions. Steinberg mentions Warhol's silk-screens; Jameson, the *Diamond Dust Shoes*; and Danto, *Brillo Box*, a sculpture. But just as the interpretations of *A Bar at the Folies-Bergére* by Clark, Fried, Herbert, and Schapiro have some shared features, so too there is some overlap in the concerns of Steinberg, Jameson, and Danto. All three writers link Warhol and mass culture. Steinberg's and Jameson's and Danto's commentaries all are consistent with the facts, and so in deciding what comes after modernism, we need to ask how we want to interpret history.

The lesson provided by these examples can be productively generalized. What goals should our narrative serve? If you believe that the goal is to find

one, uniquely privileged interpretation, then this situation will seem very frustrating, for agreement is unlikely to be achieved. But if you believe that there are legitimate alternative ways of telling the story, then you may value *A Bar at the Folies-Bergére* and these various Warhols in part because they inspire intellectually productive conversations, teaching us a great deal about art and contemporary politics.

Notes to Chapter 1

1. Paul Barolsky, "Obituary: Sydney J. Freedberg and the Literature of Art," *Renaissance Studies* 11, 4 (1997): 477.

2. This chapter is indebted to the critical accounts of my earlier work by Mieke Bal, *Looking in: The Art of Viewing* (Amsterdam: Gordon and Breach, 2001), and Jonathan Gilmore, *The Life of a Style: Beginnings and Endings in the Narrative History of Art* (Ithaca and London: Cornell University Press, 2000).

3. Robert Hillenbrandt, *Islamic Art and Architecture* (London: Thames and Hudson, 1999), 11.

4. Oleg Grabar, *The Formation of Islamic Art* (New Haven and London: Yale University Press, 1973), 1.

5. Michael Baxandall, *The Limewood Sculptors of Renaissance Germany* (New Haven and London: Yale University Press,1980), 9–10.

6. Jane Austen, *Pride and Prejudice* (New York: New American Library, 1961), 5. On origins in literature, see A. D. Huttall, *Openings: Narrative Beginnings from the Epic to the Novel* (Oxford: Clarendon Press, 1992).

7. Pauline Réage (Dominique Aury), *Story of O*, translated by John Paul Hand (New York: Blue Moon Books, 1993), 3.

8. Vladimir Nabokov, *Lolita* (New York: Vintage, 1989), 9.

9. Muriel Spark, *The Prime of Miss Jean Brodie* (New York: New American Library, 1961), 9.

10. Ernst Gombrich, *The Story of Art* (London: Phaidon, 1966 [eleventh edition]), 5.

11. Craig Clunas, *Art in China* (Oxford and New York: Oxford University Press, 1997), 9.

12. Craig Clunas, "What About Chinese Art?," *Views of Difference: Different Views of Art*, Catherine King, ed. (London: Open University, 1999), 134.

13. Leo Steinberg, *Michelangelo's Last Paintings: The Conversion of St.Paul and the Crucifixion of St. Peter in the Cappella Paolina, Vatican Palace* (New York: Oxford University Press, 1975), 6.

14. Rozsika Parker and Griselda Pollock, *Old Mistresses: Women, Art and Ideology* (New York: Pantheon, 1981), 1.

15. Norman Bryson, *Looking at the Overlooked: Four Essays on Still Life Painting* (Cambridge, Massachusetts: Harvard University Press, 1990), 7.

16. James Elkins, *The Object Stares Back: On the Nature of Seeing* (San Diego, New York, London: Harcourt Brace & Company, 1996), 11.

17. Michel Foucault, *The Order of Things: An Archaeology of the Human Sciences*, translated by Anonymous (New York: Vintage, 1973), 3.

18. T. J. Clark, *Farewell to an Idea: Episodes from a History of Modernism* (New Haven and London: Yale University Press, 1999), 15.

19. See my "Was David a Revolutionary Before the Revolution?: Recent Political Readings of *Oath of the Horatii and The Lictors Returning to Brutus the Bodies of his Sons*," in an anthology edited by Dorothy Johnson (Princeton: Princeton University Press, forthcoming).

20. Clement Greenberg, *The Collected Essays and Criticism: Volume 4. Modernism with a Vengeance 1957–1969*, John O'Brian, ed. (Chicago and London: University of Chicago Press, 1993), 85, 86, 88.

21. Rosalind E. Krauss and Yve-Alain Bois, *Formless: A User's Guide* (New York: Zone Books, 1997), 13.

22. Michael Fried, *Manet's Modernism or, the Face of Painting in the 1860s* (Chicago and London: University of Chicago, 1996), 14; Michael Fried, *Courbet's Realism* (Chicago and London: University of Chicago, 1989), 284. Elsewhere Fried had traced modernism's origin back into the eighteenth century.

23. Arthur C. Danto, *Narration and Knowledge* (New York: Columbia University Press, 1985), 236, 143.

24. White was a highly sympathetic reader of the then newly fashionable French narratologists, who held that analysis of linguistic structures provides the key to knowledge. Danto's view of the relationship between language and reality was developed within the intellectual context of analytic philosophy.

25. Spark, *The Prime of Miss Jean Brodie*, 22.

26. Nabokov, *Lolita*, 15.

27. Spark, *The Prime of Miss Jean Brodie*, 176.

28. Spark, *The Prime of Miss Jean Brodie*, 186.

29. Gombrich, *The Story of Art*, 205; Leo Steinberg, *Other Criteria: Confrontations with Twentieth-Century Art* (New York: Oxford University Press, 1972), 85; Madeleine Grynstejn, "Unfinished Business," *Christopher Wool*, exhibition catalogue (Los Angeles: Museum of Contemporary Art, 1998), 266.

30. Briony Fer, *On Abstract Art* (New Haven and London: Yale University Press, 1997), 10.

31. Whitney Davis, *Replications: Archaeology, Art History, Psychoanalysis* (University Park, Pennsylvania: Pennsylvania State University Press, 1996), 138.

32. My discussion borrows from George Kubler, *Esthetic Recognition of American Amerindian Art* (New Haven and London: Yale University Press, 1991), ch. 1.

33. C. H. Sission, *Christopher Homm: A Novel* (Manchester: Carcanet, 1984), 7, 239.

34. Vladimir Nabokov, *Nikolai Gogol* (New York: New Directions, 1944), 1.

35. Jorge Borges, "Kafka and His Precursors," reprinted in *Other Inquisitions* 1937–1952, translated by Ruth L. C. Simms (New York: Washington Square, 1966), 113.

36. Erwin Panofsky, *Renaissance and Renascences* in Western Art (New York and Evanston: Harper & Row, 1969), 36.

37. Erwin Panofsky, *Perspective as Symbolic Form*, translated by Christopher Wood (New York: Zone Books, 1997), 55.

38. Rudolf Wittkower, *Art and Architecture in Italy* 1600–1750 (Harmondswirth, Middlesex: Penguin, 1973 [third edition]), 505.

39. Meyer Schapiro, *Modern Art. 19th and 20th Centuries. Selected Papers* (New York: George Braziller, 1978), 185. In his unpublished 1960s lectures, Schapiro developed this idea.

40. Rudolf Wittkower, Bernini: *The Sculptor of the Roman Baroque* (London: Phaidon, 1997 [fourth edition]), 159.

41. Giorgio Vasari, *The Lives of the Painters, Sculptors and Architects*, translated by A. B. Hinds (London: Dent, 1963), vol. 1, 21.

42. *The History of Ancient Art*, translated by G. Henry Lodge (Boston: James R. Osgood, 1880), vol. 1, 133, 107.

43. Otto Demus, *Byzantine Art and the West* (New York: New York University Press, 1970), 212, 225.

44. Gombrich, *Story of Art*, 144.

45. Hans Belting, *Likeness and Presence: A History of the Image before the Era of Art*, translated by Edmund Jephcott (Chicago and London: University of Chicago Press, 1994), *XVII*, 471.

46. E. H. Gombrich, *Art and Illusion: A Study in the Psychology of Pictorial Representation* (Princeton: Princeton University Press, 1961 [second edition)]), 144.

47. Leonid Ouspensky, *Theology of the Icon* (Crestwood, NY: St. Vladimir's Seminary Press, 1978), commentary on figs. 26 and 27.

48. David Sylvester, *About Modern Art: Critical Essays* 1948–96 (London: Chatto & Windus, 1996), 213, 214, 222, 221. But Schjeldahl is a good contender when he writes: "Diego Velázquez (1599-1660) was as good at oil painting as anyone has been at anything." Peter Schjeldahl, *The Hydrogen Jukebox*, Malin Wilson, ed. (Berkeley, Los Angeles, Oxford: University of California Press, 1991), 320.

49. Richard Wollheim, *A Family Romance* (New York: Farrar, Straus and Giroux, 1969), 48.

50. Thomas Crow, *Modern Art in the Common Culture* (New Haven and London: Yale University Press, 1996), 49.

51. Rosalind Krauss, *Passages in Modern Sculpture* (New York: Viking, 1977), 4, 282–83, 279.

52. William Tucker, *Early Modern Sculpture: Rodin, Degas, Matisse, Brancusi, Picasso, Gonzalez* (New York: Oxford University Press, 1974), 9.

53. See my *Rosalind Krauss and American Philosophical Art Criticism: From Formalism to beyond Postmodernism* (Greenwood/Praeger, 2002), ch. 1.

54. Hugh Honour and John Fleming, *The Visual Arts*: A History (New York: Harry N. Abrams, 1999 [fifth edition]), 727–29.

55. Tucker, *Early Modern Sculpture*, 29–30.

56. *Rodin and Other Prose Pieces*, translated by G. Craig Houston (London: Quartet Books, 1986), 20–21.

57. Steinberg, *Other Criteria*, 358.

58. George Kubler and Martin Soria, *Art and Architecture in Spain and Portugal and their American Dominions 1500 to 1800* (Harmondsworth, Middlesex: Penguin Books, 1959), 1.

59. Rudolf Wittkower, *Art and Architecture in Italy 1600 to 1750* (Harmondsworth, Middlesex: Penguin Books, 1973 [third edition]), 21, 23.

60. S. J. Freedberg, *Painting in Italy 1500 to 1600* (Harmondsworth, Middlesex: Penguin, 1971), 116.

61. Pliny, *Natural History*, translated by H. Rackham (London: William Heinemann, 1968), v. IX, 271.

62. Vasari, *Lives of the Painters, Sculptors, and Architects*, translated by A. B. Hinds (London, Melbourne, Toronto: Dent: 1963), v. 1, 1.

63. N. K. Sandars, *Prehistoric Art in Europe* (Harmondsworth, Middlesex: Penguin, 1985 [second edition]), 33.

64. Georges Bataille, *Prehistoric Paintings: Lascaux, or the Birth of Art*, translated by Austryn Wainhouse (Lausanne: Skira, 1955), 27.

65. S. Giedion, *The Eternal Present: The Beginnings of Art. A Contribution on Constancy and Change* (Washington, D.C.: National Gallery, 1962), 5, 536.

66. E. H. Gombrich, *Meditations on a Hobby Horse* (London: Phaidon, 1963), 2.

67. Philostratus, *Imagines*, translated by Arthur Fairbanks (Cambridge, Massachusetts and London: Harvard University Press and William Heinemann, 1960), 3.

68. James Cahill, *Treasures of Asia: Chinese Painting* (Cleveland: Skira and World Publishing Company, 1960), 11. See my "Meditations on a Scroll, or the Roots of Chinese Artistic Form," *Word & Image*, 18:1 (January–March 2002): 45–52.

69. Gombrich, *Meditations on a Hobby Horse*, 4.

70. Helen Gardner, *Art Through the Ages*, revised by Horst de la Croix and Richard G. Tansey (New York; Harcourt Brace Jovanovich, 1980), 24. Further quotations 27, 28.

71. Gardner, *Art Through the Ages*, 353.

72. Revised and expanded by Anthony F. Janson (New York: Harry N. Abrams, 1986 [third edition]), 27.

73. See Clement Greenberg, "Modern and Post-Modern," *Arts Magazine*, 54, 6 (February 1980).

74. Steinberg, *Other Criteria*, 84, 91.

75. Fredric Jameson, *Postmodernism or, The Cultural Logic of Late Capitalism* (Durham: Duke University Press, 1991), 9.

76. Joseph Masheck, "Warhol's Early Manipulation of the Mundane: The Vanderbilt Cookbook of 1961" (1971), *The Critical Response to Andy Warhol*, Alan R. Pratt, ed. (Westport, Connecticut: Greenwood Press, 1997), 69.

77. Arthur C. Danto, *Philosophizing Art: Selected Essays* (Berkeley, Los Angeles, London: University of California Press, 1999), 81.

What has our cultural tradition given us that will guide us in listening to and understanding stories? Philosophers, now as in the past, shy away from the problem. . . . Issues of "truth" in stories never correspond to the issues raised in natural language use.

—*Richard Kuhns*[1]

CHAPTER TWO:
Endings in Narrative Art Histories

A great novel may contain no superfluous words, telling a story whose conclusion brings together in harmonious unity all of the themes announced at the beginning. But even the fullest life rarely has that ideal structure. Even Louis XIV, whose tenure as absolute monarch was predetermined by his birth, hardly envisaged early on the travails and triumphs of his long, complex life. When a biographer treats his subject like a character in a traditional novel, someone whose career, family life, and love affairs have a naturally developing order, we may think that narrative something of a fiction. Still sometimes real lives seem to possess the ideal ordering of fictional tales. Could any long life end with better timing than John King Fairbank's, as described by the publisher of his last book?[2]

> Professor Fairbank delivered to Harvard University Press on the morning of September 12, 1991, the edited and approved manuscript for *China: A New History*. He suffered a heart attack that afternoon and died two days later.

He was born in 1907, and so, as the introduction explains, the changes in China his book charts are closely linked to his own long experience of that country.

Fairbank's life story describes comparison with that of a fictional character:[3]

> I understood that all these materials for a work of literature were simply my past life; I understood that they had come to me, in frivolous

> pleasures, in indolence, in tenderness, in unhappiness, and that I had stored
> them up without divining the purpose for which they were destined.

But Proust's Marcel understands this only when he conceives of writing an autobiographical book. *The Magic Mountain*, a nearly contemporary novel, concludes with a very different tone:[4]

> Farewell, honest Hans Castrop, farewell, Life's delicate child! Your
> story is told. We have told it to the end, and it was neither short nor
> long, but hermetic.

It is natural to look back, and see how we were prepared for this ending by Thomas Mann's first sentence:

> An unassuming young man was travelling, in midsummer, from his
> native city of Hamburg to Davos-Platz in the Canton of the Grisons,
> on a three weeks' visit.

Unlike Proust, Mann always stands at some distance from his character.

Marcel and Hans Castrop are but fictional characters. When, by contrast, a life of Giovanni Bellini begins and ends by evoking Albert Dürer's observation of February 1505, "He is very old and is still the best in painting," we are aware of the artifice of a skilled narrator. Because Bellini's *Madonna Enthroned with Saints* (1505) provides "a point of such perfect balance of form and content, of intention and expression, of drawing and colour, and of such penetrating harmony," it was the right painting to come at the end of Bellini's life.[5] Endings, like beginnings, can be understood as mere structures of narratives that are taken all too readily to be real features of the world.

Origins set stories into motion, and the traditional novel and most popular fiction conclude by resolving the dilemmas that set the story in motion. Darcy and Elizabeth, for example, end now happily married to each other,[6]

> both ever sensible of the warmest gratitude towards the
> persons who, by bringing her into Derbyshire, had been the means
> of uniting them.

Pride and Prejudice achieves narrative closure, bringing together the two heroes. Darcy discovers how to deal with his pride, and Elizabeth to overcome her prejudices. The frivolous Lydia and nasty Wickham end up married to each other, getting what they deserve; and Mr. Bennet learns that he has been an unwise father. Jane Austen's characters exist only in the world of the novel, and so it makes no sense to ask what happens to them next. Such novels require[7]

> conflict to generate a story and resolution to end it. . . . the traditional novelist gives play to his discontent only to assuage it in the end, much as the child in Freud makes his toy temporarily disappear the better to enjoy its reinstated presence.

The very perfection of the narrative seems unreal, which makes it art.

In Michael Crichton's *Timeline*, after the struggles are ended, the survivors "walked down the hill to the car. By now the rain had entirely stopped, but the clouds remained dark and heavy, hanging low over the distant hills."[8] This heavy weather is an obvious reminder that the resolution has not been altogether happy. And George Leonard's violent thriller *The Ice Cathedral* ends with the death of his monstrous central figure, Kessler, and the survival of his lover and their child.[9] "She picked herself up from the ice. She took a breath. She was still alive. She walked back to the house, and Michael." After desperate adventure, still there is hope. Unlike Crichton, Leonard offers an upbeat conclusion.

Sometimes the natural ending in art writing is determined by the historical facts. Poussin's last painting, *Apollo and Daphne*, was left unfinished at his death, and so usually is the last work of art discussed in monographs. But in very many cases, ending the story of a period involves a ruse. The conclusion of John Rupert Martin's *Baroque* both ends his account of that era and looks forward historically. A bronze sculpture, Soldani Benzi's water jug, is linked to Bernini's *Fountain of the Four Rivers*, the starting point of this history.[10]

> Yet in spite of the obvious derivation of Soldani's sculptural style from the Berniniesque idiom, it can be seen that certain elements in the work . . . are more suggestive of the decorative vocabulary of the eighteenth century than the seventeenth. The process of transition from

late Baroque to early Rococo is in fact already perceptible in this extraordinary piece.

Martin achieves closure by looking to the future when different art is made.

Often a narrative ends with the end of an epoch, as when Frank Jewett Mather's *Venetian Painters* concludes with that city's conquest by Napoleon.[11]

> Perhaps the most permanent inheritance from the Venetian afterglow is still her painting in its pleasant middle reaches with Canale and Longhi, in its now modest heights with Giambattista Tiepolo and Francesco Guardi.

Painting continues to be made in Venice, but because this art is unchallenging, Mather's story is over. Svetlana Alpers and Michael Baxandall reject this view. Noting that Tiepolo satisfied "neither a taste for what is loosely but confidently referred to as pictorial unity, nor a taste for narrative," they argue that we can only properly appreciate him when we get "free of tastes such as these."[12] Their Tiepolo, unlike Mather's, does not end a period, but looks to the future.

Endings often imply controversial value judgments. When did abstract expressionism come to an end—when Johns, Rauschenberg, and Warhol offered different models for art making, or when the last of the canonical abstract expressionist artists died? Clement Greenberg speaks of "the seemingly sudden death of abstract expressionism in 1962."[13] And yet, in 1962 de Kooning and Rothko still painted magnificently. If Sean Scully, today only in mid-career, belongs "with the great heroes of that moment—with Pollock, de Kooning, Kline, Rothko, and Motherwell," as Arthur Danto thinks, then that tradition continues still.[14]

An artist is born, works, and dies, and so his story is a narrative with beginning, middle, and end, in that order. A period is often understood as being like an individual, and so we ask when the baroque originated or when abstract expressionism ended. But this way of thinking relies only upon an analogy, for questions about beginnings and endings of periods, unlike the comparable questions about persons, do not have

unambiguously right or wrong answers. Caravaggio was born in 1571 and Pollock died in 1956—those are facts. But no matter of fact is at stake in asserting or denying that Caravaggio's early art marks the origin of the baroque, or that abstract expressionism died in 1962. Icon making is a pre-Renaissance technique, but since icons are still being made, who is to say that this tradition has ended? Contemporary icons, not of much interest to the art world, are very important to Orthodox believers. Impressionism ended long ago, but in provincial art shows you still find many paintings in this style.

Just as the beginning of an art writer's narrative picks out the first item in a series, so endings identify the last selection in that group of objects. As with beginnings, we may debate conceptual issues. If Guercino "lost his style after he came under what was for him the baneful influence of Domenichino and Roman classicism," so that in his late art he "ceased to have a style of his own," then his stylistic development came to an end well before he stopped painting.[15] De Chirico, too, is generally thought to have lost his style, but while some historians see this as happening by 1918, others admire his paintings of the 1920s and even 1930s. William Rubin says that[16]

> my own resistance to the late de Chiricos has finally something to do
> with a perception of the pictures that goes beyond aesthetics—a
> response to something I will have to call the "ethos" of the work.

Bad later painting does not downgrade Rubin's admiration for the early art, but since Matisse, after early success, continued to evolve dramatically, there is a felt need to explain why de Chirico did not also progress.

When Marc Chagall died in 1985 at ninety-seven, his "essential conservatism, his profound and sophisticated nostalgia for the museum," explains why he was thought to have long outlived his era.[17] Neither cubism nor futurism nor surrealism had any influence on him. Still, even if his late art is relatively weak, he [18]

> was a complicated and many-faceted individual who was more than
> able throughout his long career to produce images of considerable
> strength, in which an acknowledgement of the powers of darkness

coexists with a moving faith in the powers of love, art and the creative imagination.

An upbeat conclusion is appropriate for the story of an artist dealing in optimism. Meyer Schapiro makes a subtler point, observing that "in undertaking to illustrate the Bible, Chagall was moving against the stream of modern art," showing how the painter "has surmounted . . . what seem to be the limits of his own and perhaps of all modern art."[19] Chagall's career, in suggesting that "artists have greater resources than modernity allows them to disclose," serves to critique his time.

A history of art must describe a beginning, but it need not also describe an ending. Just as a novel can end with the phrase "and they lived happily ever after," so an art writer may conclude by saying that although his narrative is completed, the story of art continues. Not all artists or periods come to a satisfactory end, but there is a felt need to achieve narrative closure. The concept of individual style, Richard Wollheim argues, can be used "to explain how a given painting by a painter who has a style of his own looks the way it does."[20] An artist finds a style; may lose it; can, when "confronted by a challenge that he cannot meet," bypass his own style because it "will not reach to the new assignment"; and can even appropriate an opponent's style, "which remains, for a brief moment, undigested within his own."

Perhaps we cannot identify individual style in autobiographical terms, or tell of an artist's stylistic development by reference to his life, but the art writer aims for an effectively unified story. Whether or not Paul Delaroche (1797–1856) had an individual style, the career of this once famous academic French painter makes a fascinating narrative. If the "antagonistic interests" he tried to satisfy "did not permit Delaroche to achieve a unified and harmonious way of working . . . ," his very failure attracts us, for much contemporary art also valorizes inability to achieve aesthetically satisfying organic unity.[21]

Judgments that an artist has lost his style affect the market in his art. Worried by the quality of the later paintings by Sam Francis, Richard Polsky's *Art Market Guide* observes that[22]

large quantities of dubious production . . . tells the collector to be extra selective when buying a late Francis. . . . The artist's failure to edit himself, the dealers' lack of discernment, as well as the collectors' abdication of connoisseurship all contribute to this dilemma.

Wollheim makes an absolute distinction between major artists who have a style and the less important ones who do not. When relatively minor figures are written about, their biographers often are apologetic. "We may regret" that Andrea[23]

Sacchi did not decide to limit himself to easel pictures for private patrons during the last ten or fifteen years of his life instead of crippling himself with his fears of failing at more ambitious projects, but such a decision would have been contrary to a long Italian tradition.

Fair enough, but why then memorialize such relative mediocrity? When, similarly, Anita Brookner concludes her life of Jean-Baptiste Greuze by suggesting that though "in comparison with David, Greuze seems suddenly a little shabby, a little muddled," still, although "his work was uneven and his life tormented, he has his comments of triumphant simplicity," that is an anticlimax.[24] By contrast, Norman Bryson, who says that "the real power of Greuze is to embarrass, to disturb our normal categories, to flirt with abomination," provides a much more satisfying conclusion.[25]

How an historian ends a narrative says much about his ultimate values. After linking Goya and nihilism, Fred Licht finds something hopeful in the last still lives,[26]

due only to the vague hope that mankind, though seemingly doomed in an impenetrable universe, cannot be quite lost as long as there remain spirits such as his: incorruptible and courageous witnesses whose passage on earth lends dignity to their race.

John Ciofalo's more recent study offers a far less upbeat view:[27]

The "ambiguity" that so famously saturates his *oeuvre* is not a parlor trick. . . . it seems more like a profound human truth that he braved insanity to discover. And not to be "decoded" anymore than to be cowed by or worshiped like some untouchable holy shrine, but rather embraced.

Skeptical about traditional views of male genius and artistic creativity, Ciofalo refuses the pleasures of traditional narrative closure.

Art writers like a long-lived artist to achieve closure in his late art, working out all of the concerns implicit in earlier painting. Walter Friedlander's Poussin in old age[28]

> places the humanist corporeality of his figures and objects in a world that is unreal and undefined, beyond rationalism and civic virtue—a world that manifests, through a kind of mystic transparency, his last fears and his last loves.

Gary Schwartz, although skeptical of moralizing about artists, concludes his book about Rembrandt with his artist's *Self-portrait as Zeuxis* (1669):[29]

> This old man, an old painter, is flawed, and destroyed, through his disdain for the ugliness of a fellow human being. This is how Rembrandt let himself be remembered.

This last painting synthesizes Rembrandt's concerns. Modernists, too, achieve narrative closure, as when in Matisse's art from 1950 on, so Pierre Schneider writes, "his goal was at last reached." The happiness he sought, "merely described" in his early masterpieces "is space itself. It illuminated Matisse's earlier canvases only indirectly. Now it shone forth, omnipresent and fully revealed."[30] What was merely implicit now has been made explicit, and so the story must end.

Another way to resolve the story of an artist's life is to explain how his concerns are developed posthumously. Anthony Blunt's Poussin, looking back to Raphael and ancient Rome, and forward to Ingres and Picasso,[31]

> proves that this classicism can produce works of art which not only satisfy the mind by the perfection of their formal harmony but also touch the heart by the depth of their poetry.

But this ending feels forced, for there is little visual connection between Poussin and Picasso. At the end of his history of late–eighteenth-century art, Robert Rosenblum more plausibly links that period to an 1807 drawing by Ingres and Matisse's *Red Studio* (1911). "In art, as in all domains of history, the profound transformations of the late eighteen century left a legacy of disturbing, unrealizable dreams."[32] The eighteenth century ends,

but its artistic concerns live on with Matisse. Conversely, a great artist out-living his time may make minor art in old age. Arianna Huffington's lively potboiler *Picasso: Creator and Destroyer*, begins by describing her youthful attraction to Picasso's art, and her interest in his uses of surprise, so we are well prepared for her last sentence, which reflects on the situation of art after his death:[33]

> As we move toward the beginning of another world and a new century, what will Picasso, so irrevocably tied to the age that is dying, have to say to the age being born?

The aged Picasso, a man of a now ended era, had become irrelevant.[34]

Had Eva Hesse not died tragically young, who knows how she might have developed. Had Carl Andre died immediately after his early breakthrough, we would not have decades of repetitions of his one great conception. The man outlived the artist, as happens often. When an important artist is short-lived, like Carl Fabritius, who died in 1654 in an explosion at age thirty-two, his development may be extended by another artist. Two of Fabritius's paintings[35]

> both painted in the year of his death, are a premonition of Vermeer's best qualities in the fine, cool harmony of colours as well as the sense of classic composition and the firm handling of the brush. The distance from them to a work such as Vermeer's *Woman Reading a Letter* is not very great.

Seurat, more fully achieved, also was short-lived (1859–1891), but if he was inclined[36]

> to impose rational order over experience . . . one of the central currents of French painting, from Poussin and David to Delaunay and Léger,

then, like Blunt's Poussin, he is part of a much longer history. But noting that Seurat's close follower Paul Signac was long-lived but minor, would suggest a very different ending to the story.

Individuals die, periods conclude, but art continues, and today when so much painting and sculpture is being made, we may expect the story of art to continue. But because there is pressure to achieve narrative closure, some histories suggest, perhaps inadvertently, that the story of art has

ended. Neither Ernst Gombrich nor Clement Greenberg had reason to argue in principle that the history of art ended. The making and matching described in *Art and Illusion* might continue indefinitely; the modernist tradition presented in *Art and Culture* could develop further. But the rhetoric of Gombrich and Greenberg suggests that the development of art has ended.

The ninth chapter of *Art and Illusion* concludes with a redescription of the painting that was the book's starting point, Constable's *Wivenhoe Park*:[37]

> By its very function and intention naturalistic art was driven to search for alternatives which could be developed in the media of painting. One by one it eliminated the memories and anticipations of movement and separated out those clues which fuse into a convincing semblance of the visible world. . . .

Wivenhoe Park matches appearances as closely as is possible and so, insofar as that is the central goal of European art, the story has ended. *The Story of Art*, using different examples, presents a similar conclusion. "Art has lost its bearings because artists have discovered that the simple demand that they should 'paint what they see' is self-contradictory."[38] The end came in the nineteenth century, for "the idea that the true purpose of art was to express personality could only gain ground when art had lost every other purpose." In the 1800s European artists achieved their central goal, creating illusionistic images.[39] That story ended, and because it is not clear that another comparable goal might be found, the story of art may have ended.

Greenberg's "Modernist Painting," not reprinted in his *Art and Culture*, gives a different, perhaps simpler analysis than the book, arguing that the history of modernism involves[40]

> the stressing of the ineluctable flatness of the surface. . . . flatness alone was unique and exclusive to pictorial art. . . . Because flatness was the only condition painting shared with no other art, Modernist painting oriented itself to flatness as it did to nothing else.

The long process in which Manet, the impressionists and post-impressionists, and then the cubists and abstract expressionists identified

the essence of painting has ended. Once it was discovered that a painting *is* a flat surface, and that a blank canvas already exists as a picture, it was hard to see how development could continue much further.

Greenberg did not admire the minimalist painters like Robert Mangold, whose 1960s art nicely fit into his narrative.[41] Indeed, Greenberg denied that the history of art was over:[42]

> The artists and the critics who hurried to say that painting was finished . . . were in every case . . . people who didn't know where the best painting was. . . . If painting is ever to be finished off, it won't be by middle-brows.

Greenberg suggested that that sculpture might take the lead from painting. Donald Judd's sculpture fit this way of thinking, but Greenberg did not admire it. Greenberg denied repeatedly that he gave a formula for art's history. No matter, for "Modernist Painting" offered a

Robert Mangold, *Curved Plane/Figure Paintings.* Courtesy PaceWildenstein. Photograph by Ellen Page Wilson.

clear statement, and so the more subtle or elusive aspects of Greenberg's analysis were pushed aside. There was a certain justice here, for Greenberg had frequently proclaimed that the modernist artists failed to understand the logic of their development. In the end, Cézanne found[43]

> not so much a new, as a more comprehensible principle; and it lay not in nature, as he thought, but in the essence of art itself, in art's "abstractness." That he himself could not recognize this makes no difference.

The same could now be said about Greenberg himself. That he did not recognize the logical implications of his own claims made no difference.

Neither Gombrich nor Greenberg claim that the story of art had ended, but their rhetoric reveals a real need to end that story at the conclusion of their histories. Gombrich's treatise on decoration, *The Sense of Order*, describes a multicultural tradition that runs parallel to the pursuit of illusionism discussed in *Art and Illusion*. When the pursuit of naturalism ended, painters might turn to decoration. Greenberg, focusing on the development of modernism from Manet to color field painting, said nothing about what could happen after that. Gombrich has a very conservative view of twentieth-century art, and so extending his account beyond the end of illusionism would be an academic task. But Greenberg gives a convincing story through the time of abstract expressionism, and so when critics rejected his view of what came next, there was great interest in providing a plausible alternative narrative.

We have described accounts telling of the end of individual artists, or periods. These are merely parochial historical endings. Some art writers think that it is possible to describe the absolute end of art history. Hegel and, following him, Danto have taken this view. Like the creation of the world from nothing, the absolute end of history will be a grand event. The skies will light up, all of our computer screens will go dark, and—if the frescoes of Giotto and Michelangelo are accurate—God will come to judge us.

For Hegel, the end of art's history is understood in these grandiose religious terms:[44]

> We may well hope that art will always rise higher and come to per-
> fection, but the form of art has ceased to be the supreme need of the
> spirit. No matter how excellent we find the states of the Greek gods,
> no matter how we see God the Father, Christ and Mary so estimably
> and perfectly portrayed: it is no help; we bow the knee no longer. . . .
>
> The spirit only occupies itself with objects so long as there is
> something secret, not revealed, in them. . . .
>
> No content, no form, is any longer immediately identical with
> the inwardness, the nature, the unconscious substantial essence of
> the artist. . .
>
> No Homer, Sophocles, etc., no Dante, Ariosto, or Shakespeare can
> appear in our day; what was so magnificently sung, what so freely
> expressed, has been expressed; these are materials, ways of looking at
> them and treating them which have been sung once and for all.

The Romantic era is over, which means both that no longer is authentic art made, and that now we can understand this time.

Marx and Engels, secularizing Hegel, envisage the end of history in the communist society where[45]

> nobody has one exclusive sphere of activity but each can become
> accomplished in any branch he wishes. . . (making) it possible to . . .
> hunt in the morning, fish in the afternoon, rear cattle in the evening,
> criticize after dinner, just as I have a mind, without ever becoming
> hunter, fisherman, shepherd, or critic.

Recent commentators take up this theme. Francis Fukuyama's *The End of History and the Last Man* argues that world history has ended. Modernizing industrialization inevitably leads to liberal democracy. The alternatives, fascism and communism, have failed, and so while disaster is possible, in the foreseeable future neither new forms of government nor grand international wars are likely. Bourgeois democracy is the only viable form of government, for only it has survived Darwinian struggle. History thus has come to an end and that also "will mean the end . . . of all art that could be considered socially useful, and hence the descent of artistic activity into the empty formalism of the traditional Japanese arts."[46]

Fukuyama, a follower of the famous Hegel-commentator Alexandre Kojève, who believed that the end of history came in 1950s America or

Japan, gives an interesting description of the twentieth century, but no good reason to think that history has ended. The claim that the history of art has ended may seem equally problematic. Seventeenth-century Florentine painting, like nineteenth-century Venetian painting or French art of the 1960s, was minor enough to suggest that major artistic traditions had ended. But surely some of our highly competitive artists might do something dramatically new.

Unlike Hegel, Danto discusses only the end of art's history, not the end of political history; unlike Fukuyama, Danto offers a philosophical argument, not prophecy. What distinguishes *Brillo Box* from a Brillo box and makes it a work of art, we have seen, is the associated theorizing. Once, it was believed that visual art had to represent. But Malevitch and Mondrian made abstract paintings. Then it was thought that visual art had, at least, to be expressive. But when Duchamp, Warhol, the minimalists, and the performance artists made art that was not expressive, then it became clear that visual art needed to be neither representative nor expressive. Under appropriate conditions, anything whatever—a banal object like *Brillo Box* or an ordinary action like those of Yoko Ono's fluxus performances—could be art. The definition of art could not be extended any further. Danto's ontological history ends because the field of potential art objects has expanded to include any kind of object.

For Fukuyama, the end comes because one political system has triumphed; for Danto, because we now know the essence of art. More Hegelian than Danto, Fukuyama links the end of art's history with the end of history. Fukuyama and Danto both are optimists, though for different reasons. For Fukuyama, the end of political history is a good thing, for liberal democracy is a better form of government than communism or fascism. For Danto, the end of art's history is a good thing, because the struggles of the abstract expressionists are replaced by happy play of our post-historical artists who know that every- and anything is possible. *Brillo Box* could be only made in our industrialized consumer economy. Fukuyama and Danto, Hegelians looking at different realms of culture,

locate the ending of history at almost the same moment. And so, there may be some connection between Fukuyama's view of the end of history and Danto's account of the end of art's history.

Art, Hegel claims, depicts[47]

> a quasi-object (called "The Divine," "The Absolute," "The Truth")—it would be easy to connect this with Hegel's obvious assumption that the archetypical form of art is a representation of a god (in the form of a statue, or picture).

Tying art to religion, he fails to imagine the essentially secular modernist tradition. Writing in the 1820s, Hegel could hardly have anticipated Manet, post-impressionism, cubism, expressionism, surrealism, and abstract expressionism. Significant art, he argues, "expresses a truth," a way of thinking which links him with Danto. For Hegel, art brings to conscious awareness our deepest interests, showing how they are realized or realizable, satisfies our need for reconciliation, and thus shows why we should be optimistic. Art does this by using objects having a "common external existence" which are "the product of the activity of a human artist" and have "sensible properties which are perceived by a 'worshipping' subject . . . who is a member of a community of such subjects."[48]

Making allowance for the obvious differences between Hegel's culture and our democratic consumer economy, is that view of what artists can do not remarkably similar to the role Danto attributes to Andy Warhol?[49]

> He once said, "Pop art is a way of liking things." . . . His art was an effort to change people's attitudes toward their world. . . . he sought to reconcile the ways of commerce to those who lived in the world it created.

Radically secularizing Hegel's religious chiliastic vision, Danto detaches this view of art from claims about the end of history. Danto the art critic keeps finding new art of great interest, while Danto the aesthetician asserts that the history of art has come to an end. Danto has written about many post-Warholian artists—Robert Mapplethorpe, Sean Scully, Cindy Sherman, Saul Steinberg, and Mark Tansey. So long as significant

contemporary painting, photography, and sculpture is being made, art critics have gainful employment. But there is nothing inconsistent in Danto's procedure, for noting how Mapplethorpe's erotic images go further than Warhol's, and Scully differs from his abstract expressionist precursors, is compatible with thinking that the history of art has ended.

According to Danto, the discovery of art's essential properties, the story told by Plato, Kant, Hegel, Heidegger, and also Gombrich and Greenberg, ended with *Brillo Box*. Objects continue to be made, but no longer can they be set in a developmental sequence. "Giotto's Padua frescoes inaugurated the Renaissance"; "Cézanne's landscapes mark the origin of cubism": In 1300 and 1885, the future of art could be prophesized in these narrative sentences. But once the history of art ended, no more such claims are possible. No interesting narrative sentences about our contemporary art will someday be written. Because the history of art has ended, the introduction of new kinds of things into the art world cannot continue.

Danto the philosopher needs *Brillo Box*, the sculpture visually indistinguishable from a mere Brillo box; Danto the sociologist wants art containing everyday things, showing how "Pop set itself against art as a whole in favor of real life."[50] Carl Andre's sculptures or Robert Mangold's early paintings are very nearly indiscernible from physical objects, but they don't support Danto's sociological thesis. Claes Oldenberg's 1960s soft sculptures and Lichtenstein's paintings support Danto's sociological thesis, but they are not similar to non-art. Oldenberg's sculptures are bigger and softer than the banal things they copy, and Lichtenstein's paintings are representations. Only Warhol's *Brillo Box* supports both the philosopher's and the sociologist's theses.

Relativizing how we identify endings would allow that one narrative has ended, while another story goes on. Danto resists that way of talking, speaking of "objective narrative structures in the way human events unfold," identifying the ending of his story of art's history with the ending of the story, not just an ending of a particular narrative.[51] *After the End of Art* carries the history further than Gombrich and Greenberg, building upon their intuition that art history requires a narrative, but outflanking

them by showing how their narratives are incomplete. Gombrich's history, in which Duccio leads ultimately to Constable, requires foregrounding the story of representation, and leaving in the background concern with the function and social role of art. Claiming that this is *the* story of art requires highly selective reading of the evidence. The same can be said of Greenberg's narrative, in which Manet and his successors lead to cubism, and on to Pollock and Jules Olitski. Greenberg's narrative omits Salon art, Rodin, pre-Raphaelites, most of Picasso, futurism, dada, photography, American realism, and much more.

Danto's argument against *Art and Illusion* is that Gombrich's history of representation is not the history of art. Already van Gogh, Matisse, and other early modernists are involved in other concerns. Danto's argument against *Art and Culture* is that Greenberg's history of modernism is not the history of art, for it cannot explain the importance of *Brillo Box*.[52] A great deal of debate is required before Danto's very ambitious, highly controversial analysis can be properly evaluated. How tricky are endings!

Notes to Chapter 2

1. Richard Kuhns, *Tragedy: Contradiction and Repression* (Chicago and London: University of Chicago Press, 1991), 129.

2. John King Fairbank, *China: A New History* (Cambridge, Massachusetts and London: Harvard University Press, 1992), 491.

3. Marcel Proust, *Remembrance of Things Past*, translated by C. K.Scott Moncrieff, Terence Kilmartin, Andreas Mayor (New York: Vintage, 1982), III, 935.

4. Thomas Mann, *The Magic Mountain*, translated by H. T. Lowe-Porter (New York: Modern Library, 1955), 715, 3.

5. Giles Robertson, *Giovanni Bellini* (New York: Hacker, 1981), 2.

6. Jane Austen, *Pride and Prejudice* (New York and Scarborough: Signet, 1961), 326.

7. D. A. Miller, *Narrative and Its Discontents: Problems of Closure in the Traditional Novel* (Princeton: Princeton University Press, 1981), 265.

8. Michael Crichton, *Timeline* (New York: Ballantine Books, 1999), 489.

9. George Leonard, *The Ice Cathedral* (New York: Simon and Schuster, 1984), 221.

10. John Rupert Martin, *Baroque* (New York: Harper & Row, 1977), 269.

11. Frank Jewett Mather, *Venetian Painters* (New York: Henry Holt, 1936), 480.

12. Svetlana Alpers and Michael Baxandall, *Tiepolo and the Pictorial Intelligence* (New Haven and London: Yale University Press, 1994), 3.

13. Clement Greenberg, *Avant-garde Attitudes: New Art in the Sixties* (Sydney: Power Institute, 1969), 6.

14. Arthur C. Danto, "Painting Earns Its Stripes," catalog essay, *Sean Scully* (New York: Knoedler & Company, 2001), 5.

15. Richard Wollheim, *Painting as an Art: The A. W. Mellon Lectures in the Fine Arts* (Princeton: Princeton University Press, 1987), 30.

16. *De Chirico*, William Rubin, ed. (New York: Museum of Modern Art, 1982), 73.

17. Clement Greenberg, *The Collected Essays and Criticism: Volume 4. Modernism with a Vengeance, 1957–1969*, John O'Brian, ed. (Chicago and London: University of Chicago Press, 1993), 15.

18. Monica Bohm-Duchen, *Chagall* (London: Phaidon, 1998), 328, 330.

19. Meyer Schapiro, *Modern Art: 19th & 20th Centuries: Selected Papers* (New York: George Braziller, 1978), 121, 133, 134.

20. Wollheim, *Painting as an Art*, 27, 31, 35.

21. *Paul Delaroche: History Painted* (Princeton: Princeton University Press, 1997), 156, 273.

22. Richard Polsky, *Art Market Guide: Contemporary American Art* (San Francisco: Marlit Press, 1998), 52.

23. Ann Sutherland Harris, *Andrea Sacchi* (Princeton: Princeton University Press, 1977), 35.

24. Anita Brookner, *Greuze: The Rise and Fall of an Eighteenth-century Phenomenon* (Greenwich, Connecticut: New York Graphic Society, 1972), 155.

25. Norman Bryson, *Word and Image: French Painting of the Ancien Régime* (Cambridge: Cambridge University Press, 1981), 153.

26. Fred Licht, *Goya: The Origins of the Modern Temper in Art* (New York: Harper & Row, 1979), 281.

27. John J. Ciofalo, *The Self-Portraits of Francisco Goya* (Cambridge: Cambridge University Press, 2001), 178.

28. Walter Friedlaender, *Nicolas Poussin: A New Approach* (London: Thames and Hudson, 1966), 88.

29. Gary Schwartz, *Rembrandt. His Life, His Paintings* (Harmondsworth, Middlesex: Viking, 1985), 356.

30. Pierre Schneider, *Matisse*, translated by Michael Taylor and Bridget Strevens Romer (New York: Rizzoli, 1984), 706.

31. Anthony Blunt, *Nicolas Poussin* (Washington, D.C.: National Gallery of Art, 1967) 358. In his *Picasso's "Guernica"* (New York and Toronto: Oxford University Press, 1969), Blunt returns to this theme and indicates in a more precise way how he understands the connection between Poussin and Picasso.

32. Robert Rosenblum, *Transformations in Late Eighteenth-Century Art* (Princeton: Princeton University Press, 1967), 191.

33. Arianna Stassinopoulos Huffington, *Picasso: Creator and Destroyer* (New York: Simon and Schuster, 1988), 475.

34. But Picasso's late art, once disparaged or dismissed, recently has been interpreted sympathetically. See Gert Schiff, *Picasso. The Last Years, 1963–1973* (New York: George Braziller, 1973).

35. Jakob Rosenberg, Seymour Slive, E. H. ter Kuile, *Dutch Art and Architecture: 1600 to 1800* (Harmondsworth, Middlesex: Penguin, 1972), 191.

36. Robert L. Herbert, *George Seurat: 1859–1891* (New York: Metropolitan Museum of Art, 1991), 8.

37. E. H. Gombrich, *Art and Illusion: A Study in the Psychology of Pictorial Representation* (Princeton: Princeton University Press, 1961 [second edition]), 329, 380.

38. E. H. Gombrich, *The Story of Art* (London: Phaidon, 1966 [eleventh edition]), 426.

39. Gombrich underplays a further obvious consideration, which privately he allowed to be of considerable importance; photography made the search for painted illusionistic representations redundant.

40. Clement Greenberg, *The Collected Essays and Criticism: Volume 4. Modernism with a Vengeance 1957–1969*, John O'Brian, ed. (Chicago and London: University of Chicago Press, 1993), 87.

41. See my "Robert Mangold, Gray Window Wall (1964)," *The Burlington Magazine*, 1125, v. CXXXVIII (December 1996): 826–28.

42. Clement Greenberg, *Homemade Esthetics: Observations on Art and Taste* (New York and Oxford: Oxford University Press, 1999), 186.

43. Clement Greenberg, *Art and Culture: Critical Essays* (Boston: Beacon Press, 1961), 41.

44. G. W. F. Hegel, *Aesthetics. Lectures on Fine Art*, translated by T. M. Knox (Oxford: Clarendon Press, 1975), 103, 604, 605, 608.

45. Karl Marx and Friedrich Engels, *Basic Writings on Politics and Philosophy*, Lewis S. Feuer, ed. (Garden City, New York: Anchor Books, 1959), 254.

46. Francis Fukuyama, *The End of History and the Last Man* (New York: Free Press, 1992), 320.

47. Raymond Geuss, *Morality, Culture, and History: Essays on German Philosophy* (Cambridge: Cambridge University Press, 1999), 86.

48. Geuss, *Morality, Culture, and History,* 89.

49. Arthur C. Danto, *Philosophizing Art: Selected Essays* (Berkeley, Los Angeles, London: University of California Press, 1999), 74.

50. Arthur C. Danto, *After the End of Art: Contemporary Art and the Pale of History* (Princeton: Princeton University Press, 1997), 131.

51. Arthur Danto, *Analytic Philosophy of History* (Cambridge: Cambridge University Press, 1965), 101.

52. Gombrich, in response, might urge that he is concerned not only with representation, but also, in *The Sense of Order*, with decoration; Greenberg, in reply, could say that Warhol's sculpture is indeed an artwork but only because anything whatsoever can be seen aesthetically. But these responses need not be telling. Danto's historiography includes both everything Gombrich and Greenberg include and also much that they omit or marginalize.

Either narrative is a simple chronicling of events, in which case we can

discuss it only by relying on the teller's [the author's] art, talent,

genius—all mythic forms of chance—or else it shares with other

narratives a structure accessible to analysis.

—*Roland Barthes*[1]

CHAPTER THREE:
The Presentness of Visual Art

Describing visual art in narratives, does this not ultimately falsify its true nature? We have seen how beginnings and endings in art writing impose structures upon our thinking about painting and sculpture. And so it is natural to wonder if any form of writing might escape these constrictions. How might an inventive art writer avoid these constraints?

Focusing on beginnings and endings, we have compared novels and art writing. Like Austen, James, and Spark, art writers are storytellers, but the stylistic experimentation of recent creative writers, who playfully deconstruct traditional narrative forms, has scarcely been matched by recent art writers. Only relatively rarely have critics or historians employed nontraditional ways of telling stories about art. Why is art writing so much less adventuresome than fiction? The art writer must describe the work of art, or tell the story of an artist's life or of a period in art history. And so that writer thus is committed to being a storyteller, like a traditional novelist. But that is not the whole story. Some art writing attempts to transcend this essentially temporally oriented narrative form.

Imagine going to the Clark Art Institute, Williamstown, Massachusetts, to see Piero della Francesca's *Virgin and Child Enthroned with Four Angels*. The attribution has been questioned and the dating of this painting is controversial. And so, to fully understand what you see, it is natural to reflect upon Piero's development. When writers set a painting in a social history, or a stylistic analysis of a historical period, they set it in a larger context. Connoisseurs, by contrast, are often said to consider art for its own sake. True

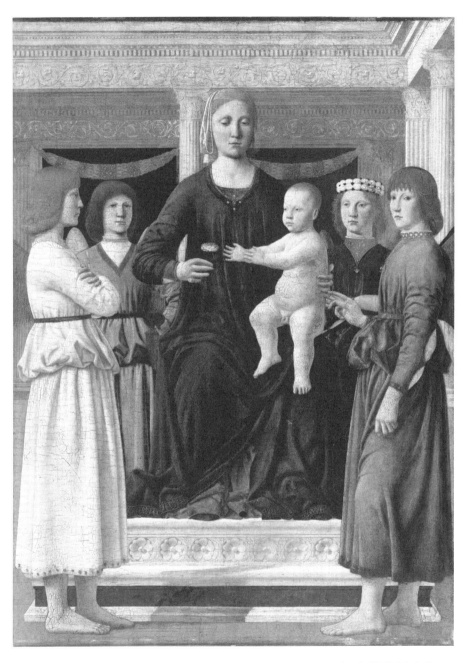

Piero della Francesca, *Virgin and Child Enthroned with Four Angels*, c. 1460–1470. Photograph copyright © 1995 Clark Art Institute.

enough, but when Kenneth Clark, writing as a connoisseur, discusses the attribution and dating of the Williamstown picture, he mentions other Pieros in Rimini, London, and Milan:[2]

> The architectural scheme, recalling the fresco of Sigismondo Malatesta, would suggest an early date. . . . On the other hand the types of the angels suggest a late work, and this is born out by the Flemish character of the child which is similar to that in the National Gallery Nativity. The angels' dresses resemble those of the angels in the Brera altar-piece.

To properly understand the intrinsic qualities of *Virgin and Child*, visual comparisons thus are essential. But when in Williamstown you imagine the Pieros in Arezzo, Perugia, and Rimini, then you turn away from the art at hand to consider distant paintings accessible only in reproduction.[3]

Aesthetic experience concentrates on what is here and now, seen for its own sake:[4]

> Every moment some form grows perfect in hand or face; some tone on the hills or the sea is choicer than the rest; some mood of passion or insight or intellectual excitement is irresistibly real and attractive to us—for that moment only.

But understanding what is immediately present, Walter Pater goes on to argue, requires making comparisons. Even the connoisseur and the aesthete must set individual paintings in some context. Does this mean that as soon as visual art is written about, it is doomed to be misunderstood? This problem, posed in our Overture, is very sensitively discussed in *Art and Culture* when Clement Greenberg turns from the visual arts to literature.[5]

> States of being are what count most in Kafka's fiction, ongoing states such as can have no beginning or ending, but only middles. . . . If Kafka's fiction admitted resolutions, they could be only melodramatic ones.

"Might not all art," he goes on to ask,

> "prosaic" as well as "poetic," begin to appear falsifying to the Jew who looked closely enough? And when did a Jew ever come to terms with art without falsifying himself somehow?

Quite apart from Greenberg's personal concerns, his question is of general interest. Like a mystic trying to describe God, or Roger Fry faced with Cézanne's greatest paintings, the art writer sometimes feels that since no words can do justice to his experience, any verbal description will inevitably distort.

Developmental stories impose temporal structures on essentially atemporal visual art. It is natural to set one painting in a story of the artist's development, or in an account of the period. Piero's *Virgin and Child Enthroned with Four Angels* is seen all at once, but when described in an account of his career, or an analysis of fifteenth-century painting, it becomes one item in a series. And then we are taken away from focus on that one artifact. Since any narrative requires time to be read, while visual art is seen rapidly, how could writing do art justice? The two media, it would seem, are too different. Can any art writer avoid beginnings and endings, offering not merely an interpretation but a view of the visual work of art as it really is? The writer sets art in some context—he interprets. Could art writing not classify, historicize, pigeonhole, or otherwise interpret, but simply point to a work of art, making it present, revealing it as it really is? Some art writers think that this is possible.

Reflection upon our experience at the Clark Art Institute suggests one tentative way of solving this problem. To describe a painting in words, the writer must present a narrative, but instead of telling a story about that artist, or the history of art, commentary might rather focus on the experience of going to view this work of art. Coming to Williamstown, the writer in search of Piero may pay little special attention to the attractive country town, or the architecture and floor plan of the Clark Institute, for *Virgin and Child* was originally made for a very different setting. But when going to see Piero's *Flagellation of Christ* in Urbino, an out-of-the-way town, everyone is aware of the intimate relationship of the artist with this region not far from his hometown.[6] You enter the Palazzo Ducale, walk upstairs and then through the rooms leading to Guardaroba del Duca, the small gallery where Piero's painting is displayed. In Williamstown, a Piero is a foreign object. But the landscape and columns in the Urbino courtyard are very like those depicted in the painting.

Historical narratives place individual works of art within some larger historical or interpretative framework, their beginnings and endings picking out moments in the history of art. But an older style of art writing took the point of view of the traveler on the grand tour. My short sketch of a trip to Urbino builds upon that tradition. Before the traveler went South, often he was naïve about visual aesthetic pleasure. After reaching Italy, he learned about art, and so, if he were a writer, he needed to explain the effects of that change. A narrative requires describing first one thing, then another. In an art-historical account of the Renaissance, for example, we learn of Cimabue, then Giotto, and finally Masaccio. In a traveler's narrative, we read of the entry into Padua that leads a visitor to the Giottos in the Arena Chapel. The subject, the entity whose historical development is being described, is not the history of Italian art, but the experience of that traveler.

Praeterita, a very influential nineteenth-century book, describes John Ruskin's first view of the Alps. Traveling with his parents in their private coach, after sightseeing in Schaffhausen, Switzerland,[7]

> we dined at four, as usual, and the evening being entirely fine, went out to walk. . . . We must have still spent some time in town-seeing, for it was drawing toward sunset when we got up to some sort of garden promenade. . . . At one of our own distances from Malvern of Worcestershire, or Dorking of Kent,—suddenly—behold—beyond. There was no thought in any of us for a moment of being clouds. They were clear as crystal, sharp on the pure horizon sky, and already tinged with rose by the sinking sun.

His first sight of the Alps is a grand, transforming experience.

So too was Ruskin's entrance into Venice, as described at the beginning of volume two of *The Stones of Venice*, in one very long sentence which deserves quotation almost in full.[8]

> In the olden days of travelling, now to return no more, in which distance could not be vanquished without toil, but in which that toil was rewarded, partly by the power of deliberate survey of the countries through which the journey lay, and partly by the happiness of the evening hours, when from the top of the last hill he had surmounted, the traveler beheld the quiet village where he was to rest, scattered

among the meadows beside its valley stream; or from the long hoped
for turn in the dusty perspective of the causeway, saw, for the first time,
the towers of some famed city, faint in the rays of sunset—hours of
peaceful and thoughtful pleasure, for which the rush of the arrival in
the railway station is perhaps not always, or to all men, an equivalent,
—in those days I say . . . there were few moments of which the
recollection was more fondly cherished by the traveler than that which
. . . brought him within sight of Venice, as his gondola shot into the
open lagoon from the canal of Mestre.

Leisurely travel by gondola prepares for exhaustively full examination of
Venetian architecture. It is impossible to understand the architecture, paint-
ing, and sculpture of Venice, Ruskin demonstrates, without taking account
of the site. The distinctive light reflected from the water, the special
difficulties of construction, the history of the Venetian Republic—all of
these topics of *Stones of Venice* are anticipated.

Adrian Stokes (1902–1972) emulated Ruskin in his early book *The
Quattro Cento* (1932), which begins by evoking Francesco di Giorgio's
Palazzo del Commune in Jesi. After telling of the street life, Stokes
takes us to the[9]

building one has come to see, this square brick edifice that is in bloom.
For the decrepit brick has given birth to straight stone window-frames
beaded as with pips of young fruit. Wood litters the broken-down
courtyard within. The stone arches are filled up. How stone hates
wood, even this afflicted stone remembers that. Afflicted? No. The
miracle begins to catch the heart, the miracle of Aaron's blossoming
rod. That was a Quattro Cento effect, just as Moses' miracle of the
splashing water from the mountain-side is Baroque. But Aaron's rod is
the greater wonder.

The body of the book is devoted to art that displays this blossoming inner
life of the stone. The oddities of *The Quattro Cento* start with its title, which
derives from the Italian *quattrocento*, fourteenth century, written as two
words both capitalized. The Italian word identifies a period; Stokes's title
picks out the art of highest value whenever it is made. To comprehend
Italian sculpture, you need to study the material from which it is made; to
understand painting in Italy, you need to know the street life of that coun-
try. Later Stokes came to realize that this account of sculpture in Italy was
only fully comprehensible when presented in the context of his life. And

so, his autobiography *Inside Out* (1947) counted his first trip to Italy in strikingly Ruskinian terms:[10]

> We arrived at Turin in the late afternoon. . . . I stood enraptured. . . . never before had I been so much at home. . . . There was a neatness in the light. Nothing hid or was hidden.

His life changed dramatically, Stokes was ready to become an aesthete.

We find a similar narrative structure, a modern version of the travel narrative, in some essays of Robert Smithson. His "Tour of the Monuments of Passaic, New Jersey" begins with a recounting of the start of a trip:[11]

> On Saturday, September 20, 1967, I went to the Port Authority Building on 41st Street and 8th Avenue. . . . I went to ticket booth 21 and purchased a one-way ticket to Passaic. After that I went up to the upper bus level (platform 173) and boarded the number 30 bus of the Inter-City Transportation Co.

In Smithson's account, which is both totally serious and somewhat ironical, this everyday businessman's journey to the suburbs acquires something of the grandeur of the grand tour, as presented in Ruskin's entry into Venice or Stokes's first trip to Italy.

When a narrative focuses on the art writer's life, dealing with a story of his development, then it is possible to preserve that all-at-oneness of visual art that is lost in an art historian's narrative. The narrator develops, and his story describes an encounter with art, which is set not in a developmental account of art's history, but within the narrative of his life. In this literature, just as we learn of Ruskin's first encounters with the Alps and Venice, and Stokes's coming to Italy, so descriptions of that narrator's first experience of major sculpture or painting often are of great importance.

About two thirds of the way into *Stones of Rimini*, Stokes's account of the architecture and sculpture of the Tempio Malatestiano, Rimini, he remarks:[12]

> Certainly, though I have studied the subject on and off for six years, I have added no new intensity of feeling to my first "ignorant" impression of the Tempio. I have only found images and names and explanations and reasons and theories—in general, literary data—to express what on July 5th, 1925, I knew at once of the life, the landscape, the condition of which the Tempio is the emblem.

Michael Fried describes his first experience of Anthony Caro's earliest abstract sculptures, *Midday* (1960) and *Sculpture Seven* (1961) in similar terms:[13]

> I was alone with these for several minutes before Caro came out of the house. But that was long enough to experience the unshakable conviction that they were two of the most original and powerful sculptures I had ever seen, that *Midday* in particular was nothing less than a masterpiece. . . .

And I have told of a similar experience:[14]

> In January, 1982, I visited "Critical Perspectives," a group of exhibitions organized by critics with diverse sensibilities, at P.S. 1, a major outpost for contemporary art, in Queens, New York, just two subway stops away from mid-town Manhattan. In the room curated by Joseph Masheck was the twenty-foot long *Backs and Fronts* by an artist unknown to me, Sean Scully.

I instantly knew that I had seen a great, unknown painting, though only twenty years later could I adequately articulate what happened then.

Stokes, Fried, and I describe initial encounters with exalted works of art, experiences of what may be called absolute presentness, setting them in narratives of our lives.[15] Michael Frayn's *Headlong*, a novel about the rediscovery of an imaginary, long hidden masterpiece, also presents such an experience:[16]

> I recognize it instantly.
>> I say I recognize it. I've never seen it before. I've never seen even a description of it. . . .
>> And I say instantly. The picture's uncleaned, and for a few seconds all I can see, until my eye adjusts to the gloom, is the pall of dirt and discolored varnish. Then again, how long is an instant?

Quite a few words are needed to describe this lightning-fast encountering. "For a picture this size," Frayn notes, "some four feet high by five feet long, even the most cursory scan must take a matter of seconds."

On September 11, 2001, unexpected traumatic catastrophe came absolutely unannounced, and so took significant time to comprehend. The visual discoveries Stokes, Fried, and Frayn record are the converse, instantaneous discovery of something absolutely wonderful. Freud

defines trauma as experience "which within a short period of time presents the mind with an increase of stimulus too powerful to be dealt with or worked off in the normal way."[17] These experiences of presentness are, by contrast, something like a positive trauma, to speak in suggestive but paradoxical terms. The first sight of a masterpiece is an experience that takes some time to comprehend, and no doubt seems mysterious to outsiders. Nowadays few tourists go to the Tempio, Caro is out of fashion, and *Backs and Fronts*, long in storage, is too big to appear in Scully's retrospectives. And so, Stokes's, Fried's, and my revelations are not easy to understand.

In "Art and Objecthood," Fried describes such an occasion in terms that are very suggestive for my present purposes:[18]

> One's experience of a Caro is not incomplete, and one's conviction as to its quality is not suspended, simply because one has seen it only from where one is standing. . . . It is this continuous and entire presentness, amounting, as it were, to the perpetual creation of itself, that one experiences as a kind of instantaneousness, as though if only one were infinitely more acute, a single infinitely brief instant would be long enough to see everything, to experience the work in all its depth and fullness, to be forever convinced by it.

Many commentators, including Fried himself, have wrestled unsuccessfully to unpack the theological implications of this analysis. To evaluate a work of art takes time, and so to claim that you could instantaneously grasp the virtues of a Caro, the Tempio, or *Backs and Fronts*, seems a myth. Stokes, Fried, and I need many words to explain our conviction that these dramatic experiences were essentially instantaneous. Surely we are not implying that all the thoughts laid out in these accounts ran through our minds all essentially instantaneously. But how, then, are our recountings of these experiences to be understood?

To say that we recognized the presentness of these masterpieces, the Tempio, Caro's sculpture, Scully's *Backs and Fronts,* is a way of underlining the depth, importance, and lasting significance of our aesthetic experiences. Our commentaries therefore emphasize the incommensurability of the most significant visual art and words used to describe it. God, it is

sometimes said, views the world atemporally, seeing the events as if laid out in space. Perhaps Fried thought in such religious terms, for "Art and Objecthood" begins with a long epigraph from Perry Miller's *Jonathan Edwards* citing Edwards' frequent private speculation that God could create the world anew at every moment. "It is certain with me that the world exists anew at each moment; that the existence of things every moment ceases and is every moment renewed."[19]

Theology certainly is relevant here, for no physical thing could be present in the way that Fried describes Caro's sculpture. As we move around an ordinary object, there is always more to view. Looking at the front of Caro's sculpture, the back is in part hidden. And when then we view the back, the front is impossible to see. But Fried makes a distinction between the physical object and the work of art as such. In his study of eighteenth-century French art and art writing, he presented a similar claim:[20]

> Diderot's conception of painting rested ultimately upon the supreme fiction that the beholder did not exist, that he was not really there, standing before the canvas. . . .

Fried responds to the paintings of Chardin, Greuze, and David, and also the modernist art he loves, as if they were not physical objects.

If Morris Louis's paintings do not "compel conviction *as* painting," Fried argued, then "they will be experienced as a kind of object. . . ."[21] Jacques Derrida's theorizing, which attracted great attention in the American art world soon after "Art and Objecthood" was published, explains some of the problems here. Derrida's elusive arguments certainly oppose this way of thinking about presence and about Fried's belief that the meaning of art could be transparently self-evident.[22] A memory or fantasy image can have presence, for I stand at no distance from, and have no point of view upon these mental pictures. But as you walk around Caro's sculptures, or move around Louis's paintings, you see them differently. If Fried's account accurately describes the presence of Caro's sculptures and Louis' paintings, then further interpretation would be supererogatory. But in fact, new commentators do describe this art differently. God may see His world as it really is, but we mere mortals

often revise our judgments. The belief that a work of art can be present all at once surely is a myth.

Adrian Stokes developed this myth of presence in his *Stones of Rimini*, which concludes with a richly suggestive fantasy about the Tempio Malatestiano:[23]

> Diana is at her height. Sea and sea-life mount the shore still higher without harm to the land because of the infusion of air and moonlight in the heavy water. The mysteries of ocean and of earth, taut now and exemplified to the last atom, at peace, together they are forging the new element which shall the better sustain the offspring of dust and water, the living form, their offspring of a now-remembered marriage before the feud.

The fifteenth-century sculptor Agostino di Duccio showed love of stone, Stokes suggests, by bringing to the surface of his shallow reliefs the geological history of that material in these images which achieve perfect stillness, avoiding the rhythm of lesser art.

Stokes loved this purely spatial, all-at-once sculpture:[24]

> Why always seek for rhythm in visual art, why desire that rhythm or music and other temporal abstractions be conveyed by objects; why desire from the concrete an effect of alternation, since the very process of time can be expressed, without intermittence, as the vital steadiness of a world of space, as a rhythm whose parts are laid out as something simultaneous, and which thus ceases to be rhythmical?

The distance between this commentary and the accounts of modern art historians, who mostly do not mention Stokes, is immense:[25]

> Agostino sought his solutions in surface-play and in the rushing impulses of quite unmeasurable linear rhythms. . . . His most successful reliefs at Rimini are either on the subject of water or suggest a metamorphosis of the lithe and twisting shapes of hair or flowing folds of drapery into aqueous equivalents. (Charles Seymour)
>
> The Graces placed against a rich foliage of laurel . . . [recur] in Agostino di Duccio's relief of Apollo in the Tempio Malatestiano in Rimini. Since the Greek and Latin worlds for "matter" signify sylvan vegetation . . . it was not illogical to suggest the musical animation of matter . . . by placing the Graces in a sylvan setting. (Edgar Wind)
>
> [The forms] in the Tempio Malatestiano were in the first instance addressed to the humanists, whose primary concern was the study, interpretation, and aesthetic appreciation of the Greek and Latin

Agostino di Duccio (1418–1498), *The Great Flood*. Tempio Malatestiano, Rimini, Italy. Courtesy Scala/Art Resource, NY.

classics rather than the discursive contemplation of "pure form" as this was defined by art criticism at a much later date. (Stanko Kokole)

Seymour, Wind, and Kokole think that Agostino presented humanistic themes, and so they seek to identify the sculptor's influences, placing him within his culture. Because they do not believe that this sculpture can achieve presence, making its meaning transparently accessible to the eye, they offer mere interpretations, accounts subject to future revision.

Stokes's distance from art history marks his period style. He was originally closely associated with Ezra Pound, who thought that[26]

> there is no description of the Tempio in accordance with Vorticist logic: one art does not attempt what another can do better, and the meaning of the Tempio has been fully explicated on the spot by Agostino di Duccio with his chisel.

Pound's friend Henri Gaudier-Bzeska claimed that he could read Chinese without knowing that language, because the ideograms are transparently meaningful.[27] Stokes, similarly, thinks that the meaning of Quattro Cento sculptures can be seen directly. Historians seek to recover an artist's sources, looking in the culture, and so Stokes's approach is too different from that of Seymour, Wind, and Kokole to make fruitful debate possible. Indeed, Stokes's table of contents shows how eccentric is his book, judged by the standards of art history:

Part One: *Stone and Water*
 I. Stone and Water
 II. The Pleasures of Limestone: A Geological Medley
 III. The Mediterranean
Part Two: *Stone and Clay*
 IV. Carving, Modelling, and Agostino
Part Three: *Stone, Water and Stars*
 V. The Tempio: First Visit
 VI. Chapel of the Planets
 VII. The Final Picture

Normal historians deal with the fantasies represented in art, but do not think it appropriate to understand that sculpture by presenting their own fantasies about its subjects.

According to Stokes, Agostino used his medium to present the history of stone, bringing to the surface images of the process in which marble and limestone are created. Carving, by articulating the story of what already exists in the stone, comes to life when Agostino's reliefs depict water and water-life become marble. These sculptures express their material, translating the long temporal process in which the stone was created, into images seen all at once. There is no evidence that Agostino thought he was doing this, and plenty of indirect evidence that in fifteenth-century Italy sculpture was understood in very different terms. Stokes seeks no such evidence because he thought that you could see directly the meaning of this art. Like Fried, he believes in presence. This marvelous fiction inspired magnificent writing.

But imagine that some young scholar discovers in a hitherto-explored archive a contemporary appreciation of the Tempio by a poet friend of Agostino. In this historian's idiomatic translation, the fifteenth-century commentary reads:

> *Diana is at her height. Sea and sea-life mount the shore still higher without harm to the land because of the infusion of air and moonlight in the heavy water. The mysteries of ocean and of earth, taut now and exemplified to the last atom, at peace, together they are forging the new element which shall the better sustain the offspring of dust and water, the living form, their offspring of a now-remembered marriage before the feud.*

Identical word for word with Stokes's fantasy, this commentary would have an entirely different status. Modern scholars, all too aware of how little is known of Agostino's life and times, strive to reconstruct that sculptor's now historically distant milieu. Documentation by a man who knew Agostino would have great value. Art historians would cite this commentary.

Art writers like Stokes or Fried who believe in the presentness of visual art face an obvious dilemma. If we can see the meaning of the art they describe, why write about it? Insofar as they would just point and say, "Here it is!" how can they compose a narrative? Traditional travel writing offered one obvious solution, which was employed, as we have noted, in later writings by Stokes. When Ruskin presents his journeys south, Goethe

describes his trip to Italy, and William Hazlitt narrates his travels, they tell how they became art lovers. The subject of these narratives is not the story of art, as for an art historian, but the writer's own life. The change that they describe is a change in their lives, described in relation to the art that matters to them. In understanding these art writers, we learn to comprehend the visual art they discuss.

In two autobiographical books, *Inside Out* (1947) and *Smooth and Rough* (1951), Stokes tells the story of how he, a child who feared hidden spaces in London, came to love the visually open worlds of Italy, where nothing frightening could be hidden. His earlier love of even, southern light and ideal openness, and what he, like many other travelers, associated with Italy—youthful homosexuality—was succeeded by a life devoted to marriage, children, and radical revision of his aesthetic. Now we are prepared to understand why Stokes gave such value to the sculpture he found in Rimini and why, in his later books, a different aesthetic was developed.

Even we admirers of Fried's very distinguished contributions to art history find his early aesthetic ideal something of a mystery, as indeed Fried himself does, judging by his recent introduction to his collected art criticism. Why value so highly the presentness, the all-at-onceness achieved by Caro's sculpture and Morris Louis's paintings? Fried never gives a satisfactory answer to that question. But there is one modern tradition of art writing, which, appealing like Stokes and Fried to presentness, aims to escape the limits of historical narratives.

Presenting a story of art's history, so we have seen, involves telling how one event leads to another. Ultimately, storytelling requires narrative. But it is possible for writing to escape these seemingly unavoidable limitations, and match the essential nature of visual imagery. Instead of setting art in a historical commentary, imposing the structures of beginnings and endings, writers can translate the history of art into an immediately present image completely visible all at once. Just as God is said to make no distinction between what to mere humans is past, present, and future, so the structuralist looks at cultures and art ahistorically. God is omniscient, and so He

looks at a closed historical period. For Him, and for the structuralist, all art is contemporary art.[28]

Imagine some part of the history of art mapped onto a diagram, a picture that translates temporal development into the all-at-onceness of a picture. According to Sheldon Nodelman's structuralist account, which does just that, Mark Rothko was hostile to Piero della Francesca's fresco cycle in Arezzo: "He condemned it as 'too narrative' and disparagingly compared it to the sequential box-narrative of a comic strip."[29] Rothko preferred Fra Angelico's frescoes, and this preference for avoidance of narrative appears also in Rothko's de Menil Chapel, Houston. In his highly complex account, Nodelman appeals to the semiotic theorizing of A. J. Greimas, who identifies the structures of narratives in a square marking contraries and negatives.

Assertion	Contrary
Negation of Contrary	Negation of that Assertion

We can translate an essentially temporal form into this atemporal structure. In giving a Greimas diagram for a story by Balzac, or a history by Marx, we make present all at once the narratives of these stories, showing them in one picture. Rothko's chapel also realizes such a structure.[30]

In his structuralist commentary on Native American art, Claude Lévi-Strauss rejects the usual art historian's ways of thinking about influences:[31]

> We reserve . . . the right to compare American Indian art with that of China or New Zealand, even if it has been proved a thousand times over that the Maori could not have brought their weapons and ornaments to the Pacific Coast.

All that matters, he argues, are the visual comparisons themselves, for if they are convincing, then we need not seek causal connections between these geographically distant visual cultures.[32] As Jacques Derrida remarks in his discussion of Lévi-Strauss,[33]

> The absence of a center is here the absence of a subject and the absence
> of an author. . . . If it is asked where the real center of the work is to
> be found, the answer is that this is impossible to determine.

This essentially atemporal analysis is naturally associated with these relatively
changeless societies whose art can be analyzed in structuralist terms.[34] Since
both Old Master and modernist European painting are deeply concerned with
rapid development, a structuralist analysis of this art might seem impossible.
But this is not the entire story, at least when dealing with art made in a closed
period of history.

In *Principles of Art History,* Heinrich Wölfflin applies a structuralist
way of thinking to the development of European painting when he com-
pares planar classical painting with recessive baroque art. In Vermeer's
recessive *Painter with Model,*[35]

> The model is placed far back in the room, but lives only in relation to
> the man for whom she poses, and thus, from the outset, a vigorous
> into-the-picture movement comes into the scene, materially supported
> by the lighting and perspective.

Wölfflin contrasts Dirk Bouts's planar *St. Luke Painting the Virgin* in which,
he says, "the principle of the stratification of the picture in parallel planes
is carried out . . . in absolute purity." In *Renaissance and Baroque,* similarly,
he compares these two styles:[36]

> Renaissance art is the art of calm and beauty. . . . Its creations are per-
> fect: they reveal nothing forced or inhibited, uneasy or agitated.
> Baroque aims at a different effect. It wants to carry us away from
> the force of its impact, immediate and overwhelming.

And in his *Sense of Form in Art: A Comparative Psychological Study* he con-
trasts Italian and German composition:[37]

> Razor-sharp boundaries and exact measurability characterize not only
> Leonardo's "Last Supper" but also earlier Quattrocento interiors; and
> northern interiors will always appear more or less unintelligible in
> comparison.

Ernst Gombrich objected to this way of thinking, arguing
Wölfflin's polarities "are not true polarities at all, for they always con-
trast other forms of pictorial organization—the baroque, or German

composition—with the real norm, the High Renaissance classical style."[38] A baroque artist could avoid composition like the classical art he knew, but a classical artist could not have desired to paint unlike the baroque painters of the future.

> If we want to see Raphael in his own terms, we cannot ignore the dimension of time and the horizon of his knowledge. He cannot have rejected what he never knew.

Certainly Wölfflin's analysis is quite unlike that found in writings of such a near contemporary of Raphael as Vasari. But as Lévi-Strauss says, comparing Native American myths with a language, it would be best, "disregarding the thinking subject completely," to "proceed as if the thinking process were taking place in the myths. . ."[39] Wölfflin compares and contrasts classical and baroque, or Italian and German art, from the vantage point of a modern-day historian. Just as Lévi-Strauss takes no interest in what the Native Americans would think of his structural comparisons, so Wölfflin is not worried that these European artists would not understand their achievement in his terms. The test of a structural analysis is that it convincingly allows us to compare diverse works of art; what matters is the successful use of our categories, not their relationship to the thinking of the artist.

According to Lévi-Strauss, myths form a closed system:[40]

> I am convinced that the number of these systems is not limited and that human societies . . . never create absolutely: all they can do is to choose certain combinations from a repertory of ideas which it should be possible to reconstitute.

The same now presumably is true of old master painting. Now when the traditions of the classical and baroque are closed, we can adopt the structuralist perspective and understand this art atemporally. Indeed, if Arthur Danto is correct, the entire story of art is closed, and so we can provide a structuralist analysis confident that nothing essentially new will be made. Here we can see some implications of his view that the history of art had ended. If we imagine three possible styles—mannerism, the baroque, and rococo—then there are eight possible combinations:[41]

	Mannerist	Baroque	Rococo
1.	+	+	+
2.	+	+	-
3.	+	-	-
4.	-	+	+
5.	+	-	+
6.	-	+	-
7.	-	-	+
8.	-	-	-

When Danto observes how this structure is based upon the

> art history lecture, in which works are juxtaposed and compared, however little they may have to do with one another causally or historically. . . . It is to treat all works of art as contemporaries, or as quite outside time,

then his way of thinking is obviously similar to Wölfflin's.

Danto has more recently abandoned this structuralist approach, thinking it inconsistent with his concern with the way that works of art like *Brillo Box* are indiscernible from physical objects.[42] As for Stokes, Fried, and the structuralists, their style of analysis has not convinced most other art historians. For Fried, a work of art achieves presence because it is not a physical object; for Stokes, because it wears its meaning on its face; and for Danto's structuralist or Wölfflin because it is one element in a bounded structure. Transcending mere perspectives, Fried, Stokes, and Wölfflin would offer a view of art as it really is. Most historians of art do not accept this vision of art's presence. The dream of these visual thinkers, that art transparently reveals its meaning, does not satisfy us, for, as was shown in the Overture, we believe that any work of art will be interpreted variously when it is placed in different contexts. Fried, Stokes, Wölfflin, and Danto the structuralist are doomed to fail. They, too, offer mere interpretations, not a God's-eye view of art. But what boldly original, deeply imaginative interpretations they present!

This structuralist theorizing ultimately does not succeed, but it does point to some real problems inherent in presenting visual art using

historical narratives. And so critical analysis of this belief in presence will lead us forward from this discussion of art writing to the second part of our analysis. Why is there all this fuss and fury about the place of beginnings and endings in writing about the visual arts? Why do we take so much interest in a genre of writing that does not attract much attention from literary scholars or historiographers? What, in short, is the significance of art writing? To answer these questions, we need to identify and critically analyze the social function of such writing. That is the task of part two of this book.

Notes to Chapter 3

1. Roland Barthes, *The Semiotic Challenge*, translated by Richard Howard (New York: Hill and Wang, 1988), 96.
2. Kenneth Clark, *Piero della Francesca* (Oxford: Phaidon 1969 [second edition]), 229.
3. See *The Complete Paintings of Piero della Francesca*, catalogue by Pierluigi de Vecchi (Harmondsworth, Middlesex: Penguin, 1985), 99.
4. Walter Pater, *The Renaissance*, Donald L. Hill, ed. (Berkeley, Los Angeles, London: University of California Press, 1980), 188.
5. Clement Greenberg, *Art and Culture: Critical Essays* (Boston: Beacon Press, 1961), 272, 273. On Greenberg's Jewishness see Louis Kaplan, "Reframing the Self-Criticism: Clement Greenberg's 'Modernist Painting' in Light of Jewish Identity," *Jewish Identity in Modern Art History*, Catherine Soussloff, ed. (Berkeley, Los Angeles, London: University of California Press, 1999).
6. See *Il palazzo ducale di Urbino*, Mario Bucci and Piero Torriti, eds. (Firenze: Sansoni editore, 1969) and Alta Macadam, *Blue Guide. Northern Italy. From the Alps to Rome* (London: A. & C. Black, and New York: W. W. Norton, 1984), 381–83.
7. I quote from the re-publication in my *John Ruskin, Walter Pater, Adrian Stokes: England and Its Aesthetes* (Amsterdam: Gordon and Breach, 1997), 36.
8. John Ruskin, *The Stones of Venice* (London: J. M. Dent, 1907), v. 2, 1.
9. Adrian Stokes, *The Quattro Cento: A Different Conception of the Italian Renaissance: Florence and Verona: An Essay in Italian Fifteenth-Century Architecture and Sculpture* (New York: Schocken, 1968 [original 1932]), 7.
10. *The Critical Writings of Adrian Stokes* (London: Thames and Hudson, 1978), II, 156–57. For commentary, see my introduction, "England and Its Aesthetes."
11. *Robert Smithson: The Collected Writings*, Jack Flam, ed. (Berkeley, Los Angeles, London: University of California Press, 1996), 68.
12. Adrian Stokes, *Stones of Rimini* (New York: Schocken, 1969), 171.
13. Michael Fried, *Art and Objecthood: Essays and Reviews* (Chicago and London: University of Chicago Press, 1998), 7.
14. See my *Sean Scully* (London: Thames and Hudson, 2003), Introduction.
15. Fried does not, so far as I am aware, mention Stokes in his writings.
16. Michael Frayn, *Headlong* (Henry Holt: New York, 1999), 39.
17. Freud quoted in J. Laplanche and J.-B. Pontalis, *The Language of Psycho-Analysis*, translated by Donald Nicholson-Smith (New York: W. W. Norton, 1973), 466, which has a useful analysis.
18. Fried, *Art and Objecthood*, 167.
19. Fried, *Art and Objecthood*, 148, quoting Miller quoting Edwards.

20. Michael Fried, *Absorption and Theatricality: Painting & Beholder in the Age of Diderot* (Berkeley, Los Angeles, London: University of California Press, 1980), 103.

21. Fried, *Art and Objecthood*, 128.

22. Fried makes brief, inconclusive remarks in his "Afterword," *Dia Art Foundation: Discussions in Contemporary Culture*, Hal Foster, ed. (Seattle: Bay Press, 1987), 86–87.

23. Stokes, *Stones of Rimini*, 255.

24. Stokes, *Stones of Rimini*, 141.

25. Charles Seymour Jr., *Sculpture in Italy: 1400 to 1500* (Baltimore: Penguin, 1966), 133; Edgar Wind, *Pagan Mysteries in the Renaissance* (New York: W. W. Norton, 1968), 130 n. 5; Stanko Kokole, "*Cognito formarum* and Agostino di Duccio's Reliefs for the Chapel of the Planets in the Tempio Malatestiano," *Quattrocento Adriatico: Fifteenth-Century Art of the Adriatic Rim*, Charles Dempsey, ed. (Baltimore: Johns Hopkins University Press, 1994), 178.

26. Hugh Kenner, *The Pound Era* (Berkeley and Los Angeles: University of California Press, 1971), 107.

27. See Frank Kermode, *Romantic Image* (London and Glasgow, 1971).

28. An earlier version of the present argument, with different focus, appears in my "Art History," *Contemporary Critical Terms in Art History,* R. Nelson and R. Shiff, eds. (University of Chicago Press, 1996): 129–41.

29. Sheldon Nodelman, *The Rothko Chapel Paintings: Origins, Structure, Meaning* (Austin: University of Texas Press, 1997), 303.

30. The key diagram appears in *The Rothko Chapel Paintings*, 273; as Nodelman notes, there is only indirect evidence that his Rothko himself thought in these terms. See my critical discussion, *Rosalind Krauss and American Philosophical Art Criticism: from Formalism to beyond Postmodernism* (Greenwood/Praeger, 2002), ch. 3.

31. Claude Lévi-Strauss, *Structural Anthropology*, translated by Claire Jacobson and Brooke Grundfest Schoepf (New York and London: Basic Books, 1963), 248. His account of this art appears in his *The Way of the Masks*, translated by Sylvia Modelski (Seattle: University of Washington Press, 1982), which in chapter 12 has a defense of his method. I have found Marcel Hénaff's "Chapter 8. The Lesson of the Work of Art" in *Claude Lévi-Strauss and the Making of Structural Anthropology*, translated by Mary Baker (Minneapolis and London: University of Minnesota Press, 1998) useful.

32. In his polemic against Jean-Paul Sartre's Marxism, Lévi-Strauss rejects the claim that cultures with writing, which have a history, are superior in kind to the primitives, as they were then called.

33. Jacques Derrida, *Writing and Difference*, translated by Alan Bass (Chicago: University of Chicago Press, 1978), 287.

34. When Lévi-Strauss discusses Nicolas Poussin's *Et in Arcadia ego*, he adapts a very different approach, seeking sources in the style of an art historian. See his *Look, Listen, Read*, translated by Brian C. J. Singer (New York: Basic Books, 1997), ch. 3.

35. Heinrich Wölfflin, *Principles of Art History: The Problem of the Development of Style in Later Art*, translated by M. D. Hottinger (New York: Dover, nd,), 79.

36. Heinrich Wölfflin, *Renaissance and Baroque,* translated by Kathrin Simon (Ithaca: Cornell University Press, 1967), 38.

37. Heinrich Wölfflin, *The Sense of Form in Art: A Comparative Psychological Study,* translated by Alice Muehsam and Norma A. Shatan (New York: Chelsea Publishing Company, 1958), 52.

38. E. H. Gombrich, *Norm and Form: Studies in the Art of the Renaissance* (London: Phaidon Press, 1966), 93, 90. I discuss this argument in my *Rosalind Krauss and American Philosophical Art Criticism*, ch. 3.

39. Claude Lévi-Strauss, *The Raw and the Cooked*, translated by John and Doreen Weightman (New York: Harper & Row, 1975), 12.

40. Claude Lévi-Strauss, *Tristes Tropiques*, translated by John Russell (New York: Atheneum, 1965), 160.

41. Arthur C. Danto, *After the End of Art: Contemporary Art and the Pale of History* (Princeton: Princeton University Press, 1997), 163, 164.

42. Danto, *After the End*, 162.

With the advance of civilization, a time generally comes in

the case of every people when art points beyond itself. . . .

But if the perfect content has been perfectly revealed in

artistic shapes, then the more far-seeing spirit rejects this

objective manifestation and turns back into its inner self.

This is the case in our own time.

—*Hegel*[1]

INTERLUDE

We have seen how art writing, be it about fictional or real works of art, is a distinctive literary form. Art criticism and history describe art, evaluate it, place it in historical context, analyze it as social commentary, and judge it politically. In art writing, as in the novel, descriptions of paintings are used to tell stories. Like Flaubert, James, and Eco, historians and critics set individual pictures in narratives with beginnings and endings. But where novelists discuss fictional characters, art writers tell true stories about real things. Art writing in fiction and in histories or criticism thus serves quite different functions. *Madame Bovary*, *The Golden Bowl,* and *The Name of the Rose* are fiction, and so Charles Bovary's hat, the Prince's golden bowl, and Eco's medieval library have no more reality than the characters in these novels. It makes no sense to ask whether Flaubert, James, and Eco accurately portray these objects, for no rival novels could better describe this hat, bowl, and library. But unlike these novelists, Schapiro, Clark, Herbert, and Mauner describe the same object, Manet's *Bar at the Folies-Bergére*, and so it makes sense to compare and contrast their accounts.

Philosophy, we have noted, aims to be necessarily true, while literature, by allowing us to metaphorically assume the identity of the hero, is about its reader. Literature[2]

> is not universal . . . as philosophy in its nonliterary dimension aspires to be, nor about what may happen to be the case in just this particular world, as history . . . aspires to be, but rather about each reader who experiences it.

Descartes's *Meditations* begins with a sweeping statement:[3]

> I have realized that if I wished to have any firm and constant
> knowledge in the sciences, I would have to undertake, once and for all,
> to set aside all the opinions which I had previously accepted,

which is *about* every reader. You are meant to test this claim by performing these meditations yourself, taking on the role of this disembodied "I" who meditates. If Descartes is right, then you can verify his results. Reason is universal, and so this statement of a male seventeenth-century Catholic applies to everyone.

Proust's *Remembrance of Things Past* also begins in the first person:[4]

> For a long time I used to go to bed early. Sometimes, when I had put
> out my candle, my eyes would close so quickly that I had not even time
> to say to myself: "I'm falling asleep."

But this statement is not necessarily about you, Proust's reader, for you may not have gone to bed early, suffered from insomnia, and demanded a good-night kiss from your mother. You might identify with Marcel, finding common elements in your experience, but doing that is not required to understand Proust's novel, which is only about its hero. In philosophy and fiction the indexical pronoun "I" thus functions differently. Descartes's discussion of the evil demon,[5]

> I will therefore suppose that, not a true God . . . but a certain evil spirit
> . . . has bent all his efforts to deceiving me. I will suppose that the sky,
> the air, the earth, colors, shapes, sounds, and all other objective things
> that we see are nothing but illusions and dreams that he has used to
> trick my credulity,

deals with issues—the nature of madness, the possibility of knowledge— of central importance also in *Don Quixote*:[6]

> They who have enchanted me, have assumed that appearance and like-
> ness; for enchanters can easily take what form they please . . . to involve
> you in such a labyrinth of imaginations, that you shall not be able to
> find your way out though you had Theseus's clue.

But while Descartes's *Meditations* is about the nature of reason, Cervantes's novel only describes the fictional Don Quixote.

We thus make an important distinction between writing that aims for truth, and rhetoric, which merely seeks to be persuasive. "Nothing should be done for the sake of words only," Quintilian says,[7]

> Since words were invented merely to give expression to things: and those words are most satisfactory which give the best expression to the thoughts of our mind and produce the effect which we desire upon the minds of the judges.

The successful orator's gift is

> to be able to set forth the facts on which we are speaking clearly and vividly. For oratory fails of its full effect . . . if its appeal is merely to the hearing, and if the judge merely feels that the facts on which he has to give his decision are being narrated to him, and not displayed in their living truth to the eyes of the mind.

Quintilian also describes the art writer, who is concerned that we see the facts in certain ways. Like the orator, the art writer is concerned with[8]

> instructing, moving and delighting his hearers, statement of facts and argument falling under the head of instruction, while emotional appeals are concerned with moving the audience.

Diderot, Baudelaire, and Danto instruct, move, and delight, encouraging us to take an attitude toward the art that they describe. As Michael Baxandall says, "art criticism . . . is usually epideictic rhetoric: that is, it discusses art in terms of value, praise, or dispraise, and demonstrates the speaker's skill."[9] The art writer merely offers one perspective, knowing that other interpretations often are possible. Commentators who do not share Tim Clark's politics, or views about gender and modernism, may understand *A Bar at the Folies-Bergére* very differently. And in alternative histories of modernism, other art can be prominent. Art writing aims neither for necessary truth, like philosophy, nor for being about its reader, like literature. Extracted from its context, a passage from a philosophical treatise may be indistinguishable from a portion of a novel, or an excerpt from art writing. And so, to understand the differences between philosophy, literature, and art writing, we need to understand how its context determines the function and meaning of this writing.

Indiscernibles are important in that investigation, for they allow us to subtract the effect of one context and replace it with another. Both Descartes and Cervantes present seventeenth-century ideas of madness, but they make very different use of this information. When Foucault speaks of *Don Quixote* as[10]

> the first modern work of literature, because in it we see the cruel reason of identities and differences make endless sport of signs and similitudes; because in it language breaks off its old kinship with things,

and says of Descartes's *Meditations*,

> in madmen, it is medicine which must effect the awakening, transforming the solitude of Cartesian courage into an authoritarian intervention, by the man awake and certain of his wakefulness, into the illusion of the man who sleeps waking,

he deliberately undercuts our well-entrenched distinction between literature and philosophy.

An example brings out the importance of that distinction. Imagine a novelist's hero describing her fear that

> *a certain evil spirit . . . has bent all his efforts to deceiving me. I will suppose that the sky, the air, the earth, colors, shapes, sounds, and all other objective things that we see are nothing but illusions and dreams that he has used to trick my credulity.*

This description of her mental state, merely part of the story, does not call upon us to perform the Cartesian Meditations. But Descartes's words—

> a certain evil spirit . . . has bent all his efforts to deceiving me. I will suppose that the sky, the air, the earth, colors, shapes, sounds, and all other objective things that we see are nothing but illusions and dreams that he has used to trick my credulity—

are about you, his reader, when you perform that meditation.

We love reading Flaubert, James, and Eco because they tell engrossing stories about characters they have created. And we care about philosophy because it tells us how the world is and how to live. Literature and philosophy satisfy deep human needs and so, not surprisingly, they have been much analyzed and often compared. By contrast, art writing remains

a relatively unexamined literary genre. That is unfortunate, for apart from its intrinsic value, its intimate relationship with museums and galleries gives this literature a very important role in contemporary culture.

In the eighteenth century, the everyday lives of philosophers were drastically transformed when philosophy became an academic discipline. Descartes was a gentleman and Leibnitz a courtier, but Kant, Hegel, and most other later major philosophers were professors. And at that time, democracy, mass culture, and printing completely transformed the writer's social role. But these changes need not affect how we read the arguments of pre-modern philosophers or analyze old literature. Philosophers compare the arguments of Descartes, Leibnitz, Kant, and Hegel, and literary historians contrast stories by Homer, Virgil, and Dante with those of Jane Austen, George Eliot, and Virginia Woolf. Philosophy and literature thus are treated as continuous traditions. With art writing, the situation is different, for contemporary art criticism and history differ in kind from earlier art writing.

Vasari devotes one long paragraph to Piero della Francesca's frescoes in San Francesco, Arezzo.[11] After mentioning that Piero inherited the commission, he explains that the fresco, "full of admirable ideas and attitudes," tells the story of the true cross.[12] The clothes of the woman next to the queen of Sheba "are depicted in a very delightful and novel way"; there are many "very true and lifelike portraits"; the Corinthian columns are "magnificently well proportioned"; and the peasant shown listening "could not be more convincing." Other admirable details include the dead man "brought back to life at a sign of the cross," the night scene "where Constantine dreams of victory," and the battle showing "the wounded, the fallen, and the dead in scenes of almost incredible carnage." Vasari mentions the gleam on the combatants' weapons, the foreshortened horses, and the rider who is "half nude and half clothed." Perhaps he found these particular details eye-catching, maybe he thinks they have special meaning, but conceivably he merely happened to recall them.

Unlike Vasari, modern commentators identify the order of Piero's scenes, describing them in great detail. Marilyn Lavin, for example, devotes twenty-six fully illustrated pages, not counting her hundred and

fifteen footnotes dealing with the earlier literature, to these paintings. She compares earlier fresco cycles, identifies the structure of Piero's composition, cites pictorial sources for many details, and explains the meaning of the pictures in historical context. In showing this ancient story, Piero may also be painting an allegory about contemporary politics, showing the fall of Constantinople to the Turks. A great deal of erudite argumentation is now devoted to this hypothesis, which is not discussed by Vasari. Since the *Lives* lacks illustrations, perhaps for him questions about the ordering of Piero's scenes are not of especial importance. This great visual thinker had concerns very unlike those of present-day art writers, and so his *Lives* differ from Lavin's history almost as much as Piero's frescoes differ from the new art in our galleries.

Art writing describes, interprets, and reports on the art on view in galleries and museums, and so we need to analyze its relationship to the art museum and the art gallery. This literature is a distinctive product of modernist society, for only when art galleries and museums were created was our basic division between art criticism and art history established. When Vasari writes about Giotto and Piero, he is, in effect, a historian; when discussing his friend Michelangelo, he writes as a critic, devoting more words to Michelangelo than to earlier artists, but without making our distinction between criticism and art history.

In a very influential, much debated statement, Friedrich Nietzsche claims that[13]

> there is *only* a perspective seeing, *only* a perspective "knowing"; and the *more* effects we allow to speak about one thing, the *more* eyes, different eyes, we can use to observe one thing, the more complete will our "concept" of this thing, our "objectivity," be.

There is no objective knowledge, no pure presence, no entirely impersonal way of looking at the world. Visual art must always be interpreted. Whatever our ultimate judgment on Nietzsche's perspectivism, it provides a very plausible description of verbal representations of visual art. Often there is no one way that a work of art is, but many ways that it can legitimately or plausibly be described. Art writers can only provide a

perspective, which means, using the terms of the Overture, that interpreting art requires setting it in context. That there is no neutral way of describing a work of art is compensated for by the perspectives provided by competing art writers.

Novels usually do not require illustrations, for a picture of Flaubert's hat, James's golden bowl, or Eco's library would merely supplement the written account. But the art described by historians exists, and so may be described in more than one way. In art history, reproductions are essential for following the argument. Art historians and critics, in teaching us to see the art in museums and galleries, inspire visual thinking, teaching us to find and evaluate relationships amongst works of art. To understand the claims of these art writers, it follows, we need to consider their perspectives and examine the interests served by their writings. Borrowing two queries from Michel Foucault's extremely Nietzschian essay "What Is an Author?," let us ask:[14]

> Who do our art writers write for?

and

> What functions does art writing serve?

Affirming perspectivism, Foucault observes that

> historians take unusual pains to erase the elements in their work which reveal their grounding in a particular time and place, their preferences in a controversy—the unavoidable obstacles of their passion. Nietzsche's version of historical sense is explicit in its perspective . . .

When different commentators interpret one painting, we may wonder whose account is most true to the object. But that question, we have seen, is hard to answer, for each interpretation comes embedded in a distinctive context. We might better consider what function this literature serves. Art writing, I would suggest, aims to initiate and support discussions about art. The more richly suggestive perspectives we have, the more productive will be our conversations in museums and art galleries.

In examining beginnings and endings, and the structuralists' attempt to bypass narratives, we described formal features of art writing. But now that

investigation needs to be supplemented by discussion of the institutions associated with this writing. Art-history writing, developing at the same time as the art museum, structures historical presentations of art. Art criticism evaluates the contemporary art displayed in galleries. Aesthetics identifies the entire field of art, past and present. Just as art writing is divided into art criticism, which typically is journalistic reporting, and art-history writing, which provides a historical perspective on older art, so art world spaces are divided into galleries where contemporary art is shown, and museums, which provide historical visual narratives.[15] The primary goal of the museum is to tell the story of art from its origins up almost to the immediate present. The art gallery displays contemporary art, and so enables the visiting critic to evaluate new painting and sculpture aspiring to enter the museum. Museums and galleries thus supplement one another, as do the writing associated with them, art history, and criticism.

And aesthetic theory needs to be considered as well. Focusing on art's historical development, we look to the museum and then the gallery. But when describing the entire body of art, we turn to aesthetics. Art museums and gallery present art diachronically, displaying that historical development described in the narratives of art history and art criticism. Aesthetics examines the same group of objects synchronically, identifying the essence of art. For the philosopher, all art is contemporary art, for he seeks a definition of art encompassing everything in galleries and museums. Art historians analyze the development of art; art critics evaluate contemporary art; and philosophers, looking at the same group of objects from an atemporal vantage point, explain why these artifacts deserve discussion by historians and critics, telling us why they are art.

These three institutions, the public art museum, the gallery, and modern aesthetic theory, all originating in the late eighteenth and early nineteenth centuries, are distinctive products of modernist culture. The historically organized art museum, which arises in the middle of the eighteenth century, has as its great model the Revolutionary Louvre. The art gallery, anticipated by the Salons held in the Louvre devoted to

contemporary art in the 1760s, develops a few decades later. And the historical theory of art's definition was worked out by Hegel in the 1820s in response, in part, to Winkelmann's art history. Once public museums expanded to include art from all cultures, galleries were needed to display new art aspiring to enter the museum. And as radically new forms of painting and sculpture were discovered and invented, aesthetic theory had to account for this novel art. In turning, now, to study these institutions, we will provide an essential supplement to our earlier account of art writing.

Notes to the Interlude

1. G. W. F. Hegel, *Aesthetics. Lectures on Fine Art*, translated by T. M. Knox (Oxford: Clarendon Press, 1975), 103.

2. Arthur Danto, *The Philosophical Disenfranchisement of Art* (New York: Columbia University Press, 1986), 154.

3. René Descartes, *Meditations on First Philosophy*, translated by Laurence J. Lafeur (Indianapolis and New York: Library of Liberal Arts, 1960), 17.

4. Marcel Proust, *Remembrance of Things Past*, translated by C. K. Scott Moncrieff and Terence Kilmartin (New York: Vintage, 1982), I, 3.

5. Descartes, *Meditations*, 22.

6. Miguel Cervantes, *Don Quixote*, translated by Charles Jarvis (Oxford: Oxford University Press, 1992), 432.

7. *The Institutio Oratoria of Quintilian*, translated by H. E. Butler (Cambridge, Massachusetts: Harvard University Press, 1976), 195, 245.

8. Michael Baxandall, *Giotto and the Orators* (Cambridge: Cambridge University Press, 1971), 181.

9. Baxandall, *Giotto and the Orators,* 45.

10. Michel Foucault, *The Order of Things: An Archaeology of the Human Sciences,* translated by Anonymous (New York: Vintage, 1973), 48–49; Michel Foucault, *Madness & Civilization: A History of Insanity in the Age of Reason,* translated by Richard Howard (New York and Toronto: Mentor, 1967), 152.

11. Here I extend the discussion of my *Principles of Art History Writing* (College Park and London: Pennsylvania State University Press, 1991), 27–29.

12. Giorgio Vasari, *Lives of the Artists*, translated by George Bull (London: Penguin, 1965), v. 1, 194–95.

13. Friedrich Nietzsche, *On the Genealogy of Morals*, translated by Walter Kaufmann and R. J. Hollingdale (New York: Vintage Books, 1967), 119.

14. Michel Foucault, *Language, Counter-Memory, Practice: Selected Essays and Interviews*, translated by Donald F. Bouchard and Sherry Simon (Ithaca: Cornell University Press, 1977), 138, 156–57.

15. Here we discuss ideal types. Many museums display contemporary art, and some galleries occasionally exhibit older works of art; and of course, there are galleries devoted exclusively to old master art.

PART TWO:
Doing Things with Words

By far the most valuable things which we know or can imagine, are certain states of consciousness, which may be roughly described as the pleasures of human intercourse and the enjoyment of beautiful objects.

—G.E. Moore[1]

CHAPTER FOUR:
Museum Narratives

Open any history of art almost at random, and you will probably find narrative sentences. In his account of the High Renaissance, Sydney Freedberg, for example, writes:[2]

> Leonardo's invention of the idea of style that was to shape so much of the history of the Cinquecento occurred more than two decades before the century began. . . . The Cinquecento was a quarter of a century away when, close to 1475, Leonardo demonstrated the idea of what we recognize to be the core of the High Renaissance classical style. . . . His demonstration is within a painting otherwise mainly by Verocchio, *The Baptism of Christ*. . . . This was the first event in the history of classicism in the Christian world that resembles, in its essence, the classicism of the antique Golden Age.

In 1475 no one as yet could have seen *The Baptism of Christ* as the first painting in the history of Christian classicism. After reading Freedberg's *Art in Italy 1500 to 1600*, it is natural to imagine a museum show, "The High Renaissance and Its Sources." Picture *The Baptism of Christ* in the first room, and then, in successive galleries, later paintings by Leonardo, Michelangelo, and Raphael, with some sculpture from antiquity in the last room.

When, similarly, Sherman Lee writes in his survey of Asian art that *The Buddha Taming the Maddened Elephant* (late second century A.D.), in the Government Museum, Madras, is in "a style which will greatly influence the development of South Indian Hindu sculpture in the Pallava Period, A.D.500 to 750," he uses a narrative sentence.[3] No one could have known that in the late second century. Imagine that the Cleveland Museum of Art

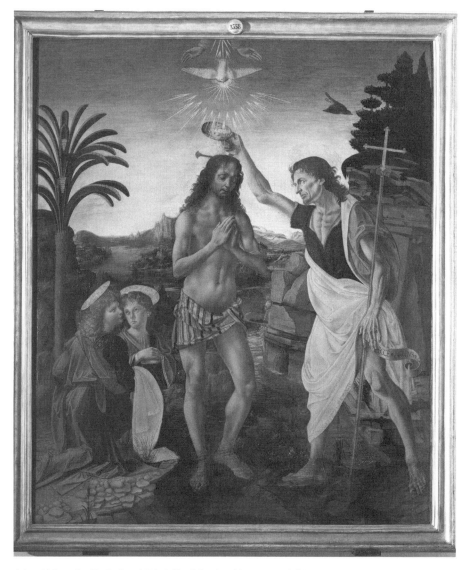

Andrea del Verocchio, *The Baptism of Christ* (with collaboration of Leonardo da Vinci for the Angels). Uffizi Gallery, Florence, Italy. Courtesy Scala/Art Resource, NY.

organizes attribute to its former director, the exhibition "Sources of Southern Indian Hindu Sculpture." In the first room is *The Buddha Taming the Maddened Elephant*. Successive galleries contain masterpieces of sixth- and seventh-century Indian sculpture.

Narrative sentences add to our knowledge of individual works of art by placing them in historical perspective. Had the Italian art world

been destroyed in 1500 by Muslim invaders, there would have been no High Renaissance, and so Freedberg's narrative sentence would not be true.[4] In that world, *The Baptism of Christ* would have a quite different historical significance. And had the history of India been different, the sculpture influenced by *The Buddha Taming the Maddened Elephant* would not exist. Here, then, our analysis offers fine examples of Danto's indiscernible visual objects. Compare two visually identical pictures, *The Baptism of Christ*, one the last altarpiece painted in this alternative world before the Muslims occupied Christian Italy, the other the painting we know, Verocchio's proto–High Renaissance masterpiece as described by Freedberg. These two works of art would have very different significance. The same point can be made about Lee's account. *The Buddha Taming the Maddened Elephant* would have to be described differently had there been no sixth- and seventh-century South Indian Hindu sculpture.

The identities of *The Baptism of Christ* and *The Buddha Taming the Maddened Elephant* are not entirely bound up with their roles in Freedberg's and Lee's art historical narratives. We see in the Uffizi that physical object made by Verocchio and Leonardo, and in Cleveland's show the sculpture of a now unfortunately anonymous Indian master. These artists certainly did not know what influence their art would have, and so there is a certain legitimate but unavoidable artificiality in treating *The Baptism of Christ* and *The Buddha Taming the Maddened Elephant* as Freedberg and Lee do, as the first objects in extended historical sequences. Setting art in the explicit sequence of the historian, or the implied story of the museum curator, changes decisively how we describe and understand those individual objects.

Imagining alternative histories of Italy and India is a natural way of generating indiscernibles; we need only consider how history could be different in order to subtract the contribution made to our knowledge by the narrative sentences. Art writers often describe individual works of art in terms the artist would acknowledge. Much can be said about the figures depicted in *The Baptism of Christ* and *The Buddha Taming the Maddened Elephant*, the compositions, and how the artists handled their media. Freedberg's and Lee's

narrative sentences do something more, offering perspectives unavailable to the original artists. By displaying art in historical sequences, museums make visually available this knowledge embedded in narrative sentences.

A successful exhibition displays original visual thinking, presenting previously unrecognized visual connections between works of art. Seeing Caravaggio's sources in the Metropolitan Museum's 1984 retrospective made his real originality more apparent. After viewing Matisse's pre-stylistic paintings in the Museum of Modern Art, New York, in 1992, his early masterpieces appeared more original than when seen in isolation. Looking at the early Poussins at the Kimbell Museum, Fort Worth, in 1989, which included some controversial attributions, the difficulty of reconstructing his development became obvious to connoisseurs.[5] Exhibitions devoted to minor figures may help change their status, as when recently a large show at the Metropolitan devoted to Pierre-Paul Prud'hon was a revelation.[6] And a well-planned exhibition can aid an established artist's reputation.[7] But poorly selected retrospectives can be devastating.[8]

By identifying causal connections, narrative sentences suggest how to place works of art in historical sequences. And not just special exhibitions, but the entire ordinary organization of our typical museums depends upon narrative sentences. We expect paintings and sculptures to be shown in historical order because we think that the Italian High Renaissance really leads to the baroque, and French modernism moves toward abstract expressionism. Our museums are organized as if to illustrate a book survey of the history of art. Art history gives a well-developed vocabulary for individual paintings, terminology describing composition, iconography, and stylistic features. But we lack a similarly accessible lingua franca to describe groupings of pictures, the gallery architecture, and sequences of galleries, for art historians[9]

> have rarely addressed the fact that a work of art, when publicly displayed, almost never stands alone: it is always an element within a permanent or temporary exhibition created in accordance with historically determined and self-consciously staged installation conventions.

But every visually sensitive museum visitor is aware of these experiences.[10]

Museum displays matter because we tend to visually relate individual works of art on display to the paintings, sculptures, and architecture surrounding them. Great hangings make good paintings look better, but awkward installation diminishes art. The Barnes Foundation shows Matisse's *Bonheur de vivre* on the stairs, seemingly making it all but impossible to properly view the picture. By contrast, in the Prado, Velázquez's *Las Meninas* is at the far end of the largest gallery, directly off the middle axis; at the Norton Simon Museum in Pasadena you see Giovanni Battista Tiepolo's *The Triumph of Virtue and Nobility over Ignorance* at the end of a very long sequence of galleries of European painting; and in the Philadelphia Museum of Art, Cézanne's *Large Bathers* is visible from the far distance as you walk through the rooms devoted to impressionism, towards the section presenting modernism. These excellent hangings spotlight masterpieces.

A long critical tradition charges that museums, by taking older art out of its original context, change or perhaps even destroy entirely its original meaning. Thus Martin Heidegger writes:[11]

> The works themselves stand and hang in collections and exhibitions. But are they here in themselves as the works they themselves are, or are they not rather here as objects of the art industry? . . . Even when we make an effort to cancel or avoid such displacement of works . . . the world of the work that stands there has perished.

Hans Sedlmayr claims:[12]

> [From] the old churches, castles and palaces there issues from the end of the eighteenth century onward an endless stream of works of art each . . . fragments of what once had been a coherent whole. Torn from their mother soil, they wander, like forlorn refugees, to take shelter in the art-dealer's market or into the soulless institutional magnificence of public or private art galleries. In the museum. . . . things which were originally integral parts of a single whole are shown forth after this heartless process of dismemberment as exhibits. . . .

And, working with a very different political perspective, Douglas Crimp says:[13]

> Art as we think about it *only came into being* in the nineteenth century, with the birth of the museum and the discipline of art history. . . . The

> idea of art as autonomous . . . as destined to take its place in *art* history, is a development of modernism.

They describe this change in very negative terms.

The claim that art is not preserved in museums has been made for as long as there have been public art museums. As soon as the modern Louvre was created during the French Revolution, it was argued that "removal of ancient and Renaissance works from their living historical context destroys their meaning."[14] In the nineteenth century, Théophile Thoré summarized this melancholy tradition:[15]

> Museums have never existed when art is in good health and creative vitality flourishes. Museums are no more than cemeteries of art, catacombs in which the remains of what were once living things are arranged in sepulchral promiscuity.

Certainly Heidegger, Crimp, and these other commentators are right to point to ways in which old master sacred art is transformed, and in some ways diminished, in museums.[16] But what should also be noted, are the manifold ways in which these displays contribute to our understanding of older visual art. Setting in near proximity objects often originally far apart, museums and illustrated art writing enable us to see visual relationships difficult for anyone but the most indefatigable traveler to identify.

Modern survey histories give a fuller picture of the baroque than was accessible to anyone but very visually erudite art lovers of that era. And displaying that older art alongside new paintings and sculptures, as the Baltimore Museum of Art recently did, gives suggestive new perspectives.[17] That historical narratives can be rewritten, and museums rehung, reminds us that visual thinking is always open to revision. Creative curators who continually find new ways to display the relations between present and older art thus demonstrate the plausibility of perspectivism. Observing that putting Duchamp's *Fountain* and Warhol's *Brillo Box* in museums makes them works of art, in the Overture we drew an analogy with the ways that writing sets art in context. Now we can generalize that analysis. Setting art in contexts, creating comparisons, or displaying historical sequences, museum displays provide implicit narrative interpretations. The unit of discourse in

art history is art presented in literary context, and the unit of discourse in museums is art set in physical context. Just as we cannot entirely subtract *A Bar at the Folies-Bergére* from the particular interpretative contexts provided by Schapiro, Clark, and the other interpreters, so in museums we cannot totally abstract one painting from its position in the display. But we can place that painting in different hangings, and thus subtract the effects of any one installation.

Museum exhibitions are essential to connoisseurs, as we see when Denis Mahon argues against Anthony Blunt's view that Nicolas Poussin's *Inspiration of the Poet* and *Martyrdom of St. Erasmus* were done at nearly the same time:[18]

> Certainly the placing of the forms in relation to each other is quite strikingly different, with the angular and abrupt recessional superimpositions of the one [*St. Erasmus*] contrasting forcibly with the balanced harmonies within the plane which are typical of the other . . . In the *Inspiration* the light hovers gently over the forms, caressing them; a passage lit with such delicacy as that centering round Apollo's lyre is not to be found in the *St. Erasmus*, where the light strikes forcefully, often bringing out brilliant chords of colour. The scrupulous care taken to articulate the draperies of the Muse in the *Inspiration,* in which the lighting plays so helpful a part, finds no echo in the *St. Erasmus.*

Since *The Inspiration of the Poet* normally is in the Louvre, and *Martyrdom of St. Erasmus* in Rome, retrospectives were almost essential for Mahon. Connoisseurs teach us to see what Ludwig Wittgenstein called family resemblances, the visual relationships amongst these diverse Poussins.

And when works of art are not moveable, art historians rely upon good color reproductions to display visual thinking. Caravaggio's *St. John the Baptist with a Ram*, Rome, Dora Gallery, Freedberg notes, involves[19]

> aggression toward the great deities of sixteenth-century painting, Michelangelo in particular. A deliberate translation into realist prose of overt classic sources on the sacred *Sistine Ceiling*, the *Baptist* is not just anti-ideal; it is derisive irony . . . to which its contemporary audience would have been more susceptible than we.

Freedberg reproduces the Caravaggio and one figure from the group *Ignudi around Sacrifice of Noah* on the Sistine ceiling.[20] Since picking out

a detail from Michelangelo's elaborate ceiling and comparing it to the Caravaggio some distance across Rome is not easy, only unusually visually sensitive viewers would have been susceptible to this derisive irony. Unlike Michelangelo's ceiling, many masterpieces are movable, and so assembling them in museum narratives adds greatly to our visual knowledge.

Schapiro and his rivals offer perspectives on *A Bar at the Folies-Bergére*. Freedberg and Lee suggest how to view sequences of works of art. And so if their historical comparisons are convincing, we should be able to see these visual connections. Just as it is not a fact that Manet's painting embodies the political commentary identified by Tim Clark, so too it is not a fact that *The Baptism of Christ* and *The Buddha Taming the Maddened Elephant* have the historical significance given them by Freedberg and Lee. Like Clark and his rivals, Freedberg and Lee offer one possible perspective. Identifications of the origin of the High Renaissance or of South Indian Hindu sculpture are likely to be controversial. And when young art historians give different accounts of *The Baptism of Christ* and *The Buddha Taming the Maddened Elephant*, offering different narrative sentences, their commentaries may inspire other exhibitions.

The philosopher offers abstract arguments, spelled out in so many words, which then have to be accepted or rejected. Mahon the connoisseur asks us to see a stylistic connection between successive Poussins; Clark the social historian to see how *A Bar at the Folies-Bergére* fits into his political context. And Freedberg and Lee, narrative historians, ask that we see *The Baptism of Christ* and *The Buddha Taming the Maddened Elephant* as first items in historical sequences. In asking us to see visual connections, these art writers identify similarities amongst distinct, different things, aware that we may choose to reject their interpretation in favor of some alternative perspective. The art writer and curator propose that we adopt their perspective, while knowing that alternative points of view are possible.

When a philosopher asks that we "see" her argument, she speaks metaphorically. When an art writer voices that same demand, he is being literal. Testing Freedberg's and Lee's arguments requires seeing their

visual comparisons, not just reading. The plates in their books are useful didactic devices, but the real test of their claims is confrontation with the artifacts they describe. The narrative sentence, *"The Baptism of Christ* is the first painting in the history of Christian classicism," makes explicit Freedberg's historical vision. But our imaginary exhibition "The High Renaissance and Its Sources" only implies that statement. When critically reading Freedberg's *Art in Italy 1500 to 1600*, you cannot avoid evaluating his analysis, but in "The High Renaissance and Its Sources" you might focus exclusively on *The Baptism of Christ*, tuning out the nearby High Renaissance paintings. A viewer in Cleveland, similarly, might attend only to *The Buddha Taming the Maddened Elephant*, avoiding looking across to its connection with the "Sources of Southern Indian Hindu Sculpture."

Art museums set objects in sequences. A stroll through the galleries is a narrative under another name, for you need but describe what you see to construct a historical commentary. As Philip Fisher has observed, there is a strong analogy between experiencing such sequences of works of art and reading the historical accounts provided by art writers.[21]

> That we walk through a museum, walk past the art, recapitulates in our act the motion of art history itself, its restlessness, its forward motion, its power to link. . . . In so far as the museum becomes pure path, abandoning the dense spatial rooms of what were once *homes*, or, of course, the highly sophisticated space of a cathedral, it becomes a more perfect image of history. . . .

Unlike typical collectors, pre-modern museums, or cathedrals, our public museums tend to display art in historical order.

Just as art history books have successive chapters, so museum gallery rooms are organized in chronological order. And just as an exhibition needs a starting point and conclusion, so an art writer needs a beginning and end for her narrative. Like art history writing, museums thus translate groupings of visual works of art into temporal structures. The floor plan of the museum and the narratives of the art writer are unavoidably interconnected because one function of art writing is to organize museums. Art writing employs narrative sentences—and the structure of the typical

Level 1

Level 2

Lower Level

museum exemplifies these causal connections, linking objects from the origin of art up almost to the immediate present.

Ideally our museum narratives begin with the Egyptian and Greek art of antiquity, show Roman sculptures and paintings, take us through the Christian Middle Ages, and then move into galleries devoted to the Renaissance, the baroque, and Neo-classicism arriving, finally, at rooms showing modernist and contemporary art. Of course, no museum fully duplicates the standard art history surveys, the admirable museums without

walls by Gardner, Gombrich, or Laurie Schneider, which walk undergraduates through the history of art, for even the grandest collections are limited by the happenstance of local collecting traditions. But ambitious museums aim to approximate this ideal, filling gaps in their collections to present major examples of art from all of these periods.

In surveys of world art history, it is hard to make smooth transitions from the story of art in Europe to narratives about painting and sculpture in Asia. Museums therefore typically present the story of Asian art in contiguous rooms, separate from those devoted to European art, with selective links to the decorative arts, painting, and sculpture of China, Japan, and India. Once curators believed that not only Renaissance Italy, but also Spain, Germany, and other European countries produced important painting and sculpture; and that the arts of India, China, and Africa deserved attention, then the art museum expanded to include visual artifacts from all of these human cultures.

Sometimes conservatives argue that the demand that museums show the contributions of all cultures, not just Europe, is a newfangled desire for political correctness. The art historian observing the "Mongol types" in Pisanello's fresco *St. Seorge*, St. Anastasia, Verona (1440), or the cufic writing in Duccio's *Rucellai Madonna* in the Uffizi (1285) will think differently.[22] The history of European art is unavoidably intermingled with the larger story of art. But this is not, of course, to say that museums present a peaceful history. Pisanello depicted Asian slaves, and Muslims were often at war with Duccio's Christian culture. Indeed, the great collections of non-European art in American and European museums are a legacy of colonialism. A plaque in the Louvre near the entrance to the galleries displaying art from cultures without writing, says that now this sculpture can enter into dialogue with the arts of Europe. True enough, but as yet that dialogue occurs only in Paris, not in French-speaking Africa.

Describing the ways in which Vermeer's *Woman Standing at a Virginal* (1672) looked different when its position in the National Gallery, London, was changed, Ivan Gaskell speaks of "how meaning might be generated by the juxtaposition of such objects" as works of art.[23] "No object," he notes,

"is perceived in isolation. . . ." Once a hanging arrangement is familiar, it may be taken for granted. And so one useful way to understand installations is to study their history, or imagine how they might be different. In the 1970s, Piero della Francesca's *Baptism of Christ* was in a room of Pieros to the left of the entrance of the National Gallery, London, immediately before the galleries devoted to Italian painting. In the new Sainsbury Wing, *The Baptism of Christ,* flanked by Piero's *Nativity* and *St. George*, is alongside Italian and Northern fifteenth-century paintings.[24] By stressing links between Southern and Northern European art, this new hanging suggests a different interpretation of *The Baptism of Christ*. In his book on Piero, Kenneth Clark, onetime director of the National Gallery, links the angels to Domenico Veneziano and Masolino; the cool color to Vermeer and Corot; and the unity of "pattern with depth" to Cézanne.[25] Perhaps, then, some curator will rehang *The Baptism of Christ* in such an installation.

When a painting is exhibited in a museum and described in art-history writing, how we understand it can depend in part upon what other art we link it with. In art writing, one painting is linked with other art by a written narrative. And in museums, connections are created by the floor plan, which visually relates that work of art to others. Since art writing and museums accomplish the same task in different ways, it is unsurprising that they both originated in the late eighteenth century.[26] In antiquity, Pliny wrote a long history of art, and in 1550 Vasari published his *Lives*. These books did not bring about the proliferation of art writing, nor the creation of museums like ours. But in the late eighteenth century, there was a decisive change in sensibility. The first museums organized along historical lines appeared just before the old regime ended, when royal museums and the pope's collections were opened to the public. And after the Revolution, the Louvre was turned into a public museum filled with looted art.[27]

Recent historians of the pre-modern museum describe *Kunstkammers* and *Wunderkammers* in which precious stones, rare fossils, stuffed animals, scientific apparatus, jewels, and works of art were intermingled.[28] These private collections blurred our distinction between art museums and

Titian Room, *Rape of Europa*. © Isabella Stewart Gardner Museum, Boston.

natural-history museums, were generally accessible only to gentlemen, and lacked the historical organization we expect in museums. The creation of the modern art museum depended upon a clear distinction between visual art and the animals, minerals, and other artifacts transferred to the natural-history museum. Just as the survival of constitutional monarchies in England, Norway, and Sweden reveals the otherwise long-vanished old regime, so major old-fashioned private collections, such as the Palacia Liria, Madrid, with its great paintings hung amongst family souvenirs and photos of the owners, now appear survivals of pre-modern museums.[29] The Isabella Stewart Gardner, Boston, and the Frick Art Gallery, New York, like English stately homes, show the personal tastes of the owners. In the Gardner, you find her Rembrandt *Self-Portrait* on the second floor, and ascend another floor to *Europa*. Using silk from one of her wedding dresses to set off *Europa* may comment on this great picture showing a rape.[30] In the grand gallery of the Frick, Rembrandt's *Polish Rider* is set close to Venetian Renaissance art, Constables and Turners, and a Vermeer. Like most pre-modern museums, these institutions show visually pleasing groupings of paintings hung without regard to historical connections.

Our public museums rationalize the older, idiosyncratic personal installations. Before the Revolution, the Louvre was the king's palace, but although its intricate relationship with the monarchy, Napoleon, and French politics, is evident in the older galleries, for two centuries this radically transformed institution has been a public space.[31] Many older European museums originally were princely homes, but usually newer art galleries, like most museums in America, were designed as museums. Traditional museums like the Morgan Library, New York, or the Wallace Collection in London, are former houses of very rich men. In public museums like the National Galleries in London and Washington, or the Metropolitan in New York, donors are allowed to name galleries, but these institutions otherwise are anonymous public spaces, like libraries or train stations.

A private collection, however grand, serves the pleasures of its owner and his guests. Gardner and Frick, like Charles Saatchi who has his own museum

in London, bought what they liked, without seeking to assemble a represen-
tative sampling of world art. But major museums aspire to show painting,
sculpture, and decorative art from all cultures, providing a comprehensive
historical panorama. The public character of the modern art museum thus
aligns it with art-history writing. Many public institutions are decisively
influenced by the tastes of a few important collectors and curators. Gifted
connoisseurs assembled great Chinese collections in Cleveland and Kansas
City. The Robert Lehman pavilion in the Metropolitan, irrationally segre-
gating his collection, shows the power of one rich man, and the Norton
Simon Museum displays the admirable taste of one willful person. But gen-
erally even the most forceful personalities are eventually submerged in these
public museums. Modern museums in this way are like corporations, which
preserve the names of the great capitalist entrepreneurs without maintaining
much connection with their founders.

Which came first, historical narratives about art or our modern muse-
ums? Since our art museum and art history writing were created at about
the same time in response to broader historical trends, that question is
hard, perhaps impossible to answer. What matters is that historical ways of
thinking about art appeared simultaneously in both art-history writing
and in museums.[32] The key philosophical account of this transition appears
a couple of decades after Napoleon's Louvre, in the section of Hegel's lec-
tures on aesthetics entitled "Historical Development of Painting," which
discusses the museum:[33]

> Unless we bring with us in the case of each picture a knowledge of the
> country, period, and school to which it belongs and of the master who
> painted it, most galleries seem to be a senseless confusion out of which we
> cannot find our way. Thus the greatest aid to study and intelligent enjoy-
> ment is an *historical* arrangement.

Mentioning that the Berlin museum was about to open, he notes that

> in this collection, there will be clearly recognizable not only the exter-
> nal history of painting . . . but the essential progress of the inner his-
> tory. . . . It is only such a living spectacle that can give us an idea of
> painting's beginning . . . of its becoming more living, or its search for
> expression and individual character.

Visitors will see the visual history of the succession of European cultures, each expressing themselves in their own terms.

In Italian painting Hegel finds the "peaceful deep feeling of the soul" found also in the poetry of Petrarch and Dante.[34] "Only through this rich, free, perfect beauty were the Italians enabled to produce the ideals of antiquity amid those of the modern world." Without using the word, Hegel identifies the Renaissance. Italian painters were able to show "pure deep feeling and piety" because "men nearly contemporaneous with the painters themselves were canonized." The Flemish masters, by contrast, "could not rise to the same beauty of form and freedom of soul." They, rather, show "the greatest uglinesses and deformities which are external forms corresponding to an inner corruption of heart." Hegel's fullest characterization of a visual culture is his justly famous set piece on Dutch art:[35]

> Satisfaction in present-day life, even in the commonest and smallest things, flows in the Dutch from the fact that what nature affords directly to other nations, they have had to acquire by hard struggles and bitter industry . . . they are a nation of fishermen, sailors, burghers, and peasants and therefore from the start they have attended to the value of what is necessary and useful in the greatest and smallest things. . . .
>
> While classical art gives shape in its ideal figures only to what is substantial, here we have, riveted and brought before our eyes, changing nature in its fleeting expressions . . . the external shape of spiritual reality in the most detailed situations, a woman threading a needle by candlelight, a halt of robbers in a casual foray. . . . It is a triumph of art over the transitory.

Painting as social expression displays the values of the Dutch, providing a record of what mattered in their culture.

"The *Sun*—the Light—rises in the East," Hegel wrote, and this for him symbolizes the course of history. "The History of the World travels from East to West, for Europe is absolutely the end of History," he wrote.[36] He believed that Chinese art "never gets beyond formlessness," and that Chinese "religious ideas [are] incompatible with any real artistic formulation."[37] But although Hegel's brief, dismissive remarks about China and India reflect the limits of his own experience, it was easy to bring the art of those cultures into a broadly Hegelian framework. Already by the early

twentieth century, Ernest Fenollosa supplemented Hegel's history to include Asian art.[38] On Chinese Buddhist paintings, he writes,[39]

> the goddess is plainly feminine. . . . she here typifies . . . the great human and sub-human category of "motherhood." . . . millions of Chinese . . . have for seven centuries looked up to, and prayed to, such superhuman types, with the same sort of passionate confidence in the divine motherhood that the millions of European believers have to the Holy Virgin . . .

The painting, sculpture, and decorative arts of these societies reflect their basic religious and social values, he argued, and so are forms of social expression, in the way that Dutch art of the Golden Age expresses Holland's life.

Hegel uses a narrative sentence to describe classical art: "Its god is not *yet* lord of nature because he has not yet got absolute spirituality as his content and form; he is *no longer* lord of nature. . . ."[40] Classical sculpture both looks backward to Egyptian symbolic art and forward to Romantic Christian art. What moves his history of art forward is the felt inadequacy of the art forms of an era as experienced already, at least in his narrative, in that era. So, for example, in describing the transition from sculpture to painting, from the classical to romantic art, Hegel says that sculpture[41]

> lacks the principle of the depth and infinity of subjective consciousness, of the *inner* reconciliation of the spirit with the Absolute and the ideal unification of man and mankind with God. The subject-matter which enters art in accordance with this principle is brought to our eyes by Christian sculpture; but the very presentation of Christian art shows that sculpture is insufficient for giving actuality to this material, so that other arts had to appear in order to realize what sculpture is never able to achieve.

He distinguishes between how the period saw itself, and our viewpoint on that time.

Only in Hegel's romantic era can this deficiency of Christian sculpture be seen—only then can we know that sculpture was in this way inadequate, unable to achieve what painting could do.[42]

> The Divine, God himself, has become flesh, was born, lived, suffered, died, and is risen. This is material which art did not invent; it was

present outside art; consequently art did not derive it from its own resources but found it ready for configuration.

When Goethe went on his famous tour of Italy, he quickly realized that works of art from antiquity "could not, like works of nature, be grasped by the simple concept of the innocent eye, even when they were relatively undamaged."[43] Influenced by Winckelmann, he discovered the need to interpret art of the past. Hegel, another reader of Winckelmann, generalized this lesson, recognizing that an adequate definition of art must be historical, taking into account its changing character. Museums soon adopted this perspective, evaluating the art of each culture on its own terms. Changing their older picture hangings, which set art in aesthetically attractive hangings, promiscuously mixing art of different periods, newer museums presented historically oriented displays.[44]

A full study of museums must remain the task for another occasion. For our present purposes, close study of one visit to an art museum will reveal much about the relation between the visual thinking found in these displays and the literature of art history.

Bill Berkson and I enter the California Palace of the Legion of Honor, San Francisco, make our way to the gallery of eighteenth-century French and Italian paintings, stop briefly before the Fragonards, go past the Tiepolo, and come to a halt before the two Pietro Longhis. We settle in front of *The Music Lesson* (1760), a painting just under two feet tall and eighteen inches wide, in the far corner, not a large famous work of art that attracts crowds.[45] We spend a long time talking, undistracted by the few other visitors. Here, then, is an idealized transcription of our conversation:

> *Behind the seated woman stands one man, with a second, seated man shown in profile at the left, and another, legs crossed, on the right. The men at the edges in front of the seated figures—are they not reminiscent of the donors in an early–sixteenth-century Venetian altarpiece? There is an oddly provisional quality to Longhi's human relationships. His figures appear like actors improvising on stage. The odd perspective slopes the floor radically toward us, as if we were looking down on the actors from a balcony. But what is the script? Perhaps the woman on the right is being offered in marriage to the man at the left. Longhi lived and worked in Venice, dying at eighty-five in 1785, just a few years before the end of the Venetian Republic. Venice was becoming a stage set where many visitors acted out their fantasies. And so historians tend to treat*

Pietro Longhi, *The Music Lesson (The Bird Cage)*, c. 1740–1745. Courtesy Fine Arts Museums of San Francisco, Gift of Mortimer Leventritt, 1952.83.

him as marking the end of a tradition. But Longhi the painter of ordinary
domestic scenes, pictures without iconography, anticipates modernism.

 This little genre painting seemingly has little connection with the grand
Venetian tradition of the Bellinis, Giorgione, Titian, Tintoretto, and the art
of Longhi's great contemporary, Tiepolo. But as a colorist, so we can see even
from this damaged painting, Longhi owes much to this tradition. Hogarth
preaches virtue; Watteau shows the langors of love; Chardin is serious. Longhi
is harder to pin down. He shows seeming nonchalant people engaged in every-
day activities. His faces are hard to read—his people appear as if masked for
Venetian carnival. Perhaps only our familiarity with abstract painting or the
figurative art of Alex Katz allows us to adequately recognize Longhi's
remarkable interest in, and skill at handling, blankness. The floor, with an
intricate pattern of shadows, and the dark background cover move than half
the entire picture surface.

Focusing on this one picture, we relate it to a variety of old and contemporary art, and to the social history of Venice. This Longhi is hung relatively high up on the wall. And so we come up very close, and then stand back, moving constantly to find the best light. We look closely at small details, some almost invisible even under ideal viewing conditions. Even good-quality color photographs look very different from this medium-sized physical object hung on a wall. In a private collection, we would perhaps need to acknowledge our host's presence, but in this public space, we are free to invent our terms of discourse.[46]

Goethe and Hegel would be puzzled by many of our art-historical references, but Goethe's account of Venice shows attention to the visual qualities that interest us. "As I glided over the lagoon in the brilliant sunshine," he wrote in his diary, "I felt I was looking at the latest and best painting of the Venetian school."[47] Hegel never got to Italy, but he too makes an observation relevant to our Longhi, comparing the color in Venetian painting to that of Dutch art, two places "near the sea in low-lying country intersected by fens, streams, and canals."[48] And we are aided by Mario Praz's explanation that the term "conversation piece" is used[49]

> for paintings, usually not of large dimensions, which represent two or
> more identifiable people in attitudes implying that they are conversing
> or communicating with each other informally, against a background
> reproduced in detail.

The subject of the picture, a figure grouping without iconography, is well suited to our style of talk about Longhi, an old-regime painter who is very modernist in his informality.

We find it natural to employ narrative sentences. *Perhaps only our familiarity with abstract painting or the figurative art of Alex Katz allows us to adequately recognize Longhi's remarkable interest in, and skill at handling, blankness.*[50] That is to say, "in 1760 Longhi anticipated the blankness of late–twentieth-century painting." To get Longhi's painting in focus, we refer to an *early–sixteenth-century Venetian altarpiece*; the paintings of the *Bellinis, Giorgione, Titian, Tintoretto,* and *Tiepolo*; and to the art of Hogarth, Watteau, and Chardin. Our far-ranging conversation, focused on the visual qualities of our Longhi, is a natural starting point for discussion of the relation of art and politics at the end of the old regime. We describe the art seen here-and-now, knowing that on other occasions, it will be discussed in different ways. Our dialogue, not philosophy, does not claim to be *about* every reader. Other people will describe *The Music Lesson* differently and other hangings suggest other conversations, as when the Barnes Foundation surrounds its similar Longhi with watercolors by Paul Cézanne, encouraging discussion of his relationship to French modernism. Just as the richness of *A Bar at the Folies-Bergére* depends, in part, upon the variety of competing interpretations, so our pleasure in museums involves, to some degree, recognizing that there are many ways to see the art on display. On another visit, no doubt Berkson and I would describe this painting differently, or focus on other art.

Berkson and I thus offer only one perspective, but our dialogue is not literature that, because it is about its readers, allows them to metaphorically assume the identity of the hero. To be sure, a dialogue indiscernible from ours could be part of a literary narrative. Imagine a film about two fictional political activists who talk about Longhi to take a break from the rigors of revolutionary politics. Their discussion in the museum breaks the action, coming after the earlier bank robbery, their means to finance popular revolution, and the later scene when they call upon the dispossessed to rise up. The California Palace of the Legion of Honor plays a

distinctive role in Alfred Hitchcock's *Vertigo*, so it is not difficult to imagine the dialogue of these activists filmed in this museum. Here then is what they say:

> *Behind the seated women stands one man, with a second, seated man shown in profile at the left, and another, legs crossed, on the right. The men at the edges in front of the seated figures—are they not reminiscent of the donors in an early–sixteenth-century Venetian altarpiece? There is an oddly provisional quality to Longhi's human relationships. His figures appear like actors improvising on stage. The odd perspective slopes the floor radically toward us, as if we were looking down on the actors from a balcony. But what is the script?*

But now these words have a quite new significance, for this imaginary film presents two very serious political activists. Berkson and I, by contrast, only talk about art.

Like many people who love looking at art together, and have done so over the years, Berkson and I share a vocabulary. Museums are designed for people like us. We know about the discourse of Chinese aesthetes and their counterparts in Renaissance Florence. And we can imagine the discussions of Persians before their miniatures and Indians talking about Buddhist sculpture. But the Western public art museum, designed to facilitate such conversations, is a remarkable, unique institution. There are natural links between the spontaneity of this conversation, with our freely chosen goals, and democratic politics and what accompanies them, modernist art which refuses ready-made subjects or programs.

Conversation requires a shared object of discussion. Thomas Crow, speaking of the Salons in mid–eighteenth-century Paris as defining a public space in the making, points to the ways in which in a democratic culture aesthetic values are not defined from above by authorities employing fixed standards.[51]

> A public sphere of discussion, debate, and free exchange of opinion was something else again. No longer, it seemed, would non-initiates be awed at a distance by the splendor of a culture in which they had no share; a vocal portion of the Salon audience, egged on by self-interested critics, would actively be disputing existing hierarchical arrangements.

Or as Thomas Craven describes it in his 1934 commentary on modernism,[52]

> the spirit of Paris . . . is the fruit of a highly organized social life in which men and women assemble in public to exchange ideas, to exhibit and compare and discuss achievements, to observe human tastes and needs . . .

Aesthetic values are defined by discussion in the public art museum.

Berkson and I are heirs to the tradition of Diderot. The art museum was designed for people like us because people like us created it. Diderot's dialogue *Rameau's Nephew* plays a central role in the section of the *Phenomenology* called "Spirit in Self-Estrangement—the Discipline of Culture." Spirit's existence, Hegel asserts[53]

> consists in universal talk and depreciatory judgment rending and tearing everything, before which all those moments are broken up that are meant to signify something real. . . . This judging and talking is, therefore, the real truth, which cannot be got over, while it overpowers everything—it is that which in this real world is alone truly of importance.

Here, in ways that Hegel did not fully comprehend, we find a remarkable anticipation of the critical culture associated with the modern museum.

Working in Venice just thirty some years before the Venetian Republic was destroyed by Napoleon's troops, Longhi was a painter of modern life. Contemporary with the English conversation painters, his true peer is Chardin and his real heirs are Corot and the impressionists. At just about that time, Kant formulated his canonical account of aesthetic experience. "There can . . . be no rule," he wrote,[54]

> according to which any one is compelled to recognize anything as beautiful. We want to get a look at the Object with our own eyes . . . And yet, if upon so doing, we call the object beautiful, we believe ourselves to be speaking with a universal voice.

Unlike Nietzsche, Kant was very optimistic about the possibility of agreement amongst art lovers. Berkson and I are not, for we seek one suggestive perspective on *The Music Lesson*, knowing that alternative approaches are possible. As Diderot wrote in his Salon of 1767,[55]

> I simply tell you what I think, and I tell it to you as frankly as possible. If it happens that I sometimes contradict myself from one moment to another, this is because from one moment to another my reaction changed. . . . Each person has his manner of seeing, thinking, and feeling: I'll hold my own in esteem only when it proves consistent with yours.

His relentless good spirits, his ability to be charmed by only modestly interesting art, and his miraculous inventiveness, provide us a model of lasting value.

Talk can be important, for in that Salon, as in the museum today, discussion of art creates communities. A new Hollywood movie inspires discussion about the roles of women, race, economic inequalities—and a myriad of other themes. Teenagers love pop music because it allows them to create a community excluding their parents. People interested in contemporary art form another community. "Any art, when it works," Peter Schjeldhal has written, "forms a fleeting community, a oneness with imagined others in pledging allegiance to something."[56] As Noël Carroll explains in his account of popular culture,[57]

> a taste for easily accessible art will not evaporate soon, nor will the pleasure to be had from sharing artworks with large numbers of our fellow citizens. . . . We enjoy reading, seeing, and listening to the same things, and then talking about them. We enjoy working references and allusions to them into our conversations. . . . It is an important element of possessing a common culture.

Museums are very popular right now because we have great need for communities. When everyday life in advanced societies has become safer because it is controlled more than ever before, many of us have a great need to visit places where we can imaginatively play in unconstrained freedom. Today, more than ever, when we spend so much time working before our computer screens, we need to look at the world aesthetically.

Museums have become important to us because the threat of losing contact with the past is very pressing. Almost all things surrounding us change very rapidly. Baudelaire, shocked at the speed of the modernization of Paris, did not imagine how fast change would come. We write

on computers, communicate with e-mail, get information from the Web, and hear music on compact discs. Life has changed drastically in a short time. Almost all the man-made things around us are very new, for little so-called nature survives. Twenty years ago, many writers used well-worn typewriters. Now a two-year-old computer is almost obsolete. Change made Baudelaire nostalgic. Today change comes too quickly for nostalgia.

In this culture, we value museums because they permit us to experience the reality of the past. The more quickly everything changes, the stronger our desire to hold on to the past. The faster everyday life changes, the more crowded are museums. In a culture on more familiar terms with its past, our need for museums would be less pressing. Old works of art look beautiful in part because they satisfy this desire to view the past. We want to see old art preserved because it makes the past real to us. And we care about art-historical narratives because they link us with the painting and sculpture of the past. The speed and intensity of these changes explains, in part, why our conversations in art museums have become so important. In conversing about art, we expand the potential range of our experience. Looking at old European paintings, Greek and Hindu sculpture, and Chinese vases and scrolls, we imagine traveling back to the past. Viewing art from many cultures, we feel in touch with visual worlds that have vanished. Never more have the pleasures of visual thinking been more precious, or more democratically accessible.

Notes to Chapter 4

1. G. E. Moore, *Principle Ethica* (Cambridge: Cambridge University Press 1965 [Originally 1903]), 188.

2. S. J. Freedberg, *Painting in Italy 1500 to 1600* (Harmondsworth, Middlesex: Penguin, 1971), 5.

3. Sherman E. Lee, *A History of Far Eastern Art* (New York: Harry N. Abrams, 1964), 96.

4. There is a historical literature and some fiction devoted to such examples, describing our world had Mohammed not founded Islam, or if Napoleon had not invaded Russia.

5. See my "Early Poussin in Rome: The Origins of French Classicism," *Arts* (March 1989): 63–67.

6. See my Sylvain Laveissière, "Pierre-Paul Prud'hon." The Metropolitan Museum of Art, New York. *CAA On-line Reviews*. October 1998.

7. See my "Whitney. Richard Diebenkorn," *Burlington Magazine*, December 1997: 900–01.

8. See my "Sam Francis. Los Angeles," *Burlington Magazine*, June 1999: 382–83 and "Ellsworth Kelly, Guggenheim Museum," *Burlington Magazine*, January 1997: 68.

9. Mary Anne Staniszewski, *The Power of Display: A History of Exhibition Installations at the Museum of Modern Art* (Cambridge, Massachusetts and London, England: The MIT Press, 1998), xxi. See also Oskar Bâtschmann, *The Artist in the Modern World: The Conflict Between market and Self-Expression,* translated by Eileen Martin (Cologne: DuMont, 1997).

10. See Nicholas Serota, *Experience of Interpretation: The Dilemma of Museums of Modern Art* (London: Thames and Hudson, 1996).

11. Martin Heidegger quoted in Didier Maleuvre, *Museum Memories: History, Technology, Art* (Stanford: Stanford University Press, 1999), 47.

12. Hans Sedlmayr, *Art in Crisis: The Lost Centre*, translated by Brian Battershaw (London, 1957), 88–89.

13. Douglas Crimp, *On the Museum's Ruins* (Cambridge, Mass. and London: MIT Press, 1993), 98.

14. Quatremère de Quincy, *Lettres à Miranda sur le Déplacement des Monuments de l'art de l'Italie*, Edouard Pommier, ed. (Paris: Macula, nd). His argument is summarized in Larry Shiner, *The Invention of Art: A Cultural History* (Chicago and London: University of Chicago Press, 2001), 184, and Daniel J. Sherman, "Quatremère/Benjamin/Marx: Art Museums, Aura, and Commodity Fetishism," *Museum Culture: Histories, Discourses, Spectacles*, Daniel J. Sherman and Irit Rogott, eds. (Minneapolis: University Of Minnesota Press, 1994), ch. 7.

15. Quoted in Francis Haskell, *The Ephemeral Museum: Old Master Paintings and the Rise of the Art Exhibition* (New Haven and London: Yale University Press, 2000), 6.

16. See my "Art Museums, Old Paintings and our Knowledge of the Past," *History and Theory*, 40 (May 2001): 170–89.

17. See my "'Going for Baroque', Walters Art Gallery, Baltimore," *Burlington Magazine*, January 1996: 59.

18. Denis Mahon, "Poussiniana: Afterthoughts Arising from the Exhibition," *Gazette des Beaux-arts* 2 (1862): 76–77.

19. S. J. Freedberg, *Circa 1600: A Revolution of Style in Italian Painting* (Cambridge, Massachusetts and London: Harvard University Press, 1983), 59.

20. *Circa 1600* shows the isolated detail. A clearer sense of the difficulty of making this comparison comes if you look at the fuller plate 114 in S. J. Freedberg, *Painting of the High Renaissance in Rome and Florence* (New York: Harper & Row, 1972).

21. Philip Fisher, *Making and Effacing Art: Modern American Art in a Culture of Museums* (New York and Oxford: Oxford University Press, 1991), 9.

22. *Selected Lectures of Rudolf Wittkower: The Impact of Non-European Civilizations on the Art of the West,* Donald Martin Reynolds, ed. (Cambridge: Cambridge University Press, 1989), 150, 200.

23. Ivan Gaskell, *Vermeer's Wager: Speculations on Art History, Theory and Art Museums* (London: Reaktion, 2000), 86.

24. See Colin Amery, *The National Gallery Sainsbury Wing: A Celebration of Art & Architecture* (London: National Gallery, 1991).

25. Kenneth Clark, *Piero della Francesca* (London: Phaidon, 1969 [second edition]), 23–24.

26. See my "Why Were There No Public Art Museums in Renaissance Italy?," *Source* XXII, 1 (Fall 2002): 48–50.

27. See Andrew McClellan, *Inventing the Louvre: Art, Politics, and the Origins of the Modern Museum in Eighteenth-Century Paris* (Cambridge: Cambridge University Press, 1994).

28. See Horst Bredekamp, *The Lure of Antiquity and the Cult of the Machine: The Kunstkammer and the Evolution of Nature, Art and Technology,* translated by Allison Brown (Princeton: Markis Wiener, 1995) and Paula Findlen, *Possessing Nature: Museums, Collecting, and the Scientific Culture in Early Modern Italy* (Berkeley, Los Angeles, London: University of California Press, 1994).

29. See *Great Family Collections*, Douglas Cooper, ed. (New York: Macmillan, 1965).

30. See Douglass Shand-Tucci, *The Art of Scandal. The Life and Times of Isabella Stewart Gardner* (New York: HarperCollins, 1997), 222, and my "Mrs. Isabella Stewart Gardner's Titian," *Source*, XX, 2 (Winter 2001): 20–24.

31. See Geneviève Brese-Bautier and Frédric Morvan, *Palais du Louvre: Architecture et décor: guide du visiteur* (Paris: Réunion des musées nationaux, 1998).

32. Our museums of world art remain centered on European art. For just as no one has found a satisfying way of integrating the arts of Africa, the far East, India, Oceania, and pre-Columbian America into survey history books, so no one as yet understands properly how to display a unified history of world art.

33. G. W. F. Hegel, *Aesthetics. Lectures on Fine Art*, translated by T. M. Knox (Oxford: Clarendon Press, 1975), 870.

34. Hegel, *Aesthetics*, 873, 875, 879, 879, 883, 884.

35. Hegel, *Aesthetics*, 597–99, 169.

36. G. W. F. Hegel, *Philosophy of History*, translated by J. Sibree (New York: P. F. Collier & Son, 1902), 163.

37. Hegel, *Aesthetics*, I, 74, II, 1095.

38. See Lawrence W. Chisolm, *Fenollosa: The Far East and American Culture* (New Haven and London: Yale University Press, 1963).

39. Ernest F. Fenollosa, *Epochs of Chinese & Japanese Art. An Outline History of East Asiatic Design* (New York: Frederick A. Stokes, 1912), II, 49.

40. Hegel, *Aesthetics*, 455.

41. Hegel, *Aesthetics*, 791.

42. Hegel, *Aesthetics*, 505.

43. Nicholas Boyle, *Goethe: The Poet and the Age* (Oxford: Clarendon Press, 1991), v. 1, 480. His understanding of the implications of historical development was incomplete, however, for he loathed the Christian subjects of Renaissance art; see Boyle, *Goethe*, 428 and 656.

44. See Giles Waterfield, "The Origins of the Early Picture Gallery Catalogue in Europe, and its Manifestation in Victorian Britain," *Art in Museums*, Susan Pearce, ed. (London and Atlantic Highlands, NJ: Athlone, 1995), ch. 2.

45. Terisio Pignatti, *Pietro Longhi: Paintings and Drawings. Complete Edition*, translated by Pamela Waley (London: Phaidon, 1969), identified as *The Mandoline Recital*, described as lost; p. 93 and ills. p. 197; Terisio Pignatti, *L'opera completa di Pietro Longhi* (Milan, 1974), p. 97, fig. 149. David H. Solkin, *Painting for Money: The Visual Arts and the Public Sphere in Eighteenth-Century England* (New Haven and London: Yale University Press, 1993) deals with similar English pictures.

46. Our conversation was anticipated by the poetry written jointly by Berkson and Frank O'Hara; see *Hymns of St. Bridget & Other Writings* (Woodacre, California: Owl Press, 2001).

47. J. W. von Goethe, *Italian Journey: 1786–1799*, translated by W. H. Auden and E. Mayer (New York: Schocken, 1968), 79.

48. Hegel, *Aesthetics*, II, 812.

49. Mario Praz, *Conversation Pieces: A Survey of the Informal Group Portrait in Europe and America* (University Park and London: Pennsylvania State University Press, 1971), 33.

50. See my "Alex Katz at PS 1," *Burlington Magazine*, July 1998: 504–06.

51. *Painters and Public Life in Eighteenth-Century Paris* (New Haven and London: Yale University Press, 1985), 15.

52. Thomas Craven, *Modern Art: The Men, the Movements, the Meaning* (New York: Simon and Schuster, 1934), 12.

53. G. W. F. Hegel, *The Phenomenology of Mind*, translated by J. B. Baillie (New York and Evanston: Harper & Row, 1967), 542–43.

54. Immanuel Kant, *The Critique of Judgment*, translated by James Creed Meredith (Oxford: Clarendon Press, 1952), 56.

55. *Diderot on Art-II*, translated by John Goodman (New Haven and London; Yale University Press, 1995), 249.

56. Peter Schjeldahl, *Columns & Catalogues* (Great Barrington, MA; The Figures, 1994), 123–24.

57. Noël Carroll, *A Philosophy of Mass Art* (Oxford: Clarendon Press, 1998), 13.

It's not insignificant that the work of fine art is embedded in

our art language of a [more or less] *unique commodity* . . .

uniqueness is the most highly treasured and privileged

characteristic in the exchange market. Thus what *may*

once have related to genuinely personal expression has

been transformed into an impersonal factor of "mere"

economic activity.

—*Ian Burn*[1]

CHAPTER FIVE:
Art Gallery Narratives

Nowadays most contemporary art is exhibited first in galleries, and only when winning significant approval is it then sold to art museums, thus making its way from temporary private displays into permanent public collections. But although the museum and gallery are closely linked, they function very differently, have different structures, and are associated with different forms of art writing. Scholars devote much attention to the history and politics of the museum, but they give relatively little attention to the art gallery.[2] That is unfortunate, for art galleries do heavily influence how we understand contemporary art, and it is impossible to understand our museums without identifying their relationship with the art gallery.

This movement of art from the gallery into the museum is accompanied by a dramatic increase in economic value. In picking the best new art, and explaining why it matters, art critics facilitate that movement. A great many works of art are made, but only a few are really good. And so the best new art, which quickly gets sorted out, soon is very valuable. Chapter 4 discussed the ways that museums place art in contexts, setting up comparisons, and developing narrative sequences. The unit of discourse in art history, we observed, is a work of art as set in some written context, and the unit of discourse in museums is art placed in a physical setting. We also saw how conversations in museums are visual thinking. Now we can extend that analysis to art galleries. We see and understand paintings and sculptures differently when they move from temporary gallery settings into the museum. Just as

we cannot entirely isolate Manet's *Bar at the Folies-Bergére* from the interpretative contexts provided by Schapiro, Clark, and the other commentators, so, although we cannot totally separate a new work of art from its position in the gallery, we can compare and contrast the effects of diverse settings.

Observing what happens when painting and sculpture move from galleries to museums teaches much about museums. Most publicly financed museums charge admission, while entrance to galleries is usually free. Art in museums—large, often grand public spaces—is described by art historians and curators. Art in galleries—private businesses—is evaluated by critics, journalists who write in informal ways, more like newspaper reporters than academic art historians. When it is still in the studio, the significance of a work of art is as yet unknown, but by the time it moves from galleries to the public museum, its value has, to some degree, been acknowledged.[3] Art for sale in the gallery is judged by critics who ask whether it is original and inventive, and whether it measures up to the masterpieces of the past. Art critics, like lawyers or politicians, are rhetoricians who aim to get us to see the facts a certain way. Their art criticism is promotional writing, standing to art as advertising does to commerce in general.

Art dealers, extremely useful gatekeepers, middlemen between artists and museums, thus make it possible for new art to get a public hearing. Imagine a world like ours with museums just like ours, but without art galleries.[4] In this parallel universe, there is lively concern with making and collecting of contemporary art, but no organized system for display of new painting and sculpture. Collectors and curators of contemporary art, we may suppose, do studio visits. But that would be a very inefficient way of learning about new art. Our collectors and curators, and anyone else interested in contemporary art quickly learn who is doing interesting new work by visiting dense concentrations of galleries, guided by art criticism. In this imaginary world, it is safe to predict, art galleries and art criticism would soon be invented.

We may take these structures of our art world, galleries and criticism, for granted just because they are right at hand. But doing that makes it

difficult to understand art writing. Many cultures making art have preserved their artifacts, but our galleries and museums are very recent creations. The public art museum, a late–eighteenth-century creation, is only as old as the United States. The first major American museum devoted to contemporary art, the Museum of Modern Art, New York, is less than eighty years old. And the proliferation of galleries and museum curators and collectors devoted to contemporary art is a still more recent development. Our art world did not exist fifty years ago.[5]

> The enormous undergraduate art programs in American universities; the enormously expensive graduate programs in studio art; the complex global industry for marketing contemporary art . . . the dense international network of modern art museums, kunsthalles, alternative spaces, and annuales. . . . None of this existed then.

There have been other collecting cultures, but our demanding devotion to the acquisition, display, and writing about contemporary art is a new development.[6]

Originally a museum was the home of the muses and so you enter typical older museums by walking up steps, as if going into an antique temple or a cathedral. Great works of art detached from any utilitarian function are set outside the everyday world, ready to be enjoyed aesthetically. Museums, filled with treasures, need guards, cloakrooms, and staff selling tickets. Often visitors spend some hours viewing the collection, and perhaps also in the gift shop and restaurant. Art galleries, like other stores, display merchandise to window shoppers. Compared with museums, even the grandest galleries are relatively small businesses. They usually carry the owner's name and, depending upon the financial acumen of one person, only survive the founder's death if they become family dynasties. In a gallery, as in any shop, many visitors browse briefly and move on. Only those who come to purchase art or review the show spend a long time in the showroom. The dealer must create demand for visual luxuries. Selling art requires charm, showmanship, and a flair for organizing seductive displays. Successful curators, too, are visual rhetoricians, but their virtuosity is relatively disinterested, for they have nothing to sell except admission tickets.

Bill Beckley, *Stations 2, 5, 1,* and *10,* 2001 Installation: Galerie Hans Mayer, Berlin.

Leaving my study, the private place where I write, I wave to a neighbor from my porch and enter the public space of the street. A painting moving from an artist's studio through the art gallery to the museum undergoes a similar transition. New art is first seen by the public in the gallery, a place in-between the private studio and the public art museum. But just as some people hesitate to enter a posh store, even though only to go window-shopping, so they feel excluded from a fashionable art dealer's showroom. Nowadays even the haughtiest museums are extremely welcoming, doing everything in their power to underplay the obvious associations of high art with privilege. They put up banners; train docents to give tours; and hire staff for their restaurants and shops.

Museums are much visited by tourists, many of whom have only a casual interest in art, and by school groups. Going to galleries is a more special passion. You meet friends and if the dealer knows you, she may

offer a chair, talk over coffee, and pull art from storage. The private back room is where sales are made, so if you are invited in, it's easy to think of yourself as one of Stendhal's happy few, privileged to associate with the artistic (and economic) elite. Collectors and art critics do not normally dine at the same restaurants or live in the same neighborhoods, but at openings the rich with car service, and writers coming on the subway, enter the same rooms. Art critics are very poorly paid, and so may think of themselves as outside the art market. But their writing is impossible to understand without acknowledging its role within this commercial system. An art gallery, posh or not, feels like a private club, and because the goods on display are esoteric, and prices are often not listed, it may seem forbidding to someone unaccustomed to the conventions of gallery-going.

In the mid–nineteenth century, art galleries and journalistic art criticism accompanied the birth of modernism. Today in New York City, a hundred or more serious art dealers put on perhaps a thousand exhibitions each year. Ten years later, a very few of these works of art are in museums, or important private collections. But most art finds no home outside the artist's studio, and so, soon disappears. In the 1960s and 1970s, many artists, inspired by contemporary radical politics, attempted to bypass the gallery system. They failed, for it was never clear how a mercantile culture could transcend this institution. Radical artists made a great deal of anticommercial art, but the art gallery, a small-scale enterprise, is not a good starting point for analyzing capitalism, and there always was something paradoxical about art devoted to rejecting its own status as a commodity. Department stores do not urge customers to stop shopping—car dealers do not tell us to take public transportation. Because selling art is a commercial activity, dealers, collectors, and critics place a high premium on innovation. Aesthetic value, it often has been said, is incommensurate with economic value. That way of thinking is incompatible with how we now display and evaluate contemporary art. Although many people seem to hate the idea of dealing in art, without galleries our art world could not exist.

Art museums tell the story of art from its beginnings almost to the immediate present. Art galleries display contemporary art that aspires to

enter the museum. Museums and art galleries thus compliment one another. In Hugh Honour and John Fleming's survey text *The Visual Arts: A History*, such mid-career artists as Robert Gober, Damien Hirst, and Jenny Holzer appear at the end of a narrative, which begins with cave painting, and includes artifacts from every culture. If Gober, Hirst, and Holzer are part of this story, then they belong in the museum alongside ancient Greek pottery, Chinese old masters, and European modernist paintings. We want the art of our time to have the same intrinsic value, seriousness, and originality as the older museum art, for only then does tradition remain alive into the present. A collecting culture without serious new art would have very different museums.

Critics have different concerns than historians, for new art needs to be interpreted in different ways than old paintings. Imagine two visually indistinguishable paintings. The first, Piero della Francesca's *Flagellation of Christ,* displayed in Urbino, made somewhere near Arezzo around 1450, is the famously mysterious masterpiece beautifully described by Kenneth Clark in terms accepted by most recent art writers.[9]

> The subject remains obscure. This is not, obviously, a picture of the Flagellation with three indifferent onlookers, but a picture of three important figures, two of them symbolical and one a portrait, whose thoughts are expressed by the sufferings of Our Lord.

Because we know so little about the artist, whose culture is so historically distant, unavoidably this hard iconographic puzzle tests the art historian.

The second painting, visually identical, was made, let us imagine, in New York in 2001 by Peter Francesca, an obviously derivative follower of Mike Bidlo. This painting is easy to understand, for as Peter explains, his *Flagellation of Christ* is perfectly described by Bill Berkson's magisterial essay on Piero, which beautifully translates into condensed poetic language our art-historical knowledge of the artist.[10]

> Besides supplying an image of godly suffering as somehow analogous to current events, the *Flagellation* is an emblem, possibly a critique, of administrative ethics: from the conferees in the piazza to Pilate's stupor and Christ's commiserating glance, policymaking is the theme, if not what the whole thing is about.

Francesca's subject is not obscure.

What different works of art are these indiscernible paintings! Interpreting Piero's *Flagellation of Christ* requires all the most sophisticated skills of the art historian, while understanding Francesca's *Flagellation of Christ* is easy. We cannot really be sure that we properly understand Piero's picture, not when recently a renowned art historian denied that it depicts Christ's flagellation.[11] Clark's account may be mistaken, but there is no reasonable doubt that Francesca, a straight-speaking artist, correctly describes his own painting, for after all he made it. To understand Francesca's painting, we need only look, but to interpret Piero's painting, we must supplement the visual experience with reading. When Piero's and Francesca's paintings are exchanged, even the leading experts cannot tell which is which, for Francesca has meticulously imitated the techniques of the quattrocento master whom he admires. Only X-rays and other laboratory techniques permit us to distinguish Piero's and Francesca's paintings. Here again we find confirmation of Danto's thesis: the identity of art is not defined by its appearance.

Interpreting Piero's *Flagellation of Christ* is a project for the art historian, describing Francesca's *Flagellation of Christ*, a task for the art critic. The difference between art criticism and art history writing thus is determined, not by the intrinsic visual nature of the visual object, but by its temporal relation to us. When art is made in a historically distant society, then intellectual labor often is required to bridge the gap between the artist's culture and ours. And sometimes our distance from fifteenth-century Italy feels immense. But if art comes from our culture, then learning its meaning only requires understanding people like ourselves. Jasper Johns and Louise Bourgeois, mysterious enough personalities, are our living near-contemporaries, and so their art differs in kind from paintings from historically distant, late-medieval Europe.

Comparing Piero's and Francesca's *Flagellation of Christ* is a little like contrasting the scholarly *Art Bulletin* with its journalistic counterpart, *Artforum*. Both magazines are illustrated, and both publish theoretically informed art writing, but *Artforum*, a commercial journal,

pays its contributors and has many advertisements. With its extensive color plates and careful, close editing, *Artforum* appears in some ways more like *Harper's Bazaar,* or *Vogue*, than the *Art Bulletin*. But the fashion journals do not publish abstruse theorizing. Some theory is needed to understand the objects made by post-Warholian artists, but you do not need to read Barthes and Foucault to admire fashionable upscale clothing.

Art Bulletin usually deals with older painting and sculpture, while *Artforum* is concerned mostly with contemporary art, a difference that affects the form and content of these journals. Philosophers distinguish knowledge by acquaintance from knowledge by description, which gives us knowledge of history.[12] I know about Rome circa 1956 by acquaintance, for I was there. But I know of Dominique Vivant Denon, creator of Napoleon's Louvre, only by reading, since he died long before my birth. Let us apply this distinction to visual art. I know directly what belongs to a living tradition, in the way I understand what has taken place in my lifetime. What is more distant historically, by contrast, I know only through a bookish act of reconstruction. I know Robert Ryman's aesthetic directly, and so have confidence that I understand his paintings.[13] But I legitimately wonder if I correctly view Piero's paintings. And I know Francesca's *Flagellation of Christ* by acquaintance, but nowadays Piero's *Flagellation of Christ* is knowable only by description.

Once art enters the museum, it usually leaves the system of exchange. A work of art is a commodity, and so there is a somewhat uneasy relationship between art writers, who usually are focused on the aesthetic or politically significant features of art, and dealers and collectors, whose essential concerns are commercial. And while excessive concern with the economic worth of art is vulgar, a completely unworldly analysis will miss the intellectually interesting relation between aesthetic and economic value. When many artists are working and only a very few achieve recognition and commercial success, critics have a practical function. In the 1960s,[14]

> the historical confluence of accident, insight, commerce, and iconography (of promise) . . . gave birth to the big, beautiful art market as an embodied discourse of democratic values.

A market in contemporary art was not new. Early Renaissance works of art[15]

> were part of a vigorously developing worldwide market in luxury commodities. They were at once sources of aesthetic delight and properties in commercial transactions.

But the intensity of our market in contemporary art, and its intimate link with art writing, is new.

Surveying contemporary art is like picking winning stocks—the aim is to buy low and sell high. Richard Polsky's *Art Market Guide* describes the logic of this situation. Looking at the fifty most widely collected contemporary artists, and advising collectors to buy, sell, or hold may seem a crude, even vulgar way of thinking, but Polsky offers shrewd commentary. His first response to Carl Andre, he recalls, was naïve:[16]

> To a student who thought of sculpture as a bronze military statue in the park or a stone carving of Venus de Milo in a museum, the work of Andre was perplexing.

But soon Polsky became more sophisticated. Joan Mitchell, he shrewdly remarks, is marketed

> as a living link to the glories of the Abstract Expressionist era. . . . Mitchell was superior to the entire third tier of male Abstract Expressionists;

And as for Rothko,

> we like our painters to be heroic. We like them to have come from romantic humble backgrounds, to have suffered moments of doubt and pain that led to historic artistic breakthroughs, and to meet a tragic end. Rothko qualifies in all three categories.
>
> The beauty of Mark Rothko is that his work actually does what it is supposed to: it offers the viewer a moment of spiritual reflection.

Polsky combines relentless realistic concern with exchange value with the sensibility of a smart art writer.

Today the natural goal of ambitious young artists is to make art that enters the museum. If they look at the back issues of *Artforum*, they will find that in thirty-some years the magazine has put almost three hundred artists, most of them living figures, on its cover. Since surely there have not been

that many important artists in the late twentieth century, the attrition rate is very high indeed. Selecting art for the museum therefore is extremely difficult. Critics identify connections between contemporary and older art. Doing that requires constructing historical links between very different-looking artifacts. Here, then, we find another form of visual thinking, somewhat different from that of the art historians.

The critic asks us to see the relationships between novel, contemporary art in the galleries, and the painting and sculpture in the museum. "Since all centuries and all peoples have had their form of beauty, so inevitably we have ours."[17] When, at the end of "The Salon of 1846" and again in "The Painter of Modern Life," Baudelaire sorts out the relationship between the absolute beauty of old master art and our pleasure in contemporary images, he anticipates our situation. Visual relativism, the belief that each age has its own standards of beauty, different from that of other cultures but equally deserving of attention, structures our museums. Artifacts from Africa, China, India, and pre-Columbian America become art alongside the painting and sculpture of Europe and contemporary art. Historians merely reconstruct the past, but old art puts us directly in touch with earlier times, for when we see a tenth-century Chinese scroll, we view essentially that object seen by connoisseurs when it was just painted.[18] Hanging abstract expressionist masterpieces not far from that scroll makes a powerful statement about cultural continuity. We find enough overlap between the concerns of the Chinese artist and Willem de Kooning, and the quality of their art, to justify displaying their paintings in almost adjacent rooms.

When describing museum art, narrative sentences establish historical connections. When employed by art critics, narrative sentences often link contemporary art to tradition. Championing Morris Louis by constructing a formalist genealogy, for example, Michael Fried wrote:[19]

> In a series of remarkable paintings made by staining thinned-down black paint into unsized canvas in 1951, Pollock seems to have been on the verge of an entirely new and different kind of painting. . . . The man who . . . explored and developed the new synthesis of figuration and opticality sketched out in Pollock's stain paintings of 1951 was Morris Louis.

In 1951, Pollock anticipated Louis' stain paintings. In 1951, no one could have seen that. Greenberg argues that knowing Helen Frankenthaler's and Pollock's paintings[20]

> led Louis to change his direction abruptly. Abandoning Cubism with a completeness for which there was no precedent in either influence, he began to feel, think, and conceive almost exclusively in terms of open color.

In an essay which finds Jasper Johns and Ellsworth Kelly "a little too easy to enjoy. They don't challenge or expand taste," this is serious praise.

Building on Greenberg's account, Fried offers a much fuller analysis. Frankenthaler's *Mountains and Sea*[21]

> is the bridge between Pollock and Louis. . . .
> It was only when Louis discovered in the staining of such pigments the means of sustaining a broad gamut of internal articulations all of which are experienced as illusively intangible—as accessible to eyesight but not to touch—that his breakthrough was at last under way.

Just as Heinrich Wölfflin's *Principles of Art History* demonstrates that the classical tends to the baroque, so this formalist analysis shows how Pollock's all-over masterpieces lead toward Louis's stain paintings. If Pollock was great, then so too is Louis. Indeed, Fried argues that

> Louis's imagination strikes one as radically abstract in a way that not just Pollock's but that of any modernist painter before Louis, except perhaps Matisse, does not.

Other critics soon adopted this approach.

In her 1985 monograph, Diane Upright, while arguing with some details of Greenberg and Fried, extends their argument:[22]

> Louis took a major step beyond Pollock's notion of all-over composition. . . . In the *Unfurleds* . . . Louis put behind him the dilemma of figure versus ground. . . . Louis's success is comparable with that of Mondrian, despite the dramatic difference in the appearance and scale of their paintings.

And then John Elderfield pressed the analysis further:[23]

> Matisse's art came to maturity when he blended Impressionist luminism and Symbolist flat color painting in such a way as to generate light

through thinly applied intense color . . . he used sculptural contour drawing to contradict the flatness of the color areas on each side of the contour . . . this was precisely Louis's method in the *Veils*.

Now it is academic to reconstruct this argumentation, for as Arthur Danto noted in 1986,[24]

> the paintings resisted the theory. In the end it is just impossible to see them as impersonal stains, as enhancements of paint and canvas, as "autonomous abstract paintings."

When he goes on to suggest that "at their best and greatest they evoke experiences like massed flowers or sunsets," we see how out of touch Louis's champions became. Since Louis's paintings do not look that much like those of Pollock, Matisse, or the symbolists, linking their art seems highly arbitrary. Identifying various great artists as Louis's source, and suggesting that his art goes further, inevitably implied that he was as great as his precursors. But as Rene Ricard notes in his "Not about Julian Schnabel" (an ironic title, for the essay *is* in part about Julian Schnabel),[25]

> Because Franz Kline admired Albert Ryder and looked upon him as a forebear doesn't mean that Ryder has anything to do with Kline. Rather Kline has to do with Ryder.

Non-formalist critics also construct genealogies. Robert Pincus-Witten compares Brice Marden's *Grove Paintings* with Puvis de Chavannes's *Sacred Grove Dear to the Muses* (1884), in the stairwell of the Museum of Fine Arts, Lyons. The[26]

> composition in registers; in contemporary art that stratum has become the literally flat plane of modernism. . . . Beyond this surface aspect, a deeply researched and subtle color is one that also echoes Puvis de Chavannes; his color also once struck the viewer as oddly mannerist. . . . Such an alert use of color is maintained in the alchemy of Marden's wary, never-seen-before palette.

Linking Marden to this relatively obscure mural creates a subtle and elusive history. Earlier, Jeremy Gilbert-Rolfe related Marden to the dialectic of Cézanne's landscapes and Jean Luc-Godard's leftist movies, arguing that Marden's reluctance "to place ultimate faith in that which is merely

known" makes him a materialist, like Brecht.[27] And Stephen Bann compared his paintings to annunciations.[28]

> Marden makes us think . . . of the ancestral link between colour and matter. Colour was, after all, from the classical period until comparatively modern times hard to disentangle from the precious element of material which was its physical basis.

Marden's art does not look like Puvis de Chavannes's murals, Cézanne's landscapes, or Renaissance annunciations, but since his abstractions are difficult to interpret, these immensely suggestive comparisons help us to place them.

Dave Hickey places Bridget Riley by identifying[29]

> a tradition stretching from Titian to Nauman [both of whom Riley greatly admires]. . . . The fact that such a gradation does exist . . . and that Bridget Riley participates in it, is heartening. It promises that something new will happen.

His account is vague. Because Riley's optical paintings are very different from the art of either Titian or Bruce Nauman, identifying this tradition would require a more detailed analysis. Genealogies are more convincing when they offer specifically visual connections, as when Yve-Alain Bois proclaims Richard Serra's *Torqued Ellipses* (1997) masterpieces because they have the "power to make previous works of art intelligible."[30] Matisse's *Seated Nude (Olga)* (1909–10), Bois explains, suppresses the articulation between front and back, much as Serra's sculptures leave one "without any spatial coordinates, incapable of meaning the distance between oneself and any point on the 'walls.'" Walking around Matisse's small figurative sculpture or Serra's very big abstractions, you never shift from viewing the back to viewing the front.

Frank Stella's *Working Space* (1986) is self-critical about all genealogies, noting that[31]

> even if we could establish links of value and quality with some of the great art of the past, it is still not certain that abstraction's line of succession is guaranteed.

And yet, of course that is precisely the goal in discussing Caravaggio's working space which, so he argues,

is something that twentieth-century painting could use: an alternative both to the space of conventional realism and to the space of what has come to be conventional painterliness.

Caravaggio, in short, anticipates Stella's 1980s paintings. We get from Caravaggio to Stella himself when we see that

> the potential we feel in Pollock is much like the potential we would ascribe to Italian mannerist painting in the late sixteenth century—the painting whose potential Rubens realized so beautifully.

Stella himself, when young, so he now says, had but one

> goal: to paint abstract paintings. By that I meant to make paintings which were faithful to the visual culture of the past, but which were free from their dependence on conventional representational models.

In identifying his place in this history he tells with such verve, Stella concludes by reaffirming his identification with Caravaggio, and

> Cézanne, Monet, and Picasso, who insist that if abstraction is to drive the endeavor of painting it must make painting real—real like the painting that flourished in sixteenth-century Italy.

Since Caravaggio's big figurative pictures served religious functions, but Stella's abstract painting no longer has that goal, this genealogy is ultimately unconvincing. These works of art are too different to be plausibly connected in this history. Peter Halley offers a more plausible account, arguing that[32]

> Stella is neither a modernist nor a bureaucrat . . . his work conforms closely to a model of post-modernism that is dominated by ideas of hyper-realization, simulation, closure, and fascination.

And Kirk Varnedoe presents yet another suggestive narrative, identifying the absence of "pictorial space . . . with the illusion of recession of depth" as characteristic of modern painting:[33]

> The virtually airless, depthless stripes of Frank Stella's *Marriage of Reason and Squalor, II* of 1959 . . . can be taken as the outcome of a process announced in Henri Matisse's *Harmony in Red* . . . of 1908.

"What Matisse began in 1908 Stella finished." That could be known only in 1959.[34] Now when Stella generates as rich a literature as the old masters, he becomes a subject for the art historian.

Famous old art has been much written about, and even a minor painting like Longhi's *Music Lesson* fits into familiar styles of historical analysis, for it can readily be related to famous paintings. Compared with historians, critics are marginal figures, without an established institutional role, but their special skill, quickly responding to novel art in accessible prose, deserves recognition. Even when they fail, critics deserve praise for their amazing inventiveness. At the end of the twentieth century, after the demise of formalism and with increasing skepticism about genealogies, the most influential American art critics argued that visual art should critique the social order. It certainly seems ironical that Marxism triumphed within the art world just when socialism disappeared as an actual political force.[35] Thinking of art in these terms, as criticizing the society where it is sold, as so many critics did, is an obviously counterintuitive approach. No doubt the fascination with leftist ways of thinking reflects an uneasy concern with the role of criticism in the marketplace. And yet, if we look back again to Hegel, we can grasp the roots and logic of this way of thinking.

For Hegel, art is a form of social expression. In Holland in the Golden Age, to again quote his most famous set piece, we find[36]

> neither a superior nobility expelling its prince and tyrant or imposing laws on him, nor a people of farmers. . . . on the contrary . . . townspeople, burghers active in trade and well-off who, comfortable in their business, had no high pretensions, but when it was a question of fighting for the freedom of their well-earned rights . . . revolted with bold trust in God.

Knowing that these Protestants defeated "the Spanish despotism," we are prepared to understand their art, which shows

> the neatness of its cities, houses and furnishings. . . . the brilliance of its civil and political festivals, the boldness of its seamen, the fame of its commerce and the ships that ride the oceans of the world.

This art presents

> the Sunday of life which equalizes everything and removes all evil; people who are so whole-heartedly cheerful cannot be altogether evil and base. . . . The poetical fundamental trait permeating most of the Dutch painters of this period consists of this treatment of man's inner nature and its external and living forms.

Unlike their Catholic contemporaries in Rome or Madrid, Dutch artists are not primarily concerned with sacred images. Nor, unlike the painters of the French academy, established late in that century, do they serve an absolute monarch. When spirit thus expresses itself, there is no gap between art and the culture supporting it.

The Dutch bourgeois painters produced a vast proliferation of images. In Delft, perhaps two-thirds of the people lived in houses with paintings, and there were forty or fifty thousand paintings in the four thousand some houses.[37] Hegel was the first writer "to interpret Dutch painting from an artistic and sociological point of view."[38] In his sweeping analysis, it would be inappropriate to discuss individual works of art, or details about political history. Hegel was not entirely correct, Jakob Rosenberg and Seymour Slive argue, to link this art to its age, for[39]

> so much of what we recognize as especially Dutch in painting, its peculiar bourgeois taste and character . . . appears in fifteenth-century Netherlandish painting long before the birth of Calvinism.

But when their "Historical Background" begins by noting the special character of Dutch culture; the importance of that country's political independence "due above all to the heroic Dutch navy and the bold spirit and bravery of the merchant fleet"; and then says that

> there were no great princes, no cardinals, no grand seigneurs who wanted monumental sculpture and architecture. Dutch paintings were within the means of the large middle class,

then we see the lasting impact of Hegelian ways of thinking.

In older societies, art may be at one with the larger society, but in modern culture with its public sphere of discussion, debate, and free exchange, there is a new role for art— it may protest the social order. This development, too, Hegel prophesized, not in his aesthetics, but in the section of *The Phenomenology of Mind* entitled "The World of Spirit in Self-Estrangement," which tells what happens when the sphere of spirit is divided into two opposed components.[40]

> The one is the actual world, that of self-estrangement, the other is that
> which spirit constructs for itself in the ether of pure consciousness,
> raising itself above the first. This second world, being constructed in
> opposition and contrast to that estrangement, is just on that account
> not free from it.

Referring to *Rameau's Nephew*, Diderot's dialogue of Parisian intellectuals
set on the eve of the revolution, Hegel here nicely anticipates our late mod-
ernist ideal of political protest art.

Hal Foster is perhaps the best of the many contemporary critics who
write Hegelian accounts of our period, picking out the most significant
protest artists and showing how they express the period of our times.
His eclectic theorizing is unlike Hegel's and the art he describes would
puzzle Hegel, but that German philosopher would understand the nar-
rative of Foster's *Return of the Real*. "In order to advance a model," Foster
proposes to treat history "on the model of the individual subject, indeed
as a subject." [41] To identify this subject, from all the possible artists, a
few must stand for their time. Any narrative requires privileging some
events as important enough to be discussed, while omitting others.
Hegel's world history focused on Egypt, ancient Greece and Rome,
Renaissance Italy, and seventeenth-century Holland and Germany, leav-
ing aside Africa, China, and India. Foster, also selective, is concerned
with Richard Serra's sculpture, Sherrie Levine's photographs, and a post-
modern anti-aesthetic tradition, while paying little attention to other
contemporary art. He admires Marcel Broodthaers's playful deconstruc-
tion of the museum, but not Julian Schnabel's neo-expressionist paint-
ings; he praises Eva Hesse's sculpture, but not Leon Golub's leftist
paintings; he cares about Barbara Kruger's critical deconstruction of
advertising, but not Jeff Wall's photographs; he values the abstract art
of Ross Bleckner, but not recent realist paintings.

When Hegel identified Dutch artists of the Golden Age as bourgeois
Protestant genre painters, he usefully pointed to ways that these artists
differ from their Italian Catholic counterparts. By contrast, the
late–twentieth-century artists Foster admires are too various to permit sim-
ilarly useful generalization. Seeking politically critical art, recognizing that

the art world "recoups the most transgressive forms," Foster asks that good radical artists respond to this situation.[42] The artists he admires are critical of gender roles, politics, and the art market; the bad artists, refusing to challenge the culture that supports them, are complacent. But all these artists express their culture.[43]

> Both . . . pastiche and textuality . . . were referred to a general crisis in representation and authorship . . . whether in the guise of a neo-expressionist painting by Julian Schnabel or a multimedia performance by Laurie Anderson . . . both practices were related to a qualitative shift in the capitalist dynamic of reification and fragmentation.

Binary oppositions lead to moralizing, and so Foster is disturbed to find opposites conjoined, as when the "bad" art dealer and former banker Jeffrey Deitch learns from the "good" leftist artists, Daniel Buren and Hans Haacke.[44] Foster is at pains to distinguish "the macho painterly confections of Julian Schnabel" from the performances of Laurie Anderson, who[45]

> uses the art-historical or pop-cultural cliché against itself, in order to decenter the masculine subject of such representation, to pluralize the social self, to render cultural meanings ambiguous, indeterminate.

But many artists, male or female, use and critique such clichés, and since Levine and Serra, like Schnabel or Salle, are near-contemporaries, there is something scholastic in seeing them as so deeply opposed.

"The question is, finally," Tim Clark wrote in 1973, "how could there be effective political art?"[46] And the problem, he adds,

> for a revolutionary artist in the nineteenth century—perhaps it is still the problem—was how to use the conditions of artistic production without being defined by them?

But now, when it is clear that neither Courbet, Seurat, El Lissitsky, nor any of their admirers working in the 1960s have been effective politically revolutionary artists, what then is to be done? One much used way to motivate a political analysis is to construct an opposition, comparing the good critical art with its polar opposite, the bad everyday conformist works. Like Foster, Kenneth Baker does this when he writes:[47]

> At a time when most of society is in thrall to images of some kind, and
> when most images are made so as to keep people in thrall, Morandi's
> art expresses a rare commitment to freedom.

But that Morandi inspires long attentive looking, unlike television, does
not make him a political artist.[48] In truth, these moralizing ways of think-
ing about political art have long been totally unconvincing.

When African-American rhythm and blues became the source for rock-
and-roll music, and when Hollywood film deals with women's roles, then
mass art has a real political goal. But since nowadays important visual
works of art are expensive, well-guarded possessions of prosperous collec-
tors or major museums, it is implausible to think that they can be vehicles
for social protest. Art writing plays a role in the art market, and so critics
want to be self-critical about their own role in promoting sales. Fair
enough, but influential leftists like Foster are caught in an inescapable
contradiction, for when artists they champion become successful, that
shows the implausibility of their position. I am not forgetting that there
has been a great deal of magnificent political protest art. Goya's *Third of
May, 1803* (1814), Manet's *Execution of The Emperor Maximilian* (1867),
Picasso's *Guernica* (1937), along with Leon Golub's images of mercenaries,
some of Gerhard Richter's paintings, Barbara Kruger's photomontages and
a variety of other recent examples show the importance of this tradition.
But I am denying that the central concern of most late–twentieth-century
art was political protest.

Popular music, film, literature, and other mass media are in one
way inherently democratic art forms. The public supports some bands,
novels, and films, ignoring other well-publicized mass art. However
authoritarian the system of production, success in mass art depends
upon public response. By contrast, museums, inherently paternalistic
institutions, aim to attract the larger public, but collect according to
frankly elitist standards. In the old regime, culture was controlled from
above, but once public art museums depended upon public support,
then their identity was essentially divided. By making precious old mas-
terpieces democratically accessible, taking elite art and displaying it in

public spaces, museums mark the survival of the old regime into an era of mass culture. As we have seen, their very physical layout identifies this history. This strength of museums, their ability to preserve earlier cultures, also points to a real problem. How can older art be made available to a modern public?[49]

> The museum bequeathed to us by the Revolution continues to operate on the paradoxical principle of an institution ostensibly open and populist but infused by the exclusive tastes of an Old World elite and full of art fit for kings.

Contemporary art in the museum poses the same problem.

Visual art in galleries mostly attracts only art-world audiences, but once it moves into the museum, we would like the larger public to be excited, challenged, and engaged. We want museums to have the role of opera in nineteenth-century Italy, when Verdi's premiers attracted passionate adulation. But Thomas Crow's vision of the public space devoted to visual art remains utopian, for Foster's heroes—Marcel Broodthaers, Barbara Kruger, and Sherrie Levine—as much as the figures I most admire, are unknown outside the art world. Even Andy Warhol, the most celebrated recent American artist, was never remotely as famous as the movie stars he worshipped, imitated, and publicized. Compared with mass culture or spectator sports, the visual arts only interest an elite. And so the desire for socially critical contemporary art expresses, in part, the legitimately uneasy conscience of the art world, which seeks to engage historically elitist institutions in popular concerns.

In the thirtieth-anniversary issue of *Artforum*, September 1993, some contributors looked backward at the history of the magazine, and sought to judge its present state. Observing that it was easy to be nostalgic for intellectually adventuresome journal of the late 1960s, Thomas Crow noted that[50]

> *Artforum* today cannot be the magazine one rediscovers in those old bound volumes . . . the entire economy of writing about art has changed because the economy of art has changed in its scale and fundamental character.

In the 1940s, only a few New Yorkers were interested in the American abstract expressionists, but now, when many curators in America and

Europe are concerned with locating and showing the very newest visual art, artists and critics are part of the larger society, not outsiders. Observing, then, that *Artforum* "was never anything but a lived contradiction between thought and commerce," Crow concludes by claiming that, "simply getting back to a state of effective contradiction" between intellectual debate and such commercial interests "is the task of the moment." Here he fails to think through the logic of his own account of the relation between art and commerce. Diderot's *Salons*, Crow notes, were destined for a tiny audience—not the public visiting the shows in Paris.[51]

> Diderot's *Salons* were . . . contractually barred from the actual public sphere and increasingly took on a form and scope which the illicit . . . print trade in Paris could never have supported.

But when writing about contemporary art is part and parcel of an art-world bureaucracy, entirely dependent, ultimately, upon commercial interests, then a contradiction between thought and commerce is no longer possible.

Once an artist attains commercial success, his or her art has a role in the life of our present-day culture. Richard Serra is thought by some of his champions to be severely critical of capitalism, and Cindy Sherman is often said to offer a subversive perspective on images of women. However we judge these interpretations, these famous artists do provoke discussion about important issues, which is to say that there really is no contradiction between intellectual debate and commercial interests. In 1985, when he was a journalist, Foster praised "works that recall a repressed source or marginal sign-system in such a way as to disturb or displace the given institutional history of an art or discipline."[52] More recently, he has insisted that "critical theory is immanent to innovative art."[53] But now, when Foster occupies an endowed chair at Princeton University, he is not an outsider. Like other leftists, Foster often cites Marx, Baudelaire, Benjamin, and Adorno as role models. All of those men wrote in genuine opposition, at some level, to their own cultures. Marx, Baudelaire, and Benjamin were marginal intellectuals, and Adorno a political refugee, but nowadays, critical theory and leftist art history are perfectly respectable academic subjects.

"A public audience in the ideal modern sense," Crow writes, "articulate, independent, potentially resistant—was fundamentally at odds with the rigorously corporate character of Old-Regime high culture."[54] In our society, this vision of an independent public audience is still a utopian fantasy, for museums and galleries are the corporate cultures of high art. In the last days of the old regime, Crow plausibly indicates, critics writing about the *Salons* could only act in opposition to the government because they had no place within the governing elite. But the French Revolution destroyed this autocratic structure, and in our bourgeois culture leftist academics are as much a part of an unruly, democratic system as anyone else.

Nostalgia for the situation of French intellectuals, circa 1765, or Adorno and Benjamin in the 1930s, prevents Foster and other leftists from understanding the present. Neither our leftist critics nor the artists they champion are outsiders. This does not necessarily mean that leftists will triumph, or even be taken seriously, but it does show that they are not impotent outsiders. In truth, since our modern distinction between the left, the right, and the center was a product of the French Revolution, now the limits of that way of identifying political positions have become apparent. In a famous phrase in 1939, Clement Greenberg looked "to socialism *simply* for the preservation of whatever living culture we have right now."[55] Greenberg's views of art and politics differed from those of Foster's critical theorists, but his description of the few heroic abstract expressionists and their supporters struggling against an indifferent or even hostile American society conveys the same affect. But, as Crow has observed, the changed world and the art world make this view passé.[56] Political artists and advocates of critical theory face an escapable dilemma. When they achieve success, they become part of the system they would criticize. In that way, these artists are like 1960s pop musicians praising revolution who became very successful members of the establishment.

The attempts of many American critics to treat the central goal of contemporary art as providing political criticism thus are doomed. Analysis of

the narrative nature of art writing shows, I am arguing, that this independent critical role is no longer possible for art criticism. That does not mean that art writers are condemned to be apolitical, but only that we must offer a political analysis that is consistent with the present role of art-critical writing.[57] The next chapter provides the sketch of one such account.

Notes to Chapter 5

1. Ian Burn, "Pricing Works of Art," *The Fox* 1, 1, 1 (1975), 54.
2. But see *Adventures in Art: 40 Years at Pace*, Ed. Mildred Glimcher, with recollections by Arne Glimcher (New York: PaceWildenstein, 2001); *Art Gallery Exhibiting: The Gallery as a Vehicle for Art* (Pual Andriesse: Uitgeverik De Balie, 1996); and *Inside the Art World: Conversations with Barbaralee Diamonstein* (New York: Rizzoli, 1994).
3. I focus on galleries devoted to contemporary art. Galleries devoted to older art do not inspire a distinctive form of writing.
4. In China, in the absence of a domestic art market, artists seek out visiting critics and curators. The Soviet Union had museums and artists, but no commercial art market and so had a very different view of the relation of contemporary art to history. See Boris Groys, "The Struggle Against the Museum; or, The Display of Art in Totalitarian Space," *Museum Culture: Histories, Discourses, Spectacles*, Daniel J. Sherman and Irit Rogott, eds. (Minneapolis: University of Minnesota Press, 1994), ch. 8.
5. Dave Hickey, "An Address Regarding the Consequences of Supply-Side Aesthetics," *Art Issues* (Summer 1998): 11.
6. On the history of collecting, see Joseph Alsop, *The Rare Art Traditions: The History of Art Collecting and Its Linked Phenomena* (New York: Harper & Row, 1982).
7. A subtle historical discussion of the relation between art and money, and the complex relationship between aesthetic and economic value, is found in Marc Shell, *Art & Money* (Chicago and London: University of Chicago Press, 1995). A sociological account appears in Diana Crane, *The Transformation of the Avant-Garde: The New York Art World, 1940–1985* (Chicago and London: University of Chicago Press, 1987).
8. See Peter Schjeldahl, "Gallery Phobia," *The 7 Days: Art Columns 1988–1990* (Great Barrington, Massachusetts: The Figures, 1990), 139–41 and Dave Hickey, *Air Guitar: Essays on Art & Democracy* (Los Angeles: Art Issues Press, 1997).
9. Kenneth Clark, *Piero della Francesca* (Oxford: Phaidon [second edition] 1969), 34.
10. Bill Berkson, "What Piero Knew," *Art in America* 81 (December 1993): 89.
11. See my *Principles of Art History Writing* (University Park and London: Pennsylvania State University Press, l991), ch. 2.
12. I use Bertrand Russell's well-known distinction in a personal way. See D. F. Pears, *Bertrand Russell and the British Tradition in Philosophy* (New York: Random House, 1967), ch. VI.
13. See my "Robert Ryman on the Origins of His Art," *Burlington Magazine*, 1134, v. CXXXIX (September 1997): 631–33.
14. Dave Hickey, *Air Guitar*, 70.
15. Lisa Jardine, *Worldly Goods: A New History of the Renaissance* (New York and London: W. W. Norton, 1996), 19.

16. Richard Polsky, *Art Market Guide: Contemporary Art* (San Francisco: Marlit Press, 1998), 14–15, 97, 122, 105. This material is now updated on *www.artnet.com/Magazine/features/polsky/*.

17. Charles Baudelaire, *Art in Paris 1845–1862*, translated by Jonathan Mayne (London: Phaidon, 1965), 117. See my *High Art: Charles Baudelaire and the Origins of Modernism* (University Park and London: Pennsylvania State University Press, 1996), ch. 3.

18. This controversial claim is discussed in my "Art Museums, Old Paintings and our Knowledge of the Past," *History and Theory* 40 (May 2001): 170–89.

19. Michael Fried, *Art and Objecthood: Essays and Reviews* (Chicago and London: University of Chicago Press, 1998), 229.

20. Clement Greenberg, *The Collected Essays and Criticism: Volume 4. Modernism with a Vengeance, 1957–1969*, John O'Brian, ed. (Chicago and London: University of Chicago Press, 1993), v. 4, 96, 95.

21. Fried, *Art and Objecthood*, 108–9, 126.

22. Diane Upright, *Morris Louis: The Complete Paintings* (New York: Harry N. Abrams, 1985), 26–27.

23. John Elderfield, *Morris Louis* (New York: Museum of Modern Art, 1986), 53.

24. Arthur C. Danto, *Encounters & Reflections: Art in the Historical Present* (New York: Farrar, Straus, Giroux, 1990), 48, 49. He refers to my "New York, Museum of Modern Art. Morris Louis 1912–1962," *Burlington Magazine* (December 1986): 926–27.

25. Rene Richard, "Not about Julian Schnabel," *Artforum* (Summer 1981), 79.

26. *Brice Marden: The Grove Group* (New York: Gagosian Gallery, 1991), 10–11.

27. Jeremy Gilbert-Rolfe, "Brice Marden's Painting," *Artforum* 13 (October 1974): 30–38.

28. Stephen Bann, "Brice Marden: From the Material to the Immaterial," *Brice Marden: Paintings, Drawings and Prints 1975–80* (London: Whitechapel Art Gallery, 1981), 13.

29. Dave Hickey, "Bridget Riley for Americans," *Bridget Riley: Paintings 1982–2000 and Early Works on Paper* (New York: Pace Wildenstein, 2000), 9.

30. Yve-Alain Bois, "Richard Serra. Dia Center for the Arts," *Artforum* (January 1998): 97.

31. Frank Stella, *Working Space* (Cambridge, Massachusetts and London: Harvard University Press, 1986), 1, 11, 60, 89, 134, 158, 160.

32. Peter Halley, *Collected Essays 1981–87* (Zürich and New York: Bruno Bishofberger Gallery and Sonnabend Gallery, 1988), 137, 149.

33. Kirk Varnedoe, *A Fine Disregard: What Makes Modern Art Modern* (New York: Harry N. Abrams, 1990), 25.

34. But thus linking Stella to tradition does not necessarily show that his painting has as much value as what came earlier, for it would be possible to argue that in extending tradition he has lost what value in earlier art. See Richard Hennessy, "The Man Who Forgot How to Paint," *Art in America* 72 (Summer 1984); 13–25.

35. See Otto Karl Werckmeister, *Icons of the Left* (Chicago and London: University of Chicago Press, 1999).

36. G. W. F. Hegel, *Aesthetics: Lectures on Fine Art*, translated by T. M. Knox (Oxford: Clarendon Press, 1975), 885, 886, 887.

37. John Michael Montias, *Artists and Artisans in Delft: A Socio-Economic Study of the Seventeenth Century* (Princeton: Princeton University Press, 1982), 220.

38. Michael North, *Art and Commerce in the Dutch Golden Age*, translated by Catherine Hill (New Haven and London: Yale University Press, 1997), 4.

39. Jakob Rosenberg, Seymour Slive, E. H. ter Kuile, *Dutch Art and Architecture: 1600 to 1800* (Harmondsworth, Middlesex: Penguin, 1966), 20, 17, 19.

40. G. W. F. Hegel, *The Phenomenology of Mind*, translated by J. B. Baillie (New York and Evanston: Harper & Row, 1967), 513. See Terry Pickard, *Hegel's Phenomenology: The Sociality of Reason* (Cambridge: Cambridge University Press, 1994), 163–65.

41. Hal Foster, *The Return of the Real: The Avant-Garde at the End of the Century* (Cambridge, Massachusetts and London: MIT Press, 1996), 28.

42. Hal Foster, *Recodings: Art, Spectacle, Cultural Politics* (Port Townsend: Bay Press, 1985), 52.

43. Foster, *The Return of the Real*, 72.

44. Foster, *The Return of the Real*, 120 and 258 n. 36.

45. Foster, *Recodings*, 131–32.

46. T. J. Clark, *The Absolute Bourgeois: Artists and Politics in France 1848–1851* (London: Thames and Hudson,1973), 179.

47. "Redemption Through Painting: Late Works of Morandi," *Giorgio Morandi*, exhibition catalogue (Des Moines: Des Moines Art Center, 1981), 45.

48. Hegelian theories linking art to society ultimately treat the evidence in a circular way, as when Arnold Hauser deduces the qualities of seventeenth-century French painting from his picture of the culture:

> The archaic severity, the impersonal stereotyped quality, the die-hard conventionalism of classicist art. . . . were certainly characteristics in accordance with the aristocratic outlook on life . . . but the rationalism of classicist art was just as typical an expression of the middle-class philosophy as of that of the nobility. This rationalism was, in fact, rooted in the bourgeois way of thinking more deeply than in that of the nobility.

Arnold Hauser, *The Social History of Art: Volume Two*, translated by Arnold Hauser and Stanley Godman (New York: Vintage, nd), 2, 201, 202. As Hauser is honest enough to admit, his attempt to link Poussin with bourgeois patrons fails: "In spite of Poussin's rationalism, the naturalist Louis Le Nain is the middle-class painter par excellence."

49. Andrew McClellan, *Inventing the Louvre: Art, Politics, and the Origins of the Modern Museum in Eighteenth-Century Paris* (Berkeley, Los Angeles, London: University of California Press, 1994), 12.

50. Thomas Crow, *Modern Art in the Common Culture* (New Haven and London: Yale University Press, 1996), 86, 93.

51. Thomas Crow, "Diderot's *Salons*: Public Art and the Mind of the Private Critic," *Diderot on Art* (New Haven and London: Yale University Press, 1995), xv.

52. Foster, *Recodings*, 123.

53. Foster, *The Return of the Real*, xvi.

54. Thomas Crow, *Painters and Public Life in Eighteenth-Century Paris* (New Haven and London: Yale University Press, 1985), 254.

55. Clement Greenberg, *Art and Culture* (Boston: Beacon, 1961), 21.

56. See Crow, "Modernism and Mass Culture in the Visual Arts," *Modern Art in the Common Culture*, ch. 1.

57. In his critical account of my *Artwriting* (*Shows of Force: Power, Politics, and Ideology in Art Exhibitions* [Durham and London: Duke University Press, 1992], 288), Timothy Luke argues that

> in fact, art criticism can . . . be an important form of cultural and political criticism, and this sort of politicized cultural critique must delve into the real conflicts over ideology, domination, and resistance in contemporary states and societies.

I would (now) agree.

The features that characterize oneself and one's life are similar to the features of literary works. The virtues of life are comparable to the virtues of good writing—style, connectedness, grace, elegance—and also, we must not forget, sometimes getting it right.

—*Alexander Nehamas*[1]

CHAPTER SIX:
Defining Art: How We Do Things with Words

Art museums and galleries tell the story of art from its origin up to the immediate present, the gallery completing the history presented in the museum. They make it possible for critics and historians to have open-ended conversations about the paintings and sculptures on display, knowing that alternative perspectives are possible. And another, different form of writing also deals with this art. Aesthetic theory, a branch of philosophy, defines art, identifying the common features of all the objects in our museums and galleries. Having said a great deal about art writing, now it is time to look at the philosophy of art.

Aesthetic theory presents an abstract argument demonstrating what visual thinking allows us to observe directly, that the history of art is indeed one. Art writing is rhetoric, we have seen, for visual thinking projects one interpretation, making it as convincing as possible whilst allowing us to recognize that other perspectives are possible. The art described in a historian's or critic's narrative can be identified differently. And a museum or gallery display is merely provisional, for set in another context, that art might be understood differently. By contrast, the philosophy of art gives a timelessly true account of art's essence. Like all philosophy, it aims for generality, offering not merely one point of view, but an analysis transcending all perspectives.

In some ways, this role of aesthetic theory was anticipated by that art writing discussed in chapter 3, which seeks to avoid the narrative structures of normal art criticism and art-history writing. Focusing on the

presence of art, such writing calls attention to the presence of individual paintings or sculptures, without setting them in a narrative structure. That way of thinking, we saw, ultimately fails. Visual art must be interpreted—we cannot simple point to its all-at-onceness and say, "there it is." The aesthetician's definition of art also seeks to escape the confines of temporal narratives, but in a very different, much more successful way. Hegel, Danto, and other aestheticians, abstracting away from the features of individual works of art, characterize the entire body of visual art.

Part I identified the structures of art writing, and chapters 4 and 5 linked the literary analysis of art writing with a sociological account of art displays. But we still need to explain why works of art are gathered in our museums and galleries. Why are we so concerned nowadays with writing about and displaying art? What functions do our art writing and displays serve? Aesthetics answers these questions, telling what things are art and explaining why they have value. The presentation of aesthetic theory thus is necessary to complete the picture of the art world presented in this book.

Twentieth-century painters and sculptors consistently produced counterexamples to the established definitions of art. Philosophers claimed that art had to represent something, but artists made abstract paintings. Philosophers said that all art had significant form, or is expressive, and then artists made art from banal, inexpressive artifacts without significant form. The story of late modernist aesthetics is, in part, the search for criteria adequate to radically original art. When, in the 1960s, artists outflanked older definitions of art, Arthur Danto was the aesthetician who most interestingly met their challenge.

Danto's writings, combining a timelessly true definition of art with a historical account of art, have this dual identity because he has two quite distinct goals. Like Gombrich and Greenberg, Danto narrates the history of art. Gombrich tells the story of naturalism, Greenberg presents the development of modernism, and Danto explains why *Brillo Box* was art in 1964. *Brillo Box* could not have been a work of art in 1900, not because Brillo was not yet invented, but because it was slightly too early for any such mass-produced object to be art. But once *Brillo Box* was displayed, it revealed what art

essentially is. Gombrich and Greenberg are historians, not philosophers, and so they are not especially concerned with defining art. Danto is both historian and philosopher, so he provides both a historical and an atemporal analysis, explaining both where *Brillo Box* fits into the history of art and why it is in museums.

Earlier we considered individual indiscernibles like *Brillo Box*, visually indistinguishable artifacts with quite distinct qualities. Now, extending that procedure, consider two art museums containing visually indistinguishable objects. The first museum displays one hundred masterpieces, surveying the history of art from Giotto to Warhol. The second exhibits very good copies of these paintings.[2] For the casual visitor, who cannot tell the forgeries from originals, these institutions are indistinguishable. But for the connoisseur or the aesthetician, they are very different. In our culture, a mere forgery is not normally a work of art. (The exception, which proves the rule, is that a post-historical forgery can be art commenting on its nature as art.) The second institution contains no art, and so is not an art museum. The lesson provoked is Dantoesque—to properly identify a museum, you need a theory of art. We value art not just for its appearance, but for its authenticity. A collection of very good forgeries, artifacts visually indistinguishable from genuine works of art, has no aesthetic or historical value.

In order to develop a properly Dantoesque account of museums and galleries, we need to put his theory in historical context, in relation to the history of aesthetics. The philosopher is interested in many cases when banal actions or objects were dubbed art by virtue of their association with written theorizing. And so he may think of defining art as a form of verbal action. In his 1955 William James Lectures at Harvard University, published as *How to Do Things with Words*, J. L. Austin discussed the ways that language is employed, not only to state facts, but also to perform actions. When someone performs a marriage or divorce, christens a ship, or makes a bet or a will, then "the issuing of the utterance is the performing of an action—it is not normally thought of as just saying something."[3] This chapter's subtitle, "How We Do Things with Words," referring to Austin's title, alludes to the ways that art writing performs actions. In defining visual art, we will see, written and spoken language creates an art-world community.

What Austin calls performatives—marrying, betting, bequeathing, christening, and so on—require that[4]

> there must exist an accepted conventional procedure having a certain conventional effect, that procedure to include the uttering of certain words by certain persons in certain circumstances.

Consider his six conditions, here paraphrased and abbreviated:

1. We require that there is this conventional procedure
2. The persons and circumstances must be appropriate
3. The procedure executed correctly
4. And completely
5. The persons involved must have appropriate feelings and intend to conduct themselves appropriately
6. And must actually do so

These conditions can also explain how 1960s experimentation created art.

On August 21, 1966, at 5:07 P.M. in Nevada, for example, Ed Ruscha threw a typewriter out of a speeding car, took photographs of this event, and published them in his book *Royal Road Test*.[5] Merely throwing a typewriter out of a car was not enough to make art. Ruscha was an appropriate person to make art, he obeyed the conventions for art making, and he documented his action. And so, according to the conventions of the 1960s art world, his act produced a work of art.

Philosophers traditionally define art in ontological terms, identifying what sorts of things works of art are. Thus Plato argues that art is representation:[6]

> Do we not make one house by the art of building, and another by the art of drawing, which is a sort of dream created by man for those who are awake;

Aristotle claims that

> imitation is natural to man from childhood, one of his advantages over the lower animals being this, that he is the most imitative creature in the world, and learns at first by imitation;

Kant writes that

in a judgment of taste (about the beautiful) the satisfaction in the object is imputed to *everyone*, without being based on a concept (for then it would be the good);

Hegel describes the

universal demand for artistic expression . . . based on the rational impulse in man's nature to exalt both the world of his soul experience and that of nature itself into the conscious embrace of mind as an object in which he rediscovers himself;

Schopenhauer says that

the comprehended Idea . . . is the true and only source of every work of art. In its powerful originality, it is only derived from life itself, from nature, from the world, and that only by the true genius, or by him whose momentary inspiration reaches the point of genius;

and in Nietzsche we read that

art is bound up with the *Apollonian* and *Dionysian* duality: just as pro-creation depends upon the duality of the sexes, involving perpetual strife with only periodically intervening reconciliations.

These highly abstract definitions show how philosophers have responded to the changing practice of artists.

Responding to this long tradition in light of modernism, the art historian George Kubler wrote:[7]

Let us suppose that the idea of art can be expanded to embrace the whole range of man-made things, including all tools and writing in addition to the useless, beautiful, and poetic things of the world.

His account, published in 1962, anticipated Danto's encounter two years later with Warhol's *Brillo Box*. "To be a work of art," Danto says, "is to be (i) *about* something and (ii) to *embody its meaning*."[8] Like Plato, Aristotle, Kant, Hegel, Schopenhauer, and Nietzsche, he identifies the necessary and sufficient conditions required to define art. Duchamp's *Fountain* is art because "beauty indeed could form no defining attribute of art" and *Brillo Box* is art because, "public, bland, obvious, and uninteresting" as it is, Warhol's object affirms that "reliable symbols of everyday life," as much as the abstract expressionist's grand timeless subjects, could be art.[9]

Duchamp's and Warhol's works of art are about, and so embody, these statements about their identity.[10] And *Royal Road Test* is art, for Ruscha's action, unlike the otherwise similar destruction of a typewriter by a nonartist, was self-consciously meant to reveal the nature of art. Danto's definition responds to this modernist art but his general way of thinking, George Leonard notes, was anticipated by the Romantics:[11]

> Natural Supernaturalism has been about awakening to the world; now we awaken to what Natural Supernaturalism did to the artworld. We know ourselves, and thereby, free ourselves. . . . There's every chance we may decide that one of the experiences we want to continue having from art is what transfigurationist art has given us: the awakening, the wonder.

They too thought that quite banal everyday things could be works of art.

Danto's definition covers Christian and Buddhist altarpieces, Persian carpets, Hindu temple sculpture, minimalist paintings, pop art, happenings, photographs, videos, and other sorts of artifacts. And it excludes many seemingly similar actions or things, for a great deal of art being made in the 1960s looked similar to non-art. Yoko Ono's Fluxus performances, for example, were works of art, but similar banal everyday actions are not.[12] When Vito Acconci followed strangers through the streets of Manhattan, his performances were art, but similar acts of surveillance by working detectives following suspects are not art.[13] And Ed Ruscha's very literal photographs of Los Angeles buildings were works of art, but comparable photographs made by the city planning commission were not.[14]

The need to distinguish art from non-art thus certainly became pressing in the 1960s, but it was not altogether new. Bernini was the supremely successful baroque Catholic artist because his art embodied the church doctrines. The masses in S. Maria della Vittoria are about Christ's transfiguration, and embody the church doctrine of transubstantiation, but they are not art, unlike Bernini's sculpture depicting Saint Teresa, which[15]

> creates a supra-real world in which the transitions seem obliterated between real and imaginary space, past and present, phenomenal and actual existence, life and death.

We need to distinguish the artistic embodiment of Catholic dogma in Bernini's sculpture from those masses. Bernini's definition of art was unlike ours, and his Rome had neither public art museums nor our so intensively developed art writing. But his sculpture was art, and the extension of our conception of art to include things like ready-mades has not led to the expulsion of baroque sculpture from the art world. In fact, the urinal, or Brillo box, becomes art in one stage of a long process which took baroque Christian art, Buddhist sculptures, African tribal masks, and Chinese jades and made them into art as museums expanded.

How can we know if something satisfies Danto's conditions? One easy way to know that a work of art is *about* something and that it *embodies its meaning* is to see it in an art museum or gallery, or described in art writing. When you buy a urinal or a box of Brillo, you do not ask why these things are in the stores, for it is self-evident that they serve practical functions. Art does not, and so when something unusual is exhibited, or described in art writing, we expect that an interpretation is at hand. Set *Fountain* or *Brillo Box* in a gallery, or a survey history, and very soon someone will ask why they are there. Gallery owners or museum curators, like critics and historians, are prepared for questions when objects they display do not look like familiar art. They are ready to say what these objects are about and how they embody their meaning.

Danto identifies a difference in kind between an ordinary object and the indiscernible work of art. This difference is not physical, for no visual test will distinguish *Fountain* from an indistinguishable urinal, nor contrast *Brillo Box* with a mere Brillo box. Faced with a forgery of a painting by Morandi, we look closely, knowing that small, initially obscure seeming details may determine how we evaluate this object. But no such tests are appropriate for *Fountain* or *Brillo Box*. Danto's claim that there is an ontological difference between *Fountain* or *Brillo Box* and their indiscernibles suggests that this difference is like the difference between the bread and wine used in communion and what, for the Catholic believer they become, the body and blood of Christ. In the mass, too, a very dramatic difference is not physically observable.

This obvious link between Danto's aesthetic and theology is reinforced by his title, *The Transfiguration of the Commonplace*, derived from an imaginary book attributed in Muriel Spark's novel *The Prime of Miss Jean Brodie*. Spark's heroine, Sandy Stranger, became a nun, Sister Helena, and wrote a "strange book of psychology," famous enough to bring many visitors to her nunnery.[16] As Danto imagines it, this book "would have been about art" as Spark practiced it. "The practice, I suppose consisted in transforming commonplace young women into creatures of fiction, radiant in mystery: a kind of literary caravaggism."[17] Spark is of Jewish origin but became a Catholic, as in her novel the heroine is a Calvinist-born Edinburgh girl who becomes a nun.[18] And so, it is hardly wild speculation to link *The Transfiguration of the Commonplace* with theology. But to reduce *Fountain* "to a performative homiletic in demo-Christian aesthetics," Danto says, "obscures its profound philosophical originality."[19] Fair enough, especially since an alternative Protestant interpretation treats communion bread and wine as symbols in a ceremony establishing the community of believers.

One difference between *Fountain* and a urinal, or *Brillo Box* and a Brillo box, is obvious. Only when such artifacts are set in the gallery do they inspire discussion amongst art writers. This difference between finding them in a store and in the gallery is like the difference between the words "I pronounce you man and wife" as used in a proper legal ceremony and in a play. We may define art by reference to its capacity to become an object of discussion amongst art writers.[20] Danto's claim that *Fountain* and *Brillo Box* are very different from their indiscernibles can never be proved, for it is, to speak in the jargon of logical positivism, unfalsifiable. Since no empirical evidence is relevant here to evaluating this metaphysical thesis, what really should concern us, it is arguable, is not the physical qualities of these artifacts, but their role in a ceremony in which art is defined.[21] *Fountain* and *Brillo Box* are in museums, unlike their indiscernibles. Seeing *Fountain* in the Philadelphia Museum of Art, surrounded by Duchamp's body of art is very different from viewing an anonymous urinal in a shop amidst other plumbing fixtures. In the

museum, we treat it as art, while in the plumber's shop the same urinal is merely a utilitarian object. (A similar analysis can be offered of *Brillo Box*.) How much more different could two visually indistinguishable things be?

Let us define art, then, not in Danto's ontological terms, but with reference to the community interested in art writing. Doing this does not necessarily involve arguing with his claims, but it does refocus, linking his analysis to our account of art writing. This turn in our discussion was anticipated, in part, by George Dickie's institutional theory of art, an analysis much discussed by aestheticians but little known to art critics.[22] In 1964, Danto published his short essay "The Artworld," and his ideas were taken up by Dickie, who developed them in quite different ways. Philosophers of art "entirely ignored the nonexhibited property of status," Dickie wrote. "When . . . the objects are bizarre . . . our attention is forced away from the objects' obvious properties to a consideration of the objects in their social context."[23] Appeal to this community means that "when an object's status depends upon nonexhibited characteristics, a simple look at the object will not necessarily reveal that status."

Dickie seems to come very close to making Danto's claim that the identity of the work of art is not defined by its physical qualities. But while Danto then goes on to conclude that the distinction between art and non-art must be ontological, *Fountain* differing from a physically identical urinal, and *Brillo Box* from a Brillo box, because they have different essential qualities, Dickie explains these differences in sociological terms.[24] The difference between *Fountain* or *Brillo Box* and their physical counterparts is merely that they are in different kinds of places, art galleries and museums, not plumbing shops or grocery stores.

Unlike Danto's analysis, Dickie's did not carry conviction, for his account of the art-world system was very thin. As Richard Wollheim noted, Dickie failed to note that art writers do not simply arbitrarily declare things to be art, but offer reasons for their decisions.[25] But after repairing that omission, we can learn from Dickie's conception of an art-world community. "The artworld consists of a bundle of systems," Dickie writes, "each of which

furnishes an institutional background for the conferring of the status on objects within its domain."[26] A community is formed as soon as you and I find some object worth talking about, even if we are the only people who take an interest in that artifact. When our shared interest leads us to record our dialogue, it is possible that soon enough readers, too, will come to share our interest.

Other commentators also describe this art-world community. Craig Owens says,[27]

> I've come to regard the production of aesthetic meaning and value as a collective enterprise . . . as the product of a group of curators, art historians, caption writers, preparators, docents, lecturers, art historians, and even dealers and collectors . . . acting together . . . to produce what we think of as being the meaning of the work of art, and the value of the work of art.

Dave Hickey writes:[28]

> Works of art in this culture do not *have* determinate or discoverable meanings . . . Works of art mean what the consensus of opinion says they mean at any particular moment, and all of us who write about art, whether we admit it or not, are arguing as persuasively and plausibly as we can, hoping that our views will prevail.

Frank O'Hara, too, invoked this idea, in his response to a high school student who asked whether it was in poor taste to admire a painter who appeals to teenagers,

> It is never in poor taste to admire anyone, except possibly someone like Hitler. . . . If what he paints appeals to teenagers, it should hardly be held against him since teens are the future and an integral part of his audience.[29]

Theodore Zeldin, speaking in a more general way, notes: "I see humanity as a family that has hardly met. I see the meeting of people, bodies, thoughts, emotions, or actions as the start of most change."[30] And Hegel's aesthetics, as we saw in chapter 2, invokes an ideal of community.

Danto, too, dealt with this concern when he argued that the contemporary performance artist, or what he calls[31]

> the disturbatory artist aims to transform her audience into something

pretheatrical, a body which relates to her in some more magical and transformational relationship than the defining conventions of the theater allow.

He is commenting on Nietzsche's description in *The Birth of Tragedy* of how the audience was set aside from the drama. According to Nietzsche, originally the entire[32]

> scene, complete with the action, was basically . . . a vision; the chorus is the only "reality" and generates the vision. . . . In its vision this chorus beholds its lord and master Dionysus . . . it sees how the god suffers and glorifies himself and therefore does not itself act.

Danto suggests that Cindy Sherman[33]

> has reentered the pictures the performance artist has stepped out of, and done so in such a way as to infuse her images with the promise and threats of the performance artist's real presence.

United by an interest in art, these art lovers are in some ways like any group brought together by shared concerns.

Almost all of us belong to many communities. When, for example, an Orthodox Jew who is an analytic philosopher, registered Republican, and activist against capital punishment, moves from one of her communities to another, she may shift her priorities according to her setting. Communities may be defined in practical ways, as when they include everyone who lives on one short street, or in ideological terms, as when some analytic philosophers refuse to talk to their colleagues who admire Heidegger. Being in a community is compatible with thinking the ideas of others in that group foolish, harmful, or downright pernicious, but it does require believing that what they say deserves discussion. Our community devoted to contemporary art certainly is highly contentious. We argue about what artists are significant, about how art should be understood, and about the moral functions, if any, of art. But everyone shares the belief that some contemporary art, at least, has value.

The art-world community has no dues, formal membership requirements, or lists of members, but belonging to it is not entirely a subjective matter. Unless you know a certain amount about contemporary art, you

cannot belong to this community. A community is defined, in part, by willingness to engage in intellectual exchange. Art writers place themselves outside of that community when their beliefs are too eccentric. John Canaday, critic in the 1950s for the *New York Times*, reveals surprising taste, as when in 1961 he compared Dubuffet to Rembrandt in a remarkably sympathetic review.[34] But he became highly hostile to the leading movement of his day, writing in 1959 that

> in a wonderful and terrible time of history, the abstract expressionists
> have responded with the narrowest and most lopsided art on record.
> Never before have painters found so little in so much,

and saying in 1961 that Rothko "seems to have brought himself (almost literally) to a blank wall in his largest and latest and simplest paintings." In 1961, fifty-five people, including Willem de Kooning, Robert Motherwell, Harold Rosenberg, and Meyer Schapiro, published an open letter stating that in imputing to his opponents "dishonorable motives, those of cheats, greedy lackeys, or senseless dupes," Canaday had put himself outside their community.

If you set yourself too firmly against too much contemporary painting, then you effectively leave the art-world community. Like Canaday, Hilton Kramer was a *Times* reviewer with surprisingly Catholic tastes. But when he makes fun of a variety of contemporary art writers, complaining of Benjamin Buchloh, for example, that his[35]

> Marxist analysis of the history of modern art . . . appears to be based
> on Louis Althusser's *Lenin and Philosophy*. (Is this really what is taught
> as modern art history . . .? Alas, one can believe it),

then he writes like a philistine. Kramer, who surely knows that Marxist views of modernism are much discussed, takes the position of a know-nothing uninterested in dialogue. When Thomas Lawson spoke of how Kramer's[36]

> observations are for the most part trite, obvious, and topical, his ful-
> minations predictable, his rhetoric repetitious and ultimately boring.
> That such a man . . . has attained the status he has bodes ill for the
> continued health of art in America,

he expressed the art-world consensus.

Being a member of a community involves a certain capacity to accept and enjoy styles of writing and art which are not, as the saying goes, one's own. Buchloh is not my critic, for when he explains how Sherrie Levine's[37]

> work . . . threatens with its very structure, mode of operation, and status the current reaffirmation of individual expressive creativity and its implicit affirmation of private properly and enterprise. . . . Levine's work places itself consistently against the construction of the spectacle of individuality,

I find his claims very implausible. But as Roland Barthes says about Layola, "to live with an author does not necessarily mean to achieve in our life the program that author has traced."[38] I find it fun sometimes to read an art writer, Buchloh or Kramer, whose thinking is very different from mine. And there is a positive value to plurality of tastes, for "in mercantile democracies like the United States a big part of art's job is to allow people to distinguish themselves from one another."[39] I would distinguish between issues that divide a community, as when the destruction of Richard Serra's *Tilted Arc* was supported by Arthur Danto and Peter Schjeldahl, but not probably by majority opinion within the art world, and issues which tend, by contrast, to unify our community. Almost everyone in the art-world community supported Robert Mapplethorpe's right to have his exhibitions publicly funded, whatever they thought about his photographs.

Tom Wolfe's *Painted Word* (1975), a funny account of social life in the art world, shows too little interest in art and theorizing for him to belong to the community. Similarly, when in "The Malignant Object: Thoughts on Public Sculpture" the philosophers Douglas Stalker and Clark Glymour remark that[40]

> what is undeniable about nearly every critical account of the message of one or another school of contemporary art is that the message . . . is *esoteric*, and cannot be garnered from any amount of gazing at, climbing on, or even vandalizing of the object,

then they set themselves outside the art world. What defines an outsider is the belief that the issues under discussion are not worth talking about. No one can be a member of every community, and there is nothing wrong

with being an outsider to the art world. That said, there is something obviously narrow-minded about dismissing points of view unlike one's own. To be a member of a community requires the willingness to engage in dialogue. And that means that a certain tolerance is built into the very notion of a community, if only because getting along requires a certain degree of mutual respect. A community in itself is not necessarily a good thing, but often there is positive value in community.

Let us return now, in conclusion, to Danto's definition, understood in relation to this discussion of the art-world community. For Danto, not only aesthetic artifacts like Chardin's paintings, Chinese scrolls, and Persian miniatures, but also many things which were not traditionally thought aesthetically pleasing, *Fountain*, *Brillo Box*, and also African tribal masks, Dada artifacts, Native American pottery, and Maori carvings for example, are works of art. This anti-aesthetic art, it is arguable, is understandable only against the background of aesthetic art, for only when there were museums could Duchamp and Warhol make their interventions. In any case, when Danto rejects the traditional link of art with what is aesthetic, his definition marks a dramatic change in sensibility, different in kind from the earlier expansions of the museum that merely extended the older boundaries of the aesthetic. Whatever the objections to points of detail in his analysis, clearly he is onto something very significant.

Traditional aestheticians debated the relative strength of poetry and visual art, some holding that words are more powerful because they are used to tell stories, others arguing that the illusionistic presence of pictures and sculptures makes them more potent. *"Ut pictura poesis"*—this argument about the relative power of words and pictures is an ancient dispute to which our analysis can contribute. We read about visual art in the narratives of art writers, and see it in the historical hangings of art museums. What then matters more, reading or looking? One aim of this book is to suggest why ultimately this question is impossible to answer. The conversations about art which permit us to learn of our values and our history, and how to respond to historically or temporally distant cultures, take place within the public spaces of museums and galleries and appear in per-

manent form in our art writing. Whether we define our community by reference to the literature of art, or by appeal to museums and galleries, we recognize the aesthetic value of this system of art-filled buildings and the spare philosophical theorizing it inspires.

Much of the most influential recent art aims to be anti-aesthetic, rejecting the traditional qualities of visual beauty. But, perhaps paradoxically, that familiar concern with "luxury, calm, and voluptuousness," to use Baudelaire's famous phrase, associated with beauty reappears when we look beyond this visual art itself to the ways in which it is displayed and written about. The entire art-world system we have studied—art writing, museums, galleries, and aesthetic theory—has implicit aesthetic value because of what, borrowing Nehamas's evocative phrase, we can characterize as its "style, connectedness, grace, elegance—and also, we must not forget, sometimes getting it right." He compares life to literature, and we relate art-world institutions to art writing, but like Nehamas, we are interested in the continuing relevance of aesthetic experience in a world often hostile to these ways of thinking. Art writing matters, we have shown, because it informs the ways we see visual works of art. Understanding the functions of this writing also is important, we can now add, because it makes it possible for us to understand this art world composed of art museums, galleries, and aesthetic theory, and thus to identify its very real aesthetic value.

Notes to Chapter 6

1. "Talking with Alexander Nehamas," *Bomb*, Fall 1998 No. 65: 38. I quote my fuller, original interview.

2. An imaginative Italian curator created such an exhibition, for which I wrote one catalogue essay, "Le opere d'arte false nell'era della riproduzione meccanica" *Museu dei Musei:* 29–34 (Littauer & Littauer, Firenze, September 1988), reprinted in my *Aesthete in the City: The Philosophy and Practice of American Abstract Painting in the 1980s* (University Park and London: Pennsylvania State University Press, 1994).

3. J. L. Austin, *How to Do Things with Words*, J. O. Urmson, ed. (New York: Oxford University Press, 1962), 6–7.

4. Austin, *How to Do Things with Words*, 14.

5. Lucy Lippard, *Six Years: The Dematerialization of the Art Object from 1966 to 1972* (Berkeley, Los Angeles, London: University of California: 1997), 22.

6. *Philosophies of Art and Beauty: Selected Readings in Aesthetics from Plato to Heidegger*, Albert Hofstadter and Richard Kuhns, eds. (New York: Modern Library, 1964), 47, 99, 288, 401, 482, 498.

7. George Kubler, *The Shape of Time: Remarks on the History of Things* (New Haven and London: Yale University Press, 1962), 1.

8. Arthur C. Danto, *After the End of Art: Contemporary Art and the Pale of History* (Princeton: Princeton University Press, 1997), 195.

9. Danto, *After the End*, 84; Arthur C. Danto, *Philosophizing Art: Selected Essays* (Berkeley, Los Angeles, London, University of California Press, 1999), 74, 77.

10. Recently Danto has observed that the art of fluxus, which was unknown to him when he worked out his original account of the art world built around pop art examples, would further complicate the analysis.

11. George J. Leonard, *Into the Light of Things: The Art of the Commonplace from Wordsworth to John Cage* (Chicago and London: University of Chicago Press, 1994), 191.

12. On Yoko Ono, see Lippard, *Six Years*, 117.

13. Lippard, *Six Years*, 117.

14. Lippard, *Six Years*, 11.

15. Rudolf Wittkower, *Bernini: The Sculptor of the Roman Baroque* (London: Phaidon, 1997 [fourth edition]), 159.

16. Muriel Spark, *The Prime of Miss Jean Brodie* (New York: Plume, 1961), 186.

17. Arthur Danto, *Transfiguration of the Commonplace: A Philosophy of Art* (Cambridge, MA: Harvard University Press, 1981), v.

18. When in 1944 Spark came to London, she lived at "The Helena Club," which appears in one of her novels and gives Sandy Stranger her name as nun; see her *Curriculum Vitae: Autobiography* (Boston and New York: Houghton Mifflin, 1993),

143. This Danto presumably could not have known when he published *The Transfiguration*.

19. Danto, *Transfiguration*, vi. My inspiration for this reading of Danto derives from an unpublished talk given by Boris Groys at the Bielefeld author conference devoted to Danto, April 18, 1997.

20. Defining art with reference to art writing—is this circular? An art writer is someone capable of making conversation such as ours about works of art. Any definition must start somewhere.

21. I take up this metaphysical thesis in my "Indiscernibles and the Essence of Art: The Hegelian Turn in Arthur Danto's Aesthetic Theory," forthcoming in the Library of Living Philosophers volume devoted to Danto.

22. My *Aesthetics of the Comic Strip* (University Park and London: Pennsylvania State University Press, 2000) anticipates this account. I argue that comic strips are best interpreted not with reference to the artists' intentions, but in relation to the audience's response.

23. George Dickie, *Art and the Aesthetic: An Institutional Analysis* (Ithaca and London: Cornell University Press, 1974), 32, 36.

24. For Danto's account of this difference with Dickie, see Danto, *After the End of Art*, 194. See also Thomas Crow, "The Birth and Death of the Viewer: On the Public Function of Art," *Dia Art Foundation: Discussions in Contemporary Culture*, Hal Foster, ed. (Seattle: Bay Press, 1987), 1–8.

25. Richard Wollheim, *Art and Its Objects: An Introduction to Aesthetics* (New York, Evanston, London: Harper & Row, 1968), 161.

26. Dickie, *Art and the Aesthetic*, 33.

27. Craig Owens, *Beyond Recognition: Representation, Power, and Culture*, Scott Bryson, Barbara Kruger, Lynne Tillman, and Jane Weinstock, eds. (Berkeley, Los Angeles, Oxford: University of California Press, 1992), 327.

28. Dave Hickey, "Simple Hearts: Still Writing Talk," *Art Issues* March/April, 1999, 11.

29. Frank O'Hara, *What's With Modern Art?: Selected Short Reviews & Other Art Writings*, Bill Berkson, ed. (Austin, Texas: Mike & Dale's Press, 1999), 30.

30. Theodore Zeldin, *An Intimate History of Humanity* (New York: HarperPerennial, 1994), 465.

31. Arthur Danto, *The Philosophical Disenfranchisement of Art* (New York: Columbia University Press, 1986), 131.

32. Friedrich Nietzsche, *The Birth of Tragedy,* translated by Walter Kaufmann (New York: Random House, 1965), 65.

33. Arthur C. Danto, *Encounters & Reflections: Art in the Historical Present* (New York: Farrar, Straus, Giroux, 1990), 123.

34. John Canady, *Embattled Critic: Views on Modern Art* (New York: Farrar, Straus and Cudahy, 1962), 166, 33, 144, 220.

35. Hilton Kramer, *The Revenge of the Philistines: Art and Culture, 1972–1984* (New York: The Free Press, 1985), 391.

36. Thomas Lawson, "Hilton Kramer: An Appreciation," *Artforum* (November 1984), 90–91.

37. Benjamin H. D. Buchloh, "Allegorical Procedures: Appropriation and Montage in Contemporary Art," *Artforum* (September 1982), 52.

38. Roland Barthes, *Sade/Fourier/Loyala,* translated by Richard Miller (New York: Hill and Wang, 1976), 7.

39. David Pagel, "The Myth of Selling Out," *Art Issues* 68 (Summer 2001), 20.

40. Douglas Stalker and Clark Glymour, "The Malignant Object: Thoughts on Public Sculpture," republished in *Writings About Art,* Carole Gold Calo, ed. (Englewood Cliffs, New Jersey: Prentice Hall, 1994), 298.

Index

About the Author

David Carrier is Champney Family Professor at Case Western Reserve University/Cleveland Institute of Art. His art criticism has been published in such journals as *Art in America, Artforum, Burlington Magazine,* and *Art International*. He has written books about Charles Baudelaire's art criticism, Nicolas Poussin's paintings, and the comic strip genre, and he has lectured extensively throughout the United States, Canada, Europe, New Zealand, and China. He lives in Pittsburgh, Pennsylvania.

 Books from Allworth Press

The Shape of Ancient Thought
by *Thomas McEvilley* (hardcover, 6 × 9, 752 pages, $35.00)

The Chronicles of Now
by *Anthony Haden-Guest* (paperback with flaps, 6 × 9, 224 pages, $19.95)

Sticky Sublime edited
by *Bill Beckley* (hardcover, 6 1/2 × 9 7/8, 272 pages, $24.95)

Out of the Box: The Reinvention of Art, 1965–1975
by *Carter Ratcliff* (paperback with flaps, 6 × 9, 312 pages, $19.95)

Redeeming Art: Critical Reveries
by *Donald Kuspit* (paperback with flaps, 6 × 9, 352 pages, $24.95)

The Dialectic of Decadence
by *Donald Kuspit* (paperback with flaps, 6 × 9, 128 pages, $18.95)

Beauty and the Contemporary Sublime
by *Jeremy Gilbert-Rolfe* (paperback with flaps, 6 × 9, 208 pages, $18.95)

Sculpture in the Age of Doubt
by *Thomas McEvilley* (paperback with flaps, 6 1/2 x 9 7/8, 448 pages, $24.95)

The End of the Art World
by *Robert C. Morgan* (paperback with flaps, 6 × 9, 256 pages, $18.95)

Uncontrollable Beauty: Toward a New Aesthetics
edited by *Bill Beckley with David Shapiro* (paperback, 6 × 9, 448 pages, $24.95)

Imaginary Portraits
by *Walter Pater, Introduction by Bill Beckley* (paperback, 6 × 9, 240 pages, $18.95)

Lectures on Art
by *John Ruskin, Introduction by Bill Beckley* (paperback, 6 × 9, 264 pages, $18.95)

The Laws of Fésole: Principles of Drawing and Painting from the Tuscan Masters
by *John Ruskin, Introduction by Bill Beckley* (paperback, 6 × 9 224 pages, $18.95)

Graphic Design History
edited by *Steven Heller and Georgette Balance* (paperback, 6 1/2 × 9 7/8, 352 pages, $21.95)

Looking Closer 3: Classic Writings on Graphic Design
edited by *Michael Bierut, Jessica Helfand, Steven Heller, and Rick Poynor* (paperback, 6 1/2 × 9 7/8, 304 pages, $18.95)

Please write to request our free catalog. To order by credit card, call 1-800-491-2808 or send a check or money order to Allworth Press, 10 East 23rd Street, Suite 510, New York, NY 10010. Include $5 for shipping and handling for the first book ordered and $1 for each additional book. Ten dollars plus $1 for each additional book if ordering from Canada. New York State residents must add sales tax.

To see our complete catalog on the World Wide Web, or to order online, you can find us at *www.allworth.com*.